D1483128

PORTRAIT
PHOTOGRAPHY
IN PRACTICE

PORTRAIT PHOTOGRAPHY IN PRACTICE

Mary Allen

DAVID & CHARLES
Newton Abbot London

An Element technical publication
Conceived, designed and edited by
Paul Petzold Limited, London.

First published in 1985

British Library Cataloguing in Publication Data

Allen, Mary
 Portrait photography in practice.—[Updated
 and expanded version].—(An Element technical
 publication)
 1. Photography—Portraits
 I. Title II. Allen, Mary Portrait
 photography
 778.9'2 TR575

 ISBN 0-7153-8410-4

Typeset by ABM Typographics Limited, Hull
and printed in Great Britain
by Butler and Tanner Limited, Frome
and Edwin Snell Printers, Yeovil
for David & Charles (Publishers) Limited
Brunel House Newton Abbot Devon

CONTENTS

CONTENTS

FOREWORD

'All human beings are interesting; deeply interesting to all who have the heart and mind to be interested in them. All are different. Each has something that no-one else has.'

Paracelsus

These, the words of a remarkable individualist and medical revolutionary of the 16th century, attracted my attention many years ago, and still represent to me an inspiration and a challenge. The first camera portraiture closely followed the traditions of the artist. But two of the earliest pioneers, Hill and Adamson, stand in their own way for a partnership that is equally significant today. Hill was an artist, originally a landscape painter, while Adamson, trained as a chemist, was the technician. This combination of these two distinct skills was ideal. As an artist Hill had a knowledge of design, and organized his models much as a painter would. He arranged his subjects – individuals or groups – to perfection. The interplay of light and dark shapes across the structure of the face or around the flowing lines of the full skirted dresses compensate for, or even exploit the failings of the photographic process he used. But much can still be learned from him and from many other such portrait workers, not only in photography.

Julia Margaret Cameron was the first portrait photographer who, to my way of thinking, treated people as individuals. To her, portraiture was an art, not a commercial racket. She was fortunate in that she did not have to worry unduly about the financial aspect, and could choose people simply because she was interested in them and wanted them before her camera. Her exposures were long – frequently of several minutes' duration. On the whole, her models sat fairly still during this time. But if, occasionally, they moved, it did not matter too much. Julia wanted to capture the spirit which defines a personality, not the accidental details. Indeed, her means and methods were often calculated to destroy detail in the image intentionally. She would sometimes adjust the lens past the sharpest point of focus in order to suppress detail in the image. She was known to say that she tried faithfully to record the greatness of the inner spirit as well as the features of the outer man.

Her portraits are of 'living' personalities and can still hold their own among the best modern interpretations.

Like so many other portrait photographers, I am a great admirer of Rembrandt and I believe that a study of his techniques and work has greatly influenced my own approach. Rembrandt has a deep compassion for people. He has the courage to ignore fashion and reveal the truth, refusing to flatter. The viewer's attention is always drawn to the eyes, by the masterly arrangement of colour, the dull browns, greens and greys being blended together and infused with atmosphere and light, surrounding the figure but never dominating it. The modelling of the face, so truthfully rendered by simple lighting, has been the basis on which I have built my ideas of lighting for portraits which you will find expressed in these pages. I am not suggesting that any one artist should copy another, but that he should test the efficacy of any technique which seems applicable to his particular style of portrait.

Portrait photography is now recognized as an art in its own right. A great leap forward was the advent of the miniature camera, which paved the way for natural or, as they used to be termed 'candid' journalistic styles. In the 1950s the *Family of Man* exhibition showed an intimacy of life never previously portrayed. Such feeling and stark reality caused a great stir, not only among photographers, but with the general public. Some of its effect will still be felt long into the future.

A portrait photographer must be sensitive to people and, if he cannot actually like them, he should at least understand and respond to them.

1 AVAILABLE LIGHT

Some years ago we were entertaining the local photographic society to a studio evening. Among their number was a very new member, Peter, a person in his late teens. As the other people were moving into another room for a coffee break, he came up to me and said, 'I love portraiture, but I shall never be able to afford all this equipment and these lights'. My reply was, 'You have said the only thing that matters – you *love* portraiture. This is the best, in fact the only foundation on which to build if you want to be successful. Learn to use the equipment that you have, get to know its limitations, and add to it when experience tells you what equipment you need to extend your capabilities. This is far better than starting with expensive cameras and masses of lights and other accessories without having a sure knowledge of how to use them. I will prove one thing to you, that you do not need powerful lights to make a well lit and well exposed portrait.'

Following the others into the next room I set the camera up in front of one member who was reclining in an armchair. Dark curtains provided a background. Not a photogenic position, but I did not ask him to move in any way, because, well, it was a coffee break! Taking a table-lamp containing an ordinary low wattage household lamp, I held it for the modelling light, showing the nose shadow in the off-centre position. Asking Peter to keep this lamp steady, I angled the centre room light, which had a 30cm (12in) shade, towards my model to act as a fill-in. These were the only lights used. The model was asked to remain as he was but to keep perfectly still, only blinking his eyes if he felt the need to, and I gave an exposure of eight seconds.

The resulting portrait was well modelled, absolutely sharp, and what is most important, the subject appears alive and to be thinking. There could be no simpler form of lighting, but it does involve a long exposure. You may say that people cannot sit still for so long, but, if you experiment you will find that the majority can, if they are in a relaxed, comfortable position, and know that they can blink during a long exposure without appearing to have their eyes shut. In fact, it is advisable to blink because the eyes then look softer and have less tendency to stare. The lights being of low power and more natural, having time to sit and think and knowing exactly when the exposure is being made, are all factors which contribute to success, but the most important thing of all is co-operation between model and photographer.

I will give another example of making a portrait without any studio lamps, and of emphasizing the fact that it is the position of the lights rather than the source of power which creates the modelling. Of course, the lower the power of the light, the closer it has to be to the subject. This portrait was taken by the light of five candles, the room, otherwise, being in darkness. These had of necessity to be very close indeed to the model. Two candles, together, were used for the *key* light, one for the 'fill-in', and one each side at the back as effect lights. The exposure given was 12 sec, the reading being taken off a white card and multiplied by 16. This calculation will be explained in a later chapter (page 62).

In the resulting portrait the face appears well modelled, the skin texture natural, the lips pliable, the eyes thoughtful and plenty of detail is shown in the top of the head. The subject usually co-

1.1 Key light: desk lamp, 75 W, hand-held; fill-in: room light tilted forward; exposure: 8 sec.

1.2 Key light: two candles together, close to subject at an angle of 25°; fill-in: one candle, central, level; back lighting, one candle each side; exposure: 12 sec.

1.3 Key light 100 W in 30cm (12in) reflector flood; fill-in 100 W in 30cm (12in) reflector flood; exposure 8 sec.

operates well in this kind of portrait because it is something different and quite exciting.

Now progressing from candles to two medium power household lamps which, again, can be found in all homes. If two lamps of equal power are used it is very much easier to control the lighting ratio between them. If no lamp stand is available you may have to use table-lamps and, in this case there has to be an assistant to hold the lights in position. Here (fig 1.3) one was used for the key light and the other was placed by the camera as a fill-in. Exposure of 8 sec gives the full quality in the skin tones and a naturalness about the features.

Before discussing the principal source of available light, daylight, we will return to Peter and the question of cameras. After all, it is the camera that records your set-up. The examples given were all taken with a long focal length lens on 120 rollfilm. Peter's camera – his first – was a 35mm with only a standard lens available. Can this be used for portraiture? Yes, *provided* that you realize its limitations and do not attempt to obtain a large head and shoulder portrait by filling the whole picture area. We have all seen that when getting too close for holiday snapshots unflattering distortions ensue. These can be avoided by limiting yourself to nothing closer than three-quarter length shots, or by approaching the model from a greater height. You can maintain the correct drawing of the face by standing the tripod on a table and tilting the camera down towards the subject. Suppose you wish to make a half-length portrait to include the hands. Taken from such close range and at the normal camera height (just above the subject's eye level) you would find that the lower half of the face and the hands appear too large in proportion to the remainder. Looking down from a greater height, the distance is increased and the risk of distortion minimized.

From these preliminary experiments, it has become obvious that one piece of equipment you can do with is a tripod. As with every item in photography, the quality you get depends on the amount of money you can afford to spend. It is worth having a really firm tripod which will go up to a good height and down almost to ground level, and one with either a platform or a pan and tilt head, because you may need to tilt the camera at a quite considerable angle. The weight will also be a consideration if you intend to carry it around, but, generally speaking, the heavier the tripod the firmer it is in use.

The next item on the list is a lens of longer than

1 Claire Bloom. Large-scale head obtained with 135mm lens on 35mm format camera; the picture is from the whole image area of the negative. The light gives great detail in the skin texture.

standard focal length (a 'portrait' lens) with extension tubes. If your camera is designed to accept interchangeable lenses, well and good. If not, you may have to be content with three-quarter length arrangements until such a time as you can purchase a single lens reflex camera (nearly all of which allow the lenses to be interchanged). The long focal length lens, ranging between 90 and 135mm on a 35mm camera, not only reduces the risk of distortion, but allows the subject to fill the frame, which is a distinct advantage in procuring the best print quality. Also, the decreased depth of field coupled with the increased subject-to-camera distance, gives a more pronounced feeling of roundness and vitality to the features. A shutter with speeds ranging through ⅛, ¼, ½ and 1 sec is much more useful in portraiture than one which includes several very high speeds but at the lower end then jumps to a 'B' setting. The 35mm format, rectangular, for use in upright or horizontal compositions, is a reasonable film size

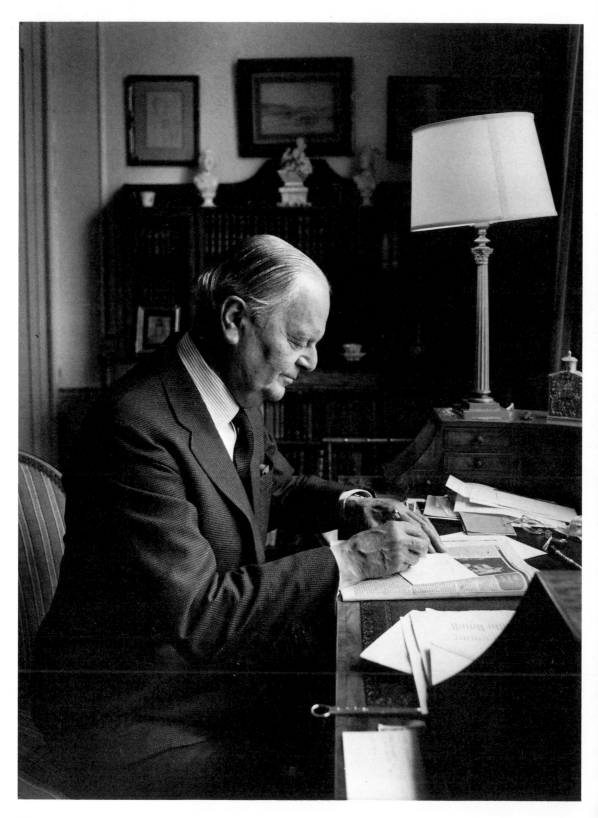

2 Lord Clark at home. Light from the window gives good modelling, wide angle lens on medium format camera.

3 Portrait of an undertaker. The composition fits nicely into a square format. A beautiful characterization by available light.

and, being comparatively light to carry, is very useful for portraiture out of doors. More will be said about equipment in Chapter 3 but, before examining technical matters in greater detail, let us have a little fun with portraiture, by using only what we have to hand.

Children enjoy doing unusual things, especially when it comes to sitting in front of a camera. The next illustration is a picture of two brothers, taken at home in a tiny kitchen. The younger one kneels on top of a cupboard, the elder stands beside him. They are really close to the window – the edge of the curtain is visible. A white reflector is used to lighten the shadow side of the faces. The boys are delightfully natural, and the daylight is soft but bright. Be careful to see that no unwanted background matter such as pictures or ornaments is included in the view. Here, a standard lens is used. Although the camera could be hand-held for this type of picture, a tripod is useful because it

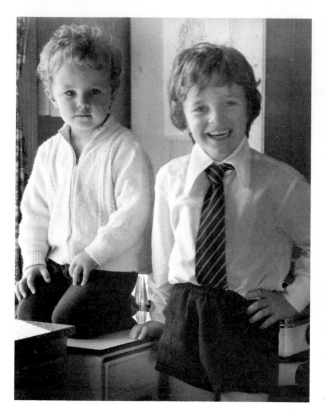

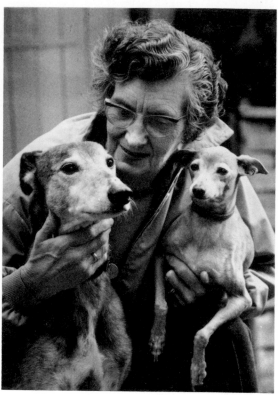

1.4 One subject kneels on cupboard close to window, the other stands beside him. White reflector for shadow side, tripod. Exposure: 1/15 sec, *f*/5.6.

1.5 Outdoors on a cold, cloudy, but quite bright day. Talking quietly to the dogs helped to keep them looking alert.

4 Available light from skylight, and available background gives strength and context to this portrait of Sir Hugh Casson, architect and former

President of the Royal Academy of Art; 35mm camera, 1/4 sec *f*5.6.

gives greater freedom to activate any object with which to attract and maintain the boys' interest.

Now you move into another small room – a study lined with books. The furniture consists of a large desk facing a single window, an office chair, bookshelves and cupboards. There are no light walls to give reflected light. Turning the chair sideways for better composition, the subject sits resting an arm on the desk and begins filling his pipe. The light from the window gives good modelling in the face – the shadow side being lit sufficiently by light from the open door. The surrounding dark tones prevent the head from being over-lit, and a relatively lengthy exposure gives sufficient detail overall.

While we are coping with taking portraits in confined spaces, we will try with a new-born baby – six days old – in the smallest bedroom. The mother is sitting on the bed holding the baby in her arms, 1m (3ft) from a net-curtained window.

The camera is hand-held from above – height is gained by standing on a chair. Patience is required before taking the picture, waiting for the eyes to open. Luckily they do, and at a time when the expression is peaceful and somewhat quizzical, the forehead wrinkled with the wisdom of the newly born and the very old! No special equipment is needed for this type of portraiture, just *you*, your camera and your vision.

To take two dogs with the owner is a subject which is more easily and successfully done out of doors. Fortunately there is a patio at the back of the house. Although a cold, rather cloudy day, the light is good and gives a brightness as well as good definition to the whole group. The arrangement makes quite an interesting composition. Quiet 'doggy' talk is better than any distracting noises for getting an alert and intelligent look on the faces of both dogs at the same time, and to keep them *still*.

2 PORTRAITURE OUT OF DOORS

Before actually taking a portrait out' of doors, we will spend a little time looking at light. You may be used to taking light into consideration when making pictures of any subject by photography. But now we shall try to understand what effect light has on colour and texture, and also something of the psychological effect that light has on us. Normally we recognize things purely from a mental impression of them. If we know something to be brown, green or red, it stays that way in our mind and we have to train ourselves to see the variations in colour produced by the changing direction and quality of light. Similarly with texture. We know the surface of a particular subject to be rough or smooth. But we have to learn to see that the direction and intensity of light have a visual effect on that texture – a rough surface may either be emphasized or, alternatively, be made to appear quite smooth.

We know that daylight varies in quality according to the time of day or the month of the year. But it also varies with changing climatic conditions. In many countries we can compare the brilliant light produced by the summer sun shining almost overhead from a cloudless blue sky with the darkness resulting from overhanging storm clouds. Or we may make comparisons between the soft brightness of an early morning heat haze and the cheerless hue of a November fog. Or, again, we may contrast the glistening white of fresh fallen snow in winter sunshine with the dreary grey of continual rain, or the magic of dawn with the mystery of twilight.

Have you noticed that the description of the quality of light has included the texture and colour as well as the actinic value? The colour of light varies according to the colour of the sky from which it is reflected. An overall grey sky reflects grey light. A sky with an abundance of white cloud reflects white light, while the cloudless blue sky reflects light tinged with blue.

In the early morning sunshine the light tends towards yellow, being reflected by the golden hue of sunrise, and in the evening the light again changes towards the reds and yellows, caused partly by the dust-laden atmosphere, but mainly

5 Maori, taken during a protest meeting in New Zealand. A deeply lined face traced by strong daylight in a white clouded sky.

6 The French photographer Brassai, in London. Outdoor portrait taken on a bright day. Reflection from light cloud gives clean, crisp detail with no overly dark shadows. Hand-held; 135mm lens on 35mm camera.

7 Sir Cecil Beaton in the garden of his Wiltshire home. Though a very sunny day, choice of a shady area with soft lighting gave good tonal quality in the skin and clothes. Despite partial paralysis and often incoherent speech resulting from a severe stroke, he managed to produce the sudden alert expression captured here. Beaton himself was pleased with the result.

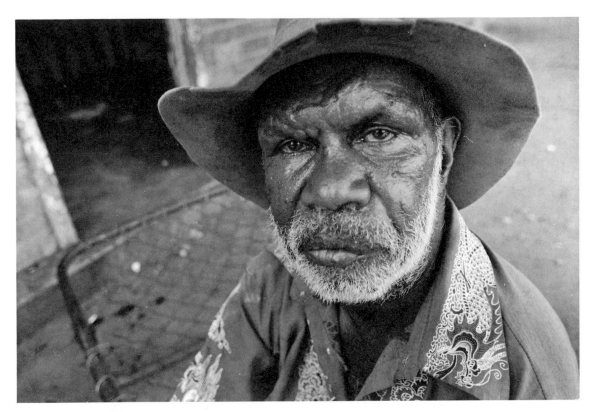

8 Aboriginal at home in his
settlement in Northern
Territory, Australia. Taken
in very low sunlight.

by the reflection of the glowing reds and yellows
of the setting sun streaming across the sky.

The atmosphere is responsible for an apparent
change in the texture as well as the colour of light.
We talk of sunlight as being harsh and glaring,
evening light as soft and mellow, light in snow con-
ditions as crisp and clean or, perhaps, dull and
heavy. We think of light through rain as being
misty or clear and through fog as either thick
white, or dirty yellow.

Light is also termed exciting or depressing,
warm or cold, and bright or dull.

It is this customary way of defining light in terms
of mood and atmosphere, as well as the visual
changes in texture and colour which occur with
variations in its direction and intensity, that makes
light such an important tool in the techniques of
portraiture.

Actinic value of light

The intensity of light varies from hour to hour, from
day to day and from month to month, according to
the direction from which the sun's rays strike the
earth. The power is greatest when the sun is di-
rectly overhead, ie at midday and, where I live at
least, during the months of May, June and July. De-
creases in intensity occur on either side, both in
the hours of the day and the months of the year.
The fewest hours of daylight in any one day occur
in December; and the changes in the actinic value
of the light occur more quickly then than in the
long daylight hours of mid-summer.

The condition of the sky, which is reflecting the
light, is a factor governing its intensity. When the
sun is shining in a sky flecked with white clouds,
the intensity of the light is greater than when re-
flected by a cloudless blue sky. This, as we have
already seen, is because the white clouds scatter
the light into the shadows. It is rather misleading
for beginners in photography, because the sun in
a cloudless blue sky appears so much more bril-
liant to the human eye and gives much greater
contrast.

The cloudy sky with no sun produces light of re-
duced actinic value, which, added to its lack of
colour and texture, makes it a less favourable light
for conventional photography, unless the subject
is primarily one of mood.

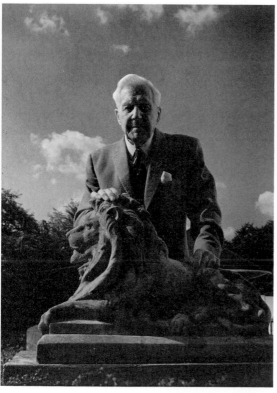

Psychological effect of light

While we are still considering the nature of light in general terms, let us think what effect, if any, the variations of light have on our personal feelings. Sunlight is a joyous thing. In the bitter cold of winter, the sunshine can be exhilarating and can make us feel cheerful. When the first touch of warmth creeps into the sun's rays we are physically warmed and feel more kindly disposed towards life in general. Summer sunshine, associated in our minds with holidays and other pleasurable pursuits, makes us feel relaxed and happy, or alternatively, active and excited.

Wet weather, with its accompanying dull, monotonous grey light, can make us feel depressed and uninspired; misty light can fill us with awe or apprehension; thick fog can make us feel isolated, and perhaps, fearful. We could continue in this way at some length imagining our feelings under the varying conditions of light, but enough has been said to make us realize its importance.

We are used to changes in lighting conditions. Change is welcome, for we soon grow tired of monotony. If it is dull and wet for too long we yearn for sunshine. If the sun shines for too long we look for the shade.

Change has some excitement about it, monotony is always dull.

We shall now begin to narrow our field of discussion from the nature of light in general, to its visible effect on a particular subject. You can select any subject you like for this study, but I have chosen a piece of bark from an old silver birch tree. It is, in the main, gnarled and deeply grooved, and the colours range from browny-grey, through silver to moss green. But it is the surface texture which is of greatest interest. Looking at it in reflected daylight with the sun shining from a cloudless blue sky, though not reaching this part of the subject, the detail in the bark is very clear. If you concentrate, you can see every small crack and mark on it. It might be said that you are seeing it as a flat pattern, and this reflected light is the most suitable for this purpose. The piece of bark does not appear exciting in this light, in fact it looks rather old, tired and useless. Now turn it round allowing the sun's rays to play on it, and note what you see. Firstly the bark no longer looks

9 The softly diffused sunlight contributes an airiness to the relaxed and happy mood of the subject, emphasizing her fair colouring and skin.

10 The low angle of evening sunlight at the three-quarter position lights one side of the face, leaving the remainder largely in shadow but with some residual reflection.

decrepit – it has become revitalized. The grooves facing the sun have been 'ironed out' – they are still visible but appear wider and more shallow. The overall colours take on a white brightness, but the yellow-green of the moss, being in a more shaded position within a crevice, remains a saturated colour and, incidentally, becomes a focus of interest. As you continue turning the bark, you will notice how the sun's rays alter the apparent depth of the grooves. We have already seen that they appear wide and shallow when filled with light. We now see that they also appear wide and shallow when filled with dark, ie when the sun's rays do not penetrate within the groove. The grooves appear narrowest and deepest when the brilliant sunshine lights one side of the groove only, leaving the other as a contrasting dark tone.

This strong side or back lighting also makes the bark appear to be strong and hard and to have a tough surface texture. Alternatively, when the whole surface of the bark is facing the sun, the grooves become scarcely visible, and the bark now appears younger, and softer, with a much smoother surface.

The recognition of this apparent change in character and surface texture obtained with the varying conditions and angles of light is most useful when considering the skin texture in portraiture.

Now, if we substitute a human face for the piece of bark, we can imagine how the direction and quality of the sun will affect the portrait. The strong side, or back, lighting will add strength to the character and produce a rough skin texture. Alternatively, if the sun shines full on the face, the lines become scarcely visible and the face appears flat and two-dimensional. There must be some visible shadow to create the third dimension. On a sunny day the shadows will be black and create too much contrast. On the other hand, the dull grey light of a cloudy day, which will give greater colour saturation, will not offer sufficient vitality. The best light to choose is when the sun is veiled by light clouds.

This light creates a happy mood, is comfortable and, if the subject is positioned correctly, will give good modelling to the face and also plenty of detail in the clothes.

11 Summer freckles become a feature in the simplified tones of black and white. Hard lighting is reinforced in printing to eliminate unwanted detail.

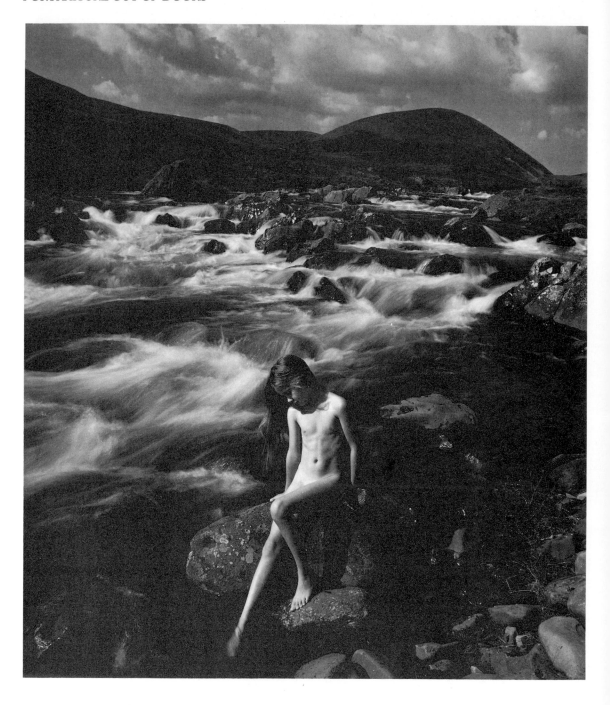

12 Girl in a landscape. Sunlight on the child's body contrasts well with the tones in the water. The stillness of the child, both physically and in thought, contrasts with the water rushing over the rocks.

3 EQUIPMENT FOR PORTRAITURE

Photographers are individualists. Like other creative people, they have their personal preferences and ideas of perfection. This is especially the case when it comes to choosing or recommending the tools of their trade. But it is not only because of personal feelings that the choice of photographic equipment can never really be definitive. Portrait photographers do not work under standard conditions and individual requirements vary according to the type of portrait, and the circumstances under which it is taken.

But the need to discuss some of the equipment used for the studio experiments outlined in the following chapters reduces the question to manageable dimensions. So here it is possible to say not only which equipment is needed by why.

If you are a beginner in photography, and money is no object, you may, in your confusion, be tempted to buy the most expensive camera in the shop – with its accompanying case of shining accessories. The thought uppermost in your mind at the time of purchase may be that henceforth the camera will make perfect pictures for you. It is natural for many beginners to think like this. They have yet to realize that it is not the camera but the man behind it who has the vision and the ability to

translate the image through the photographic medium. The camera, then, as a tool in the hands of the photographer, is chosen to suit the particular work for which it is intended.

Camera

If you consider your main requirements first, you simplify your choice by selecting the camera in which the majority of these are incorporated.

For the type of portraiture discussed in this book you will find the following features are important:

1 A standard lens, and one of longer focal length.
2 One, or more, extension tubes.
3 A shutter with slow speeds.
4 Preferably upright and horizontal format.
5 Focusing screen.
6 Cable release and lens hood (sunshade).

Lenses

With the standard lens you will experience difficulty in taking a close-up, head-and-shoulder portrait without distorting some of the subject's features. Taking the picture from a greater distance and enlarging the required portion of the

3.1A The 35mm SLR camera. Some of the lowest-priced 35mm SLR cameras are excellent for some types of portraiture. *Advantages:* Hand-held, highly mobile and suitable for fast shooting, especially outdoors. Standard, long focal length and wide-angle lenses can be used creatively. Even the wide-angle lens can be used close up to get striking results perhaps with intentional distortion.

3.1B A sophisticated 35mm SLR camera can offer a choice of exposure control methods; manual or automatic with shutter priority, aperture priority or programmed control. The model shown has built-in auto film winding and automatic focusing. If offers a wide choice of lenses and accessories.

image size than the focusing control would normally allow.

Shutter

This should have a range of slow speeds such as ⅛, ¼, ½, 1 sec. This type of shutter is of much greater use in portraiture than one which has only some fast speeds, and then a gap between these and the 'B' setting used for time exposures. The shutter can be a leaf (between lens elements) or focal plane type. As the focal plane shutter is behind the lens, interchangeable lenses can be relatively uncomplicated. Leaf shutters, being sited between the lens elements, mean that a separate shutter must be built into each lens adding to the cost and requiring extra linkages between the lens and the camera body.

Format

Besides 35mm (image area 24 x 36mm), the most popular formats with portrait photographers based on 120 size rollfilm are 6 x 6cm (2¼in

3.2 The 645 camera. This takes a 120 rollfilm, giving 15 exposures of 6 x 4.5cm per roll. It is an SLR camera, with a wide choice of lenses, very useful as a studio camera on a stand and can be used horizontally or vertically at will. It has the usual refinements of the modern camera, eg, auto diaphragm control and several types of viewfinder head incorporating an exposure meter if required. *Disadvantages:* Some models have no interchangeable back and with these quick changes from B&W film to colour are not possible. Though less portable than a 35mm camera most versions provide a special hand grip (either fitted or built in) which makes the camera nearly as rapid in use.

3.3 Most 6 x 6cm (2¼ x 2¼ in) reflex cameras, especially the SLR type, are suited for portraiture. Interchangeable lenses of different focal lengths are required. *Advantages:* Interchangeable backs are available on the more expensive models. When used in studio, the format is obviously suitable for vertical or horizontal set-ups without camera re- positioning. For outdoor work the camera is less mobile than the 35mm type but can be used very successfully hand-held.

negative is a tolerable method for occasional use, but if much portraiture is to be undertaken, or large scale enlargements are likely to be needed, a long focal length lens is essential. This not only reduces the risk of distortion, but allows for the subject matter to fill the negative frame – a distinct advantage in procuring good print quality. Also, the decreased depth of field coupled with the increased subject-to-camera distance, gives a more pronounced feeling of roundness and vitality to the features.

Extension tubes

An extension tube is sometimes necessary when using a long focal length lens in order to increase the distance from lens to film plane and so focus the lens at shorter range and obtain a larger

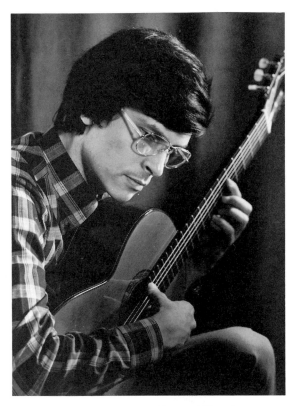

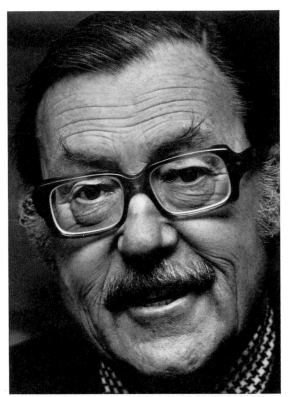

13 Reinhard Froese, concert guitarist. A half-length portrait from the whole picture area; framing that can be achieved without distortion when using a standard lens.
14 For a large image scale a lens of medium-long focal length is more suitable.

Here, a 135mm lens, on 35mm, was used.

15 Wide views require either a greater shooting distance, or a wide angle lens although perspective distortion can only be reduced by shooting from further away.

square), 6 x 7cm (2¼ x 2¾in) and 6 x 4.5cm ('645') (2¼ x 1¾in). The larger formats are particularly favoured for high quality commercial work.

Focusing screen

You need to be able to focus accurately and quickly and on a particular point in the picture – this 'point' is usually the near side eye. The ground glass screen with magnifying eyepiece or magnifier seems to provide the best answer although some people prefer the microprism type focusing screen. Split image rangefinders are, perhaps, not so suitable.

Cable release and lens hood

A cable release is a useful accessory as an aid to avoiding camera shake and is quickly and easily

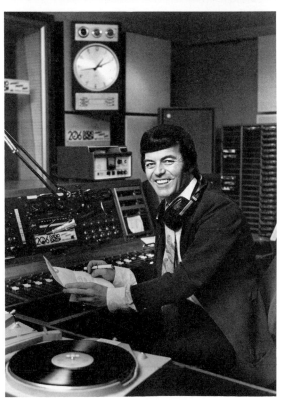

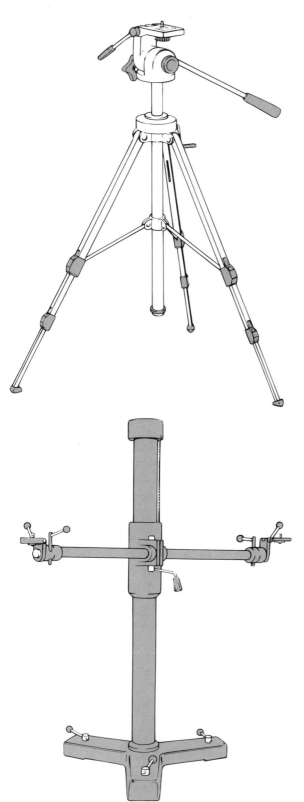

operated. A lens hood is essential to avoid flare in the lens from strong oblique light.

In considering all the foregoing features the selection of possible cameras is narrowed down considerably. You are likely to find your requirements incorporated in a single-lens reflex camera, but the size and price of the actual model remain very much an individual choice.

Tripod

Of almost equal importance to a suitable camera is a good, strong tripod. Many people think of a tripod simply as a means of steadying the camera to prevent a blurred image. This is only one of its functions.

A good tripod should, also, raise the camera to a height of at least 2.4m (8ft) yet allow it to be lowered as close as possible to ground level and, as a third facility, it should tilt the camera in all directions. With these points in mind choice does not offer much difficulty, but you may need more money than at first anticipated!

Lights

Perhaps the next most important tools are the lights. Again, there is a great variety from which to choose but your relatively simple requirements make it a fairly easy matter. Basically, you need two spotlights and two floods, the floods being identical, and one or two smaller spots or floods, preferably also on telescopic stands. It is not necessary to have more than these. Too many lights usually result in confusion. As subjects vary in character as well as in their physical features, you must be able to obtain different qualities of light – soft and hard – and have the scope to use them either reflected or directionally, diffused or undiffused.

You must also take into consideration the measurements of the studio, as the available space will affect the size and power of the lights. Generally speaking, the smaller the studio, the smaller and less powerful the lights need be, but as some

3.4 A tripod must be stable – anything shaky is worse than useless. A tripod of the type illustrated has a central column for rapid height adjustment; it is comparatively light in weight and has a pan-and-tilt head.

3.5 A typical heavy duty model in a range of professional camera stands, designed for studio use. The central column is counterbalanced, allowing instant positioning of the camera. The stand has a wheeled base and can be extended to a height of over 1.8m (6ft).

effects require strong lighting and others very little, it is advisable to compromise by having an average size in light but with interchangeable lamps of higher or lower wattages.

Your choice of lights, then, should include the spotlight for a hard, directional light, the flood for a less powerful, more widely spread light, diffusers for both, and some suitable surfaces for reflecting light.

Spotlight

This is a lamp which, by means of a reflector and lens system, sends out a narrow light beam of high intensity which can be controlled in spread by a simple adjustment.

As the kind of studio envisaged is of relatively small dimensions the usual large spotlight, fitted with a 1000 W lamp is too cumbersome. But a smaller one of a similar design fitted with a 500 W or 250 W lamp, would be very suitable. The stand, though heavy, is fitted with castors for ease of movement and the central column, being telescopic, extends up to 3m (9ft). The lamphouse is fitted with a focusing device to increase, or decrease, the width of the beam of light. Barn doors on each side can be extended to shield the camera lens from the brilliant glare and to shade off a part of the subject or studio.

Very small spotlights are useful for adding extra 'effect' light to the clothes or hair. If these are supplied without a stand, they can be clamped to a suitable object quite easily. Black paper, or tin tubes or cones are easily made to fit over the light to control the width of the beam, or to shield the camera lens.

Flood

A flood is so called because the beam of light fans outward from the centre. This gradually disperses the power of the light making it much softer when it reaches the subject than when it left its source. This is different from the spot which sends its light out in straight lines.

The width of this spread of light, in its initial stage, depends on the width of the reflector. These range from very small, similar to a pudding basin, to very wide, and are either deep or shallow.

A good choice is a reflector of 25 or 30cm (10 or 12in) in diameter, with the bulb well recessed and the inside coated with a reflective surface. This is a good average size, and the width of beam can easily be decreased by making a snout of stiff

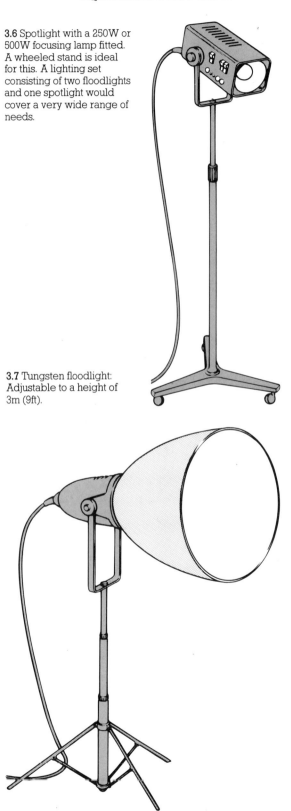

3.6 Spotlight with a 250W or 500W focusing lamp fitted. A wheeled stand is ideal for this. A lighting set consisting of two floodlights and one spotlight would cover a very wide range of needs.

3.7 Tungsten floodlight: Adjustable to a height of 3m (9ft).

black paper and fixing it over the reflector; or the beam can be diffused further by means of a diffuser placed over the front. But the lamp must be well recessed or any diffuser fixed over it can quickly burn.

Barn doors are not fitted to these lights by the manufacturer, but substitutes made from black paper, or tin, can be made and fixed to each side of the reflector. The telescopic stand must be rigid and show no sign of imbalance, even at its greatest height. Many stands on the market extend to a height of only 1.8m (6ft), whereas 2.4 to 2.8m (8 or 9ft) is often required. Interchangeable lamps of varying wattage give you plenty of control in lighting without the need for very much equipment.

In addition to the spotlights and floods you need reflectors and diffusers.

Reflectors

Any white reflective surface can be used to redirect light from the lamps onto the subject. Sheets of white polystyrene are light, easily fixed in position and reflect quite well. Stronger reflection can be obtained by using a mirror, or a piece of card covered with aluminium foil (dull side uppermost).

Diffusers

A floodlight can be purchased which incorpo-

rates a diffuser but this means either having extra equipment, or using the diffused light for all subjects. If you make a diffuser out of a piece of translucent paper, muslin or similar material you can soften the light where necessary. Placing the diffuser between the subject and the light, has the effect of softening the illumination whereas placing a piece of muslin immediately over the reflector will dull the light rather than soften it – a subtle difference, but one worth noting.

Dimmer

An electronic dimmer, placed within easy reach and close to the camera, is of great value in controlling the intensity of the studio lights A separate control for each light is necessary.

Backgrounds

Choice of background is so much a part of the individual photographer's preference that only a few suggestions can be made here.

Background and lighting tie in together. If the studio allows sufficient space, a white background can produce all shades of white, grey or black according to the amount of light it receives, which in turn depends on how far forward of the background the subject can be placed. Background paper comes in rolls 2.1 or 2.7m (7 or 9ft) wide and in a range of colours. These can be pulled down to form a continuous ground behind and beneath the subject for a full length portrait, if necessary, and the used portion torn off when soiled. Fixing an object in the beam of a spotlight, for a shadow to be formed on the background, can give an endless variety of exciting shapes to add interest to the picture. White polystyrene sheets, plastic materials, bamboo or reed screens, also make good background matter. Backgrounds can be as elaborate or as simple as the photographer, aided by his lights, wishes to make them.

Simple, portable, backgrounds can be made by using a piece of hardboard measuring 1.5 x 1.2m (5 x 4ft), either plain or painted in a suitable colour, or by stretching a piece of canvas across a light wooden frame.

No special background at all may be needed if the studio wall is suitable for use and care is taken over the objects included.

Furniture

As little furniture as possible should be in the studio while working. However, it is a great ad-

3.8 The reflector is detachable and several shapes are available any of which can be clipped on, as required. A photographic lamp is used (eg 500W). It is attached to an adjustable fitting so that the lamp can be drawn back within the reflector or extended toward the front and thus the angle of light can be widened or narrowed.

3.9 A diffusing screen can be fitted over the front of the lamp reflector, allowing a small space for ventilation if required.

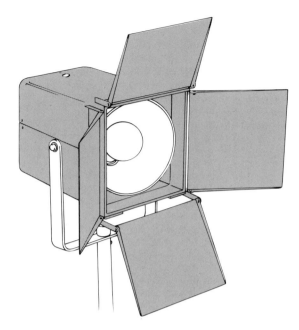

vantage to have a selection at hand from which you may quickly choose the most suitable for a particular subject. Again, only a few suggestions can be made because individual ideas and requirements vary so widely.

You are photographing people – not advertising furniture and including a model to set it off and add sex appeal. You must choose the furniture according to the person's reaction to it. Have you not yourself noticed how different you feel when perched on a high stool, sitting on a chair or at a table, or curled up on a big cushion on the floor? You respond to each in a certain way. Others will also react – not necessarily in the same way – but they will respond more happily to one than another. This reaction is the yardstick by which the furniture should be chosen.

3.10 Studio flash. This type has built-in modelling lights and barn doors. The unit has a two-position power control, and the modelling lamps adjust their light output in proportion.

3.11 Studio flash unit, with umbrella reflector.

3.12 Studio flash. The primary light has a silver reflector (umbrella). This gives a higher contrast than white: ie, crisper modelling. The secondary light has a white reflector. The power of the flash output is controlled by pre-setting as required and the modelling lamps reduce or increase in output in the same proportion. The working aperture (ie, exposure) is determined by a flashmeter connected with the primary light for a test reading.

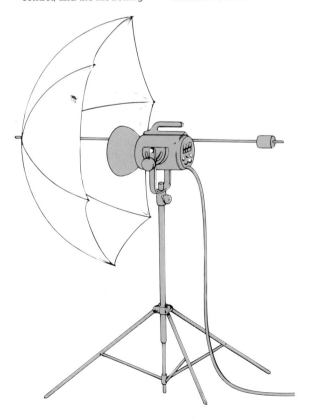

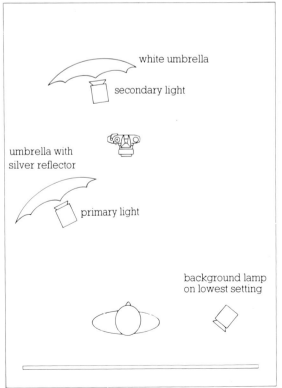

white umbrella

secondary light

umbrella with silver reflector

primary light

background lamp on lowest setting

Likely requirements might be stools of varying heights, a chair without arms, another with arms, a table, and several cushions, including one or two large ones for placing on the floor.

Accessories

It is an advantage if the studio decor allows for the occasional inclusion of walls and curtains as a part of the background. This indicates plain, light-coloured walls – or light on one side of the room and dark on the other – and plain, rich coloured curtains, which hang well and extend to floor level.

Good pictures and also, perhaps, some well arranged flowers add to the charm of the room and can be removed quite easily if necessary. The whole atmosphere of the room is happy and is designed to attract and delight. Soft music playing in the background may help to allay nervousness.

The room itself and all the equipment are contrived to increase efficiency without appearing too clinical, to create an atmosphere of confidence, of serenity and of natural enjoyment.

All this is of little use unless you, as a photographer, are able to inspire these attributes. The atmosphere you create is your responsibility.

Confidence is obtained only by a thorough understanding and knowledge of the subject and in the following chapters we examine the individual studio techniques applicable to portraiture.

4 ARTIFICIAL LIGHT IN THE STUDIO

We have been considering the nature of light out of doors, noticing the effect on colour and texture and, psychologically, on human beings.

When we begin to apply artificial light in the studio, it is helpful to use our imagination again in translating the atmospheric effects of light outdoors in terms of artificial light. By doing this we shall begin to use 'mood' as an important tool in the interpretation of character in a portrait, prior to learning how to position the lights for modelling the features.

Even with a limited number of lights at your disposal you will find that you are able to reproduce almost every effect. Broadly speaking, you use the spotlight to replace the sun, and floodlights, with the help of reflective surfaces, as a substitute for the sky.

Brilliant sunshine and blue sky
For this effect you can use the spotlight for the sun and a diffused floodlight for the sky. The highlights will be crisp, clean and hard, the cast shadows and shaded areas dark in tone with sharply defined edges, giving strong contrast.

Hazy sunshine in white cloudy sky
Lower contrast is needed here and the shadow edges do not need to be clearly defined, but the result must still be bright and clean. The spotlight acting for the sun can be reduced slightly in its power and an undiffused floodlight may be used for the sky. You must be sure to keep the right balance in light – the sun is always brighter than the sky, and if the sun is shining brightly there are always dark shadows, although detail *is* visible within them.

Sunshine on snow
An immense amount of reflected light is produced by the myriads of snow crystals under strong sunlight.

White paper, or some other reflective surfaces, must be placed everywhere around the subject and floodlights brought in to bounce light off these. A spotlight can then be used for the sunshine (or two spots if they are placed behind the subject). The cast shadows must be only very light in tone but still visible as shadow. This effect is the true high key picture – too little reflected light around the model results in a grey tone which is

more akin to dreary dirty wet snow when the exhilarating glamour has faded.

Sunlight and storm clouds
The dramatic effect which this description conjures up in our minds is easily produced by back lighting with an undiffused spotlight and the careful use of reflected light for the remainder. In this case the reflected light can be positioned first and the depth of tone required obtained by adjusting its distance from the subject – overlighting spoils the effect. This lighting is particularly effective with a subject seen in profile. All low key effects can be visualized as having dark clouds with a little sunshine or, perhaps, no sunshine at all.

Mist or haze
For this rather soft and mysterious lighting effect you need plenty of reflected light and if any direct light is felt to be necessary it must be diffused. As there is no sun, the spotlight is only used as an extra light on the background, or to be bounced off a reflective surface. The results of this lighting can be very dainty 'sketch' effects, especially suitable for children.

Psychological effect of artificial lights
Spotlight. As we have seen, the spotlight has all the attributes of strong sunlight. Its light is brilliant, exciting, sometimes dynamic, active, clean and crisp. It can be softened slightly by reduction in power (giving the softer lights greater influence) or, more substantially by a diffuser. But, normally, it is a hard light. It can either make a person feel attractive and cheerful, or more nervous and self-conscious, according to their temperament. The hardness of the light has both advantages and disadvantages. It can emphasize the character lines in the face, or it may obliterate them almost completely depending on the angle from which it is used. It can depict the strength of character which is latent within. It can lift a nondescript type of face to one of distinction and it can do much to remedy a sallow complexion. One of the disadvantages of the hard nature of this light is that it may imply a hardness in the person's character which, in fact, is quite false. A grim, determined expression tempered with a warmth of feeling, shows positive traits. But the same expression, coupled with the cold, hard aloofness which a spotlight is capable

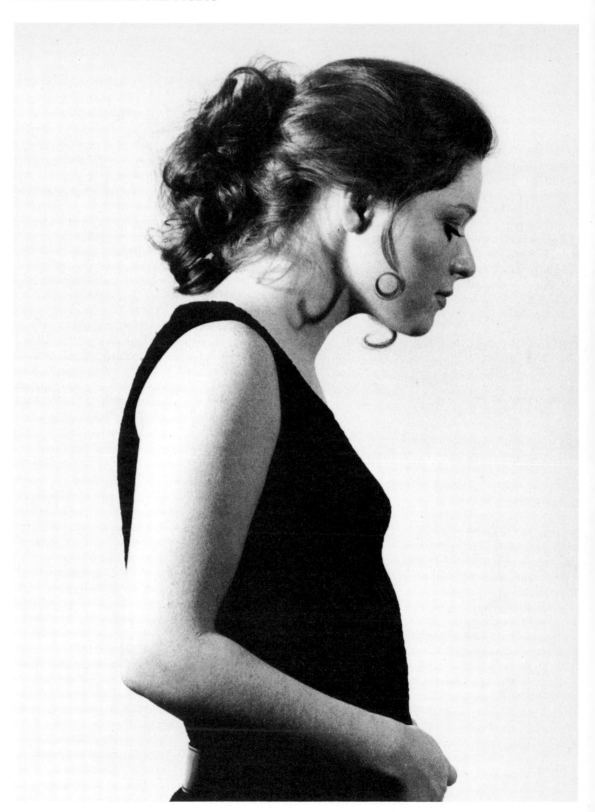

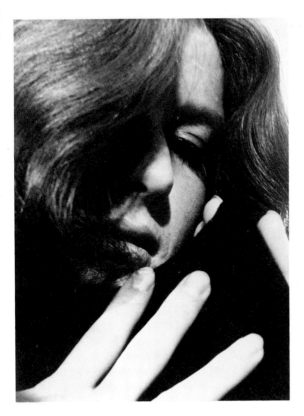

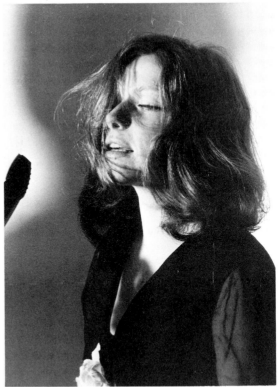

16 Puma. The clever distribution of tone values forms an effective design in black, grey and white. The relaxed expression of pleasant thought typifies the theme.

17 Feel. A poetical portrait, defining 'feel' as an inner emotion as opposed to a sense of touch. Emotion was the theme of a picture-series.

18 Another picture from the series depicting emotion; the impression of a singer during performance is supported by appropriate lighting.

of producing, is too negative. Similarly, sophisticated glamour is flattering if it suits the personality.

But the crisp contrast of light and shade can overshadow the attractive simplicity of some natures. The spotlight can promote impact by force.

Floodlight. This light is much softer and less directional than the spot, which is why it is recommended for creating sky effects. The cast shadows have softer edges. Owing to the cone-shaped beam of light each shadow actually has a dark centre and lightens outwards from this. This cone of light can be controlled by the width of the reflector, as well as by diffusing screens, which means that the nature of the light can vary from fairly hard to very soft. The floodlight then, is adaptable to the majority of personalities and can depict many varied moods. The character

lines in a face can all be shown, but the outer edge of each has a softness which maintains the natural beauty.

Bounced light. When a flood, or any other light, is directed onto a reflective surface and the light is 'bounced' back to the subject, the quality of that reflected light varies according to the material from which it is reflected. If white paper, or any white matt surface, is used, the reflected light is soft. If on the other hand, a mirror or a shiny metal surface is used, the reflected light can be hard, and often too brilliant.

Soft, reflected light is very suitable for children when a little sunlight can be added from behind the subject, and for middle-aged ladies who prefer the character lines in their faces to be obliterated. The overall soft illumination gives complete freedom of movement for the subject. It is usually most effective for high key subjects, as the ba-

lance of tones through a full range can be upset by the flattened lighting and loss of tone in the face.

When taking pictures out of doors, some of the most effective lighting arrangements are found when the sun is behind or to one side of the subject. For a similar reason, in the studio, the spotlight is nearly always placed behind the subject (except, for example, in advertising photography or for special effects) and the floodlight in front. The spotlight then becomes largely an effect light and the flood assumes the important role of a modelling light.

Before putting into practice some of the lighting effects which have been visualized, you need to understand the effect that light has on the features and the positions in which the individual lights must be placed to give both the correct modelling for the particular face, and accurate depth of tone for the shaded area and the cast shadows.

Modelling the features

We will use ordinary tungsten illumination for this experiment as it is considerably easier to work with a small lamp, and be able to make notes about its effect on the individual features. It is the *direction* from which a light comes, not the type or power, which draws the modelling in the face. For these experiments you need a patient subject and a portable light – a table lamp serves the purpose quite well.

Start with the light placed squarely in front of the subject, at a comfortable distance, and note the effect.

1 The face appears flat – two dimensional.
2 The eyes lack colour, depth and character.
3 The nose lacks form – shows no bone structure.
4 The lips lack colour, form and texture.
5 The neck appears square and flat.
6 The light is even – there are *no* shadows.

While watching the eyes only, move the light slowly upwards noting that they appear to sink further into the head, at the same time gaining in colour, tone and character. As you move the light higher, there comes a time when the shadow of the eyelid crosses the pupil. Obviously, this would lose the beauty in the eye. The best position of the light for the eyes is that reached immediately prior to the eyelid shadow touching the pupil. With this light suitably positioned, make a note of the nose shadow. As the nose is the most prominent feature, its shadow is well defined. This will

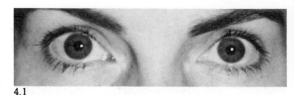

4.1

4.2

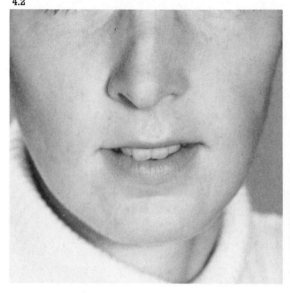

4.1 Modelling the features. Eyes only. Light placed squarely in front of model. Eyes appear to be on the surface, to lack colour, form or character.

4.2 Nose, mouth and chin Light central and level. Sketch effect – no shadows to give form, no tone to give character.

prove very useful in determining the correct position of lights for all features.

Keeping the light at the same height, move it from the central position (camera viewpoint) to approximately 25° to the right or left. Note that the eyes now appear more rounded, the whites graduated in tone, giving an impression of solidity. Look again at the nose shadow. It now forms a pleasing shape, following the line of the nostril.

Returning the light to the central, level position, proceed with the exercise as before noting the effect on the nose, lips, chin and neck when the light is level, or raised, and centrally placed, or 25° to right or left of the camera position.

Doing these exercises, you will find out for yourself what it means to 'draw with light'. To sum up your findings:

The modelling light used from the central position, at a height to place the nose shadow approximately half way between nose and mouth, em-

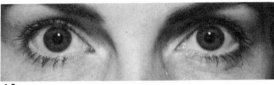

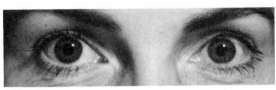

4.3

4.5

4.4

4.6

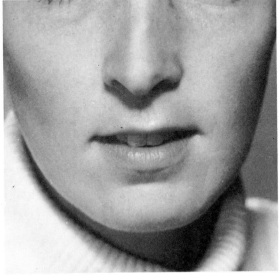

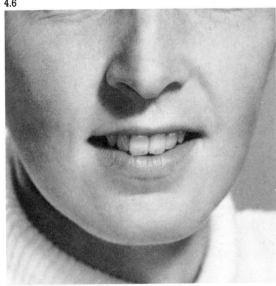

4.3 Eyes only Light moved up until shadow of eyelid is just visible. Eyes gain depth, colour and form.

4.4 Nose, mouth and chin. Light placed centrally but raised to a height to give a nose shadow half-way

between the nose and mouth. The face takes on form, the bone structure being discernible in nose, cheeks and chin. The neck is now in shadow.

4.5 Light moved up and approximately 25° to the right until eyes appear to 'sink' into the head and gain colour and roundness.

4.6 Nose, mouth and chin. Light moved 25° to the right, placed to give nose

shadow following the curve of the nostril. The features now have form as well as modelling, the face appears rounder and more pliable. The neck is in shadow but well modelled. Character takes precedence over features.

phasizes the facial contours, defines the features and outlines the bone structure. It is a popular lighting for glamour portraits.

With the modelling light in the off-centre position the features appear more pliable and the outline of the face is less clearly defined. This de-centralizes attention from the contour to the 'within-ness', in other words the viewer makes contact with the character of the subject rather than simply being made more aware of the shape of face.

So far in our feature study, we have concentrated on a subject placed square-on to the camera and looking straight ahead. If you now continue with the exercise, turning the subject to a three-quarter face position and then to a profile, you will find that the same rules apply.

For these latter two positions you can also take the light further round, to a 45° angle. This is a lighting position rarely used for full face pictures but very effective for three-quarter views, especially in portraits of men.

To position this light correctly, take it around to the far side of the model's face until the face is divided into light and shade, the rear cheek being in light, the near side dark. Move the light slowly round towards the front, raising or lowering it until you produce a small triangular highlight on the nearside cheek. The pitfalls to guard against are: producing ugly-shaped highlights, and dividing the light areas by the nose shadow. The purpose of this triangular light is to prevent the cheek from being flattened by shadow, in other words, to give the three-dimensional impression you have been

4.7 Tungsten lighting. Position of key light: with light level and square-on to the model, the face lacks form, roundness and character. The discomfort of strong light is indicated by signs of tension. It is the outward form, perhaps inherited features, which are described here not the character.

4.8 The light is placed centrally but high enough to give a nose shadow finishing halfway between nose and mouth. The model is now alive, the sparkle in the eyes echoing the smiling lips. The features are well drawn. The viewer becomes aware of an attractive personality. This lighting technique is often applied to glamour portraits.

4.9 The light here is moved 25° to the right and positioned to give a nose shadow following the curve of the nostril and finishing half-way between nose and mouth. This shadow defines the apparent length of the nose. The face is well modelled, the cheeks soft and pliable. The viewer is more aware of the inner personality than of the outward features.

4.10 Central key light on full face. Positioned to give a triangular nose shadow halfway between nose and mouth. The face is lit evenly on both sides; bone formation is well defined.

seeking in the other positions.

This one light that you have been using to draw the features is termed the 'key' light. It is the most important light in the portrait and its function must be visible. It takes the place of the sun and all other lights must be subsidiary to it.

The sun lights an object and thereby creates a shadow on the opposite side. All other light is reflected and shadows take on varying degrees of dark tone according to the power and direction of the sun and any nearby reflective surfaces. Using our key light on its own, in an otherwise darkened room, would result in an image with too much contrast. But we can control the contrast by adding or subtracting light, finally producing the exact tonal range to suit our purpose.

Adding light to reduce contrast

The light that we add to the key light is known as 'fill-in' or 'fill' light. Its purpose is to lighten shadows without creating any of its own. Perhaps the obvious position for this would be on the opposite side of the face to that of the key light. But this would only destroy the modelling of the features so carefully drawn and create confusion by adding shadows to the well-lit side of the face.

Looking back to the experiments you have already made, you will realise that you have discovered the position of this fill-in light for a full face head with the first exercise – centrally placed and level with the subject's eyes. This is the only position that gives a flat, even light over the whole face.

Continue the exercises yourself and, with the subject's head turned first to a three-quarter view and finally to profile, make notes of the position of the light when you have produced the necessary even light.

You will find that there is comparatively little difference in the position of the light for the various turns of the head, which simplifies things, making it easy to remember. The position of the fill-in light only moves from central to SSE and finally to SE on the chart for the full-face, three-quarter face and profile views of the head respectively. In all cases it is approximately level with the subject's eyes. (Should the subject be facing the other way, naturally the fill-in light would be at S, SSW or SW respectively – see key page 39).

Having discovered the correct angle of the fill-in light we must now determine its distance from the subject by considering the brightness ratio re-

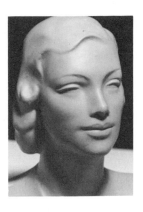
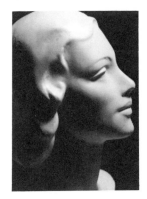
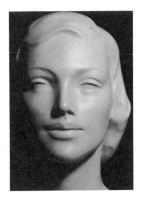
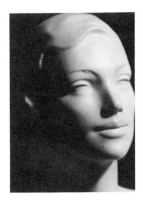

4.11 Central key light on three-quarter face. Positioned to give triangular nose shadow as indicated. The contours of the face are well defined, especially her left side against the dark background. Making sure the thinner side of the face is nearest the camera will give good drawing.

4.12 Central key light on profile. The features are clearly outlined against the dark background. Near-side cheek, jaw and neck in deep shadow. A strong effect.

4.13 Tungsten lighting. Key light 25° to the right of the central position on full face. Model facing S. Key light at SSE, positioned to give a nose shadow following the curve of the nostril and ending halfway between the nose and mouth. This controls apparent width of the face and allows for irregularities to be in shadow. Bone structure is less apparent, modelling softer and more pliable.

4.14 Key light 25° to the right on a three-quarter face. Model facing SE. Key light 25° to right of SE. Positioned to give a nose shadow following the curve of the nostril and finishing halfway between the nose and mouth. If the light is too low, the nose shadow disappears, if positioned wrongly it will create ugly shadows pointing sideways. This controls the width of the face.

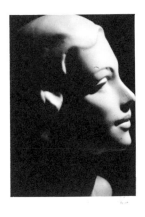
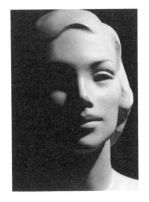
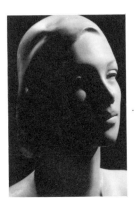
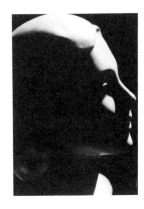

4.15 Key light 25° to the right on a profile. The model is facing E, key light at ENE. The shadow rounds the near-side nostril finishing well above the lip line.

4.16 Key light 45° to the right on full face. Model facing S. Key light approx SE. Positioned to give a triangle of light on the shaded side of the cheek. Low key lighting – not often used for full face.

4.17 Key light 45° to the right on a three-quarter face. Model facing SE, key light approx E, positioned to give triangle of light on near cheek. Especially suitable for low-key effects, this sometimes takes a little time to position correctly.

4.18 Key light 45° to the right on a profile. Model facing E, key light approximately NE. The directional beam of a spotlight is used to avoid flare in the lens and to give an added interest in the outline. Sharp edged shadows are produced in comparison with those from a flood light.

4.19, 4.20 Key light 45° to the right with fill-in light, showing wrong and right positions for a triangle of light. In **4.19** the key light is too low, overlighting the eyes and spreading the triangle. In **4.20** the key light is raised, the eyes

gaining depth and character, the triangle of light giving the third dimension to the whole face and modelling the near-side cheek. Shadow tone is controlled by the fill-in light.

quired for the finished picture. For this, we must use the key and the fill-in lights together. You will find the exercises very much easier if you employ two lights of equal power in similar reflectors. Use can then be made of the 'inverse square law' by which 'the intensity of light from a point source decreases as the square of its distance from the subject'. (This does not apply to a spotlight whose controlled beam of light travels in a straight line instead of fanning outwards from its source).

Inverse square law in practice
This sounds complicated but, in fact, the exercises are quite straightforward. By measuring distances carefully for each set-up you can soon judge the ratios visually.

In practice, the law simply means that if a light is set up 1m (3ft) from the subject and then moved back to 2.7m (9ft), the intensity of light falling on the subject would not be one-third as bright but one-ninth; thus requiring nine times the exposure (ie, more than 3 stops' difference). This is readily understood for a single light source, but the law is equally applicable to two lights of equal power – one being at 1m (3ft) and the other at 2.7m (9ft) would give a lighting (brightness) ratio of 1:9.

Continue the exercises with your subject, positioning the key light as before but this time measuring the distance of light to subject – eg, 1m (3ft). Now position the fill-in light as before but measuring the distance to 1½, 2 or 2½ times that

of the key, being 1.35, 1.8 or 2.25m (4½, 6 and 7½ft) respectively. By squaring the difference between the two measurements you calculate the ratio. The above examples work out at 1:2; 1:4 and 1:6.

These brightness ratios are the ones most often used in portraiture. A lighting ratio of 1:4 is perhaps, the most suitable for an average subject, 1:6 for a stronger portrait, needing greater contrast, while 1:2 is applicable at both ends of the scale, for high, or low key work depending on the subject – whether the model be fair skinned with blonde hair, or dark skinned with black hair. The key light at only 1m (3ft) from the subject is really too close for an average portrait. The skin tones appear hard, the contours of the face are clearly visible and every wrinkle and blemish emphasised. Moving the key light away to 1.2m (4ft) and again 1.8m (6ft) would mean raising it to get the correct modelling but would result in better skin tones. The fill-in would then have to be at 1.8, 2.4 or 3.0m (6, 8 or 10ft) and again at 2.7, 3.6 or 4.5 (9, 12 or 15ft) for the 1:2, 1:4 or 1:6 ratios.

Other factors which have to be considered when calculating the brightness ratio required are:

1 The brightness range of the printing paper.
2 The background.
3 The exposure and development of the film.

Let us look at each in turn.

1 Generally speaking, a film is able to record a far greater range of tones than can be produced in a print – for example, a ratio of 130:1 as against 50:1 (though this depends how the film is exposed and developed and also on the choice of paper). The comparatively limited (under normal conditions) contrast range of the printing paper must be taken into account.
2 When thinking in terms of contrast we must not overlook the important part played by the background. To illustrate this, take two cubes of white sugar, placing one on a piece of white paper and the other on black. The piece on the white paper will appear greyer in tone and have softer edges than the brighter, sharply defined

19 Jazz musicians. Low side lighting from an umbrella reflector angled to catch the instruments while in

each case producing the opposite tonal value in the background

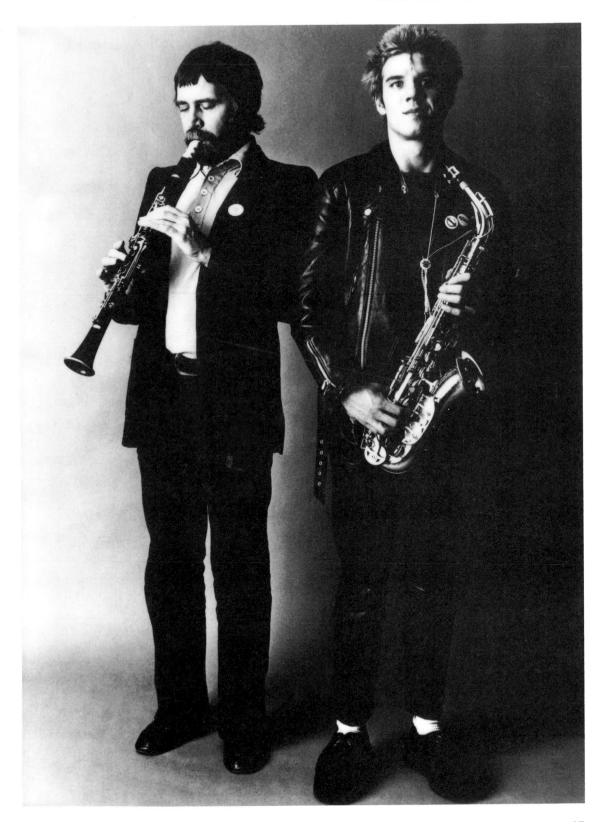

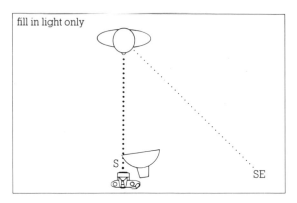

fill in light only

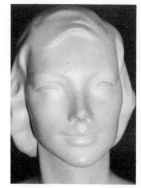

4.21 Fill-in light on a full face, model facing S. The fill-in light is as close as possible to S, positioned to give even light over the face. How near, or far, from the model this should be is determined by the brightness ratio.

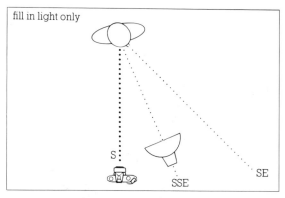

fill in light only

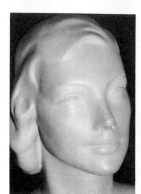

4.22 Fill-in light on a three-quarter face. The model faces SE, the fill-in light is at SSE, positioned to give even light over whole face. The distance from the model is determined by the brightness ratio.

4.23 Fill-in light on a profile. The model faces E, with the fill-in light at SE, positioned to give even light over the whole face. Its distance depends on the brightness ratio required. If the model faces SW or W, the fill-in light would be from SSW or SW respectively. The position of the fill-in depends solely on whether the model faces straight on to the camera, is seen in three-quarter view or profile, regardless of the position of the key light. It may be easier to arrange this even lighting first and then add the key light later. Distances are determined by the brightness ratio desired.

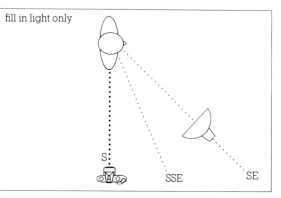

fill in light only

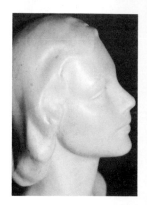

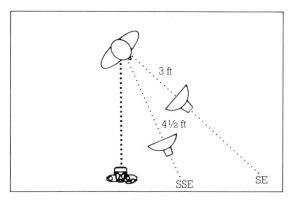

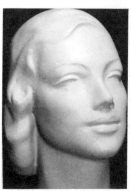

4.24 Brightness ratio 1:2 Key light at 1m (3ft). Fill-in at 1.5m (4½ft). All shadows light in tone, suitable for high-key.

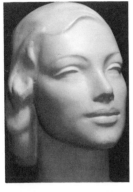

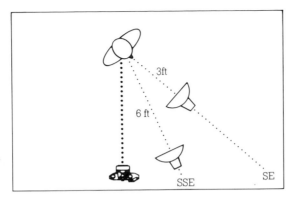

4.25 Brightness ratio 1:4
Key light at 1m (3ft).
Fill-in at 2m (6ft).
All shadows in mid tone,
suitable for average
subjects.

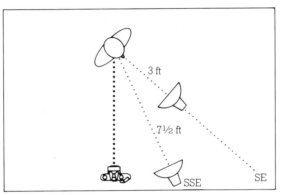

4.26 Brightness ratio 1:6
Key light at 1m (3ft).
Fill in at 2.25m (7½ft).
All shadows dark in tone;
suitable for a subject of
greater contrast.

one on the black. The white paper is reflecting light back on to the sugar lump, softening the tones, while the black paper absorbs most of the light, reflecting perhaps, only about one per cent. **3** Exposure and development of the film will be discussed in a later chapter.

You may find it simpler to arrange the flat, even, fill-in light first and then to add the key light, reversing your calculations. Using totally reflected light as the fill-in, the ratio can be calculated by using an exposure meter to find the distance at which to place the key light in order to obtain the different ratios.

Before leaving the all-important question of the distance of the light from the subject, there is one further important factor – the amazing effect that two lights, the key and the fill-in – have on the facial features, the skin texture and the general character of the personality before the camera. I call this 'retouching with light', and if you will turn to the illustrations and diagram on page 40 you will understand my meaning. In a set of four pictures illustrating the build-up of lights, **A** the subject is lit by key light only, at a distance of 1m (3ft). The lines in the face – the ravages of time and ill-

Key to lighting references.

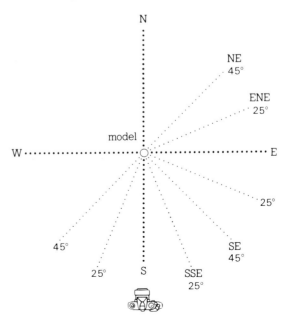

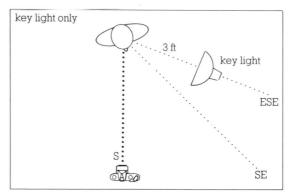

key light only

3 ft

key light

ESE

S

SE

4.27 A Retouching with light. Model facing SE, key light only, distance 1m (3ft) from model at ESE.

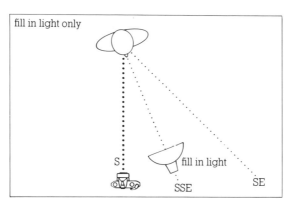

fill in light only

fill in light

S

SSE

SE

4.27 B Model facing SE, fill-in light only SSE. 2m (6ft) from model.

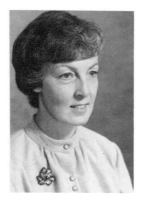

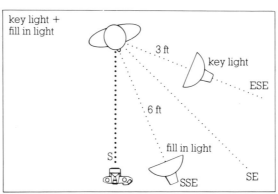

key light +
fill in light

3 ft

key light

ESE

6 ft

fill in light

S

SSE

SE

4.27 C Model facing SE, key light and fill-in together (A and B). Key light 1m (3ft), ESE. Fill-in 6ft, SSE.

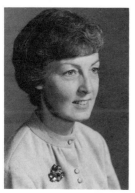

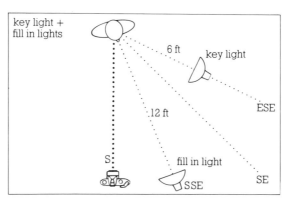

key light +
fill in lights

6 ft

key light

ESE

12 ft

fill in light

S

SSE

SE

4.27 D Model facing SE. key light 2m (6ft) ESE, fill-in 4m (12ft), SSE.

ness – are very assertive. **B** shows the 'flat' light of the fill-in on its own, at a distance of 1.8m (6ft) and **C** the result of putting **A** and **B** together. The face still looks thin and slightly haggard, the lines and wrinkles, although much improved, are still visible, especially around the eyes. **D** Now the key light is moved to a distance of 1.8m (6ft) instead of 1m (3ft) and raised to give the similar nose shadow. The fill-in light is moved back to 3.6m (12ft) instead of 1.8m (6ft), to give the same brightness ratio of 1:4, and positioned to give flat, even light over the whole face. Result – the face has virtually been retouched with light instead of pencil on the negative or print. The model no longer looks ill, the cheeks are rounded, the lines and wrinkles smoothed. The illusion of colour in the cheeks, as well as in the dress, is intensified. *No* print finishing is called for. The position of the head is the same, the expression is similar, yet the only difference is the distance of both lights from the subject.

Study this set of four pictures, and then make a set for yourself as an exercise. Select a model who shows some 'wear and tear' in her face and carry out the exercise; using no other beauty aids, bar her normal make-up. Probably only by faithfully performing this routine step by step and seeing the result on your own selected model, will you fully appreciate its implications.

By using this method you are allowing a person to be remembered by the beauty of their personality rather than the surface effects of ill health.

5 THE FLASH ALTERNATIVE

From the experiments in the foregoing chapter, we have learned that it is the *direction* of light, rather than the nature of the light source, that is of prime importance when modelling the facial features. As the majority of cameras are synchronized for flash and most professional portrait studios are fully equipped with electronic flash units, it may be helpful to spend a little time investigating the uses of flash.

Electronic flash, providing a light output approximating to daylight, is brief and intense – the duration can be anywhere between 1/200 sec and 1/1000 sec (or 1/2000 with some units) depending on the power output that is selected. On automatic operation flash durations may be much shorter. Correct synchronization with the shutter ensures that the flash occurs when the camera shutter is fully open. It may take between 3 and 30 sec to re-charge the discharged capacitor (re-cycling time) according to the design of the unit and the conditions of use. A red or amber signal light indicates the readiness of the unit for each exposure but firing the shutter before this comes on will result either in a weak flash and consequent under-exposure or no flash at all.

Electronic flash units vary enormously in size. A pocket flash gun may be fitted to a 'hot-shoe' socket on a small camera or attached to a socket on the camera by a short 'sync' lead or power cord (PC). The massive studio units may consist of a number of flash heads or units on stands, operated from a central control console. Each may be connected to the camera shutter via a sync lead but the more flexible 'slave' units can be triggered by responding to a flash of light from one master unit. The actual power of the flash reaching the subject is determined largely by its duration, its distance from the subject and the lens aperture set, *not* the shutter speed. Nevertheless the correct shutter speed is important. Electronic flash, synchronized with a focal plane shutter, sets certain limits to the minimum shutter speed that may be set to ensure that the shutter blinds are fully open when the flash fires. Most such cameras are limited to a minimum shutter speed of 1/125 sec or longer when synchronized with electronic flash. With a blade shutter, any shutter speed should work with electronic flash except, possibly, the fastest when used with a studio unit (you should test it before use). Cameras can vary in their use of coding letters for flash synchronization, but each is supplied with appropriate instructions.

Exposure

A photographer equipped with the full studio electronic units is likely to possess a flashmeter for estimating exposures. With the smaller, low power non-automatic flash units the output of the light source remains constant and exposure is controlled by the distance of light source from subject coupled with the choice of appropriate lens aperture, with the film in use. Under these conditions, whenever the lens aperture and the distance of light from subject multiplied together give the same answer, the light reaching the film is the same, eg:

Distance	3m/10ft	1.5m/5ft	1m/2.5ft	
Aperture	*f*/4	*f*/8	*f*/16	Guide number (GN) 12/40

This is the basis of the guide number (GN) supplied with each flash unit, together with an instruction leaflet for varying speeds of film. (Quoted guide numbers may be based on metres or feet and it is important to note the distinction and apply them accordingly.)
Put as a formula we can say:

$$G = DXF \quad \text{where} \quad \begin{array}{l} \text{G is the guide number} \\ \text{D is distance between flash and subject} \\ \text{F is lens aperture number} \end{array}$$

$$F = \frac{G}{D} \quad \text{and} \quad D = \frac{G}{F}$$

A basic guide number is calculated for average conditions, using a nominal film speed, such as 100 ASA film, X synchronization (with appropriate shutter speed), and for use when the flash is situated on the camera, or centrally placed on the camera-to-subject axis. Any deviations from this norm require certain calculations. In portraiture, as we have discovered, the centrally placed light is rarely suitable. The more generally used angles of 25° or 45° will need a reduction in the guide number. This might be to ¼ or ½ of the original figure although here, again, tests are advisable because illumination from a flash unit can vary considerably with the surroundings. No alteration of guide number is required for a second flash used as a fill-in, provided that the light output is similar or less.

to allow for light absorption, and the total distance calculated as flash-to-ceiling plus ceiling-to-subject. White reflecting surfaces around the subject enhance the power of the flash.

2 The flash can now be used as a direct modelling light, at the central or 25° positions. To soften the overly dark cast shadows, a double thickness of gauze, or handkerchief, can be placed over the flash. This necessitates halving the guide number. White reflective surfaces around but not too close to the subject, may also soften the shadows. A tungsten light can be used to enable you to find the correct angle and distance for the flash. Measure this distance from flash to subject and divide it into the appropriate guide number to give the lens aperture, eg,

Film speed 125; guide number 64, diffused flash GN 32
Distance, flash-to-subject, 1.2m (4ft)
Lens aperture–*f*/16 (undiffused) – *f*/8 (diffused)

3 Possibly the most satisfactory method of using the single flash with extension lead is by reflection, but in a more direct way than is possible when bouncing it off the ceiling. A white umbrella is ideal for this purpose, and may be obtained with white matt, or metalized, interior. Failing an umbrella, a piece of hardboard, 1.2 or 1.5m (4 or 5ft) square, and covered in aluminium foil or white paper would make a reasonable substitute. The umbrella is placed at, for example, the 25° position and the flash fired into it, thus reflecting the light back to the subject. Provided that all the light is contained within the umbrella, the distance is measured from the inside centre to the subject. If the matt surface is used, the guide number should be halved, but no alteration is needed for the metalized surface. In each case, the light reaching the face is softer than that of direct flash, resulting in more natural skin tone. The metalized reflector, as may be expected, results in higher contrast, the shadows, as well as being darker, have more clearly defined edges. Light-reflecting surfaces around are sufficient to lighten the shadow side of the face.

Two, or more, flash heads, preferably of equal power, both having extension leads and linked to the camera by an adapter, make for more ver-

5.1 Studio flash with light reflected from a white umbrella. The smile is slightly static, soft quality skin tones.

5.2 Light reflected from a white umbrella; a spontaneous smile and arrested movement. Soft quality.

satile lighting. Two or more electronic flash heads, each a self-contained unit, and synchronized by photoelectric cells are the simplest to use. Only one, preferably that serving as the fill-in light, needs the trigger lead to be attached to the camera. The other lights are free and easily placed in position.

If each flash unit has a built-in modelling light, you have no problems, otherwise the correct position will again have to be judged by trying it out first with a tungsten light.

Modelling, or *key light.* The correct positions for this will be found by following the illustrations for tungsten lighting. Care must be taken to shield the lens when using any of the back lighting effects. Measure the distance of the flash from the subject, not forgetting that, if the light is reflected, the distance is measured from flash-to-reflective surface plus reflective surface-to-subject. Divide this number into the appropriate guide number for the film in use to get the lens aperture. The shutter speed is, of course, set at the speed recommended for flash sync.

Second or *fill-in flash.* This, you will remember, is directed towards the model in such a way that the light is flat and even – no shadows being visible. The *distance* at which this second light must be placed is calculated by the inverse square law; to give a brightness ratio of 1:2, 1:4, or 1:6 etc. To find this distance, multiply the guide number by 1½, 2, or 2½ respectively, according to the brightness ratio required. Divide the aperture number (already calculated) into the new guide number and you have the distance. Remember that guide numbers are only guides! All calculations and results should be noted and kept for reference. In a short time you will be able to judge results without calculations.

Electronic studio units

For professional use, electronic studio units are available, with a wide variety of accessories. Self-contained units are mounted on tripods, or heavy wheeled stands, so that any number can be used and slave-synchronized by photoelectric cells. A single unit, fitted with an umbrella for reflected light, may be used on its own, very satisfactorily, for simple lighting effects, using reflecting surfaces or reflectors to lighten the shaded areas where necessary.

Some accessories

Flash meter. The flash meter is expensive but is of immense benefit. A reading can be taken of the light reaching the subject from each flash head individually, enabling the balance of light to be adjusted at will. Taking the reading from the subject position, directing the meter towards the camera and slightly towards the modelling light, will give the lens aperture necessary.

Built-in tungsten modelling light. This, most useful accessory, can be switched off or kept on during the exposure. It is probably more comfortable for the subject if you keep it on, otherwise they are momentarily plunged into blackness, which can be a little disconcerting! This asset removes all uncertainty in positioning the lights.

Dimming device. A flash unit with built-in modelling light and also a dimming device which works through a range of three or four stops is of inestimable value, especially in a small studio. The power of the light can be reduced without increasing the lamp-to-subject distance and, as the dimmer af-

23 Girl with camera. The camera, a large shop window dummy, was held in front of a flash head facing directly into the camera lens, plus a single hard light from the front.

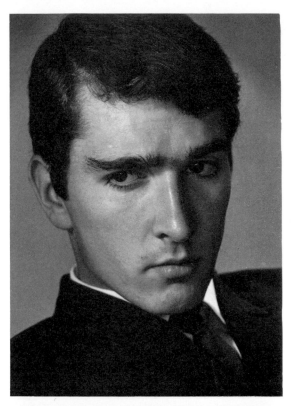

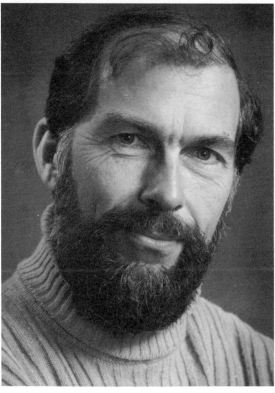

5.3 Light from a large-area reflector. Exposure made while pausing for thought. Soft modelling.

5.4 Light reflected from a silver-lined umbrella for the key light. A white umbrella was used for the fill-in light. There is great clarity of tone values. Character is revealed on the surface, but the picture has little depth.

fords the same effective light control as lens apertures, the inverse square law can still be applied to obtain desired brightness ratios. When working in colour, saturation can be judged visually.

Reflectors. There is a wide variety of reflectors from which to choose, eg, the 30cm (12in) type reflecting through a 40° angle, to the 45cm (18in) size reflecting through an angle of 75°, and many others.

Snoot. For narrowing the spread of illumination from a flash head to a 'spotlight' effect, this is a most useful accessory.

Umbrellas. Large white umbrellas, with matt white interiors, as mentioned above, can be fixed to the lamp so that all the light from the flash is contained in the umbrella and reflected back to the subject. This reflected light is indispensable for portraiture, especially of women and children, when softer skin texture is desirable. A harder, though still diffused light is obtained by changing to a silver-lined umbrella (which is black on the outside).

Photocell slave. As previously mentioned, each unit is equipped with a photocell slave to enable all flashes to be synchronized – one flash head having its trigger lead attached to the camera. Care should be taken to see that the cells are positioned accurately to receive the signal from the master flash and be sure that reliable firing will result.

The illustrations (5.1, 5.2, 5.3 and 5.4) were taken with a typical electronic studio outfit as just described, all the accessories being available. This equipment is so versatile that the photographer has complete control over the effect he wishes to produce, so much so that comparison of two monochrome portraits, one illuminated by flash, the other by tungsten, may show very little difference. Effects can be varied by reflecting the light from either white or silver-lined umbrellas and by dimming the power through one, two or three stops – resulting in softer skin texture and a greater feeling of life and movement. One important aspect of using flash in the studio is its ability to catch the fleeting expression, especially useful when photographing children – observing the ex-

24 The theatre in the studio. Umbrella flash with shadows adjusted for hardness and the upper part of the background flagged. Shadows behind the subjects were regulated by adjusting the separation between them and the seamless background paper.

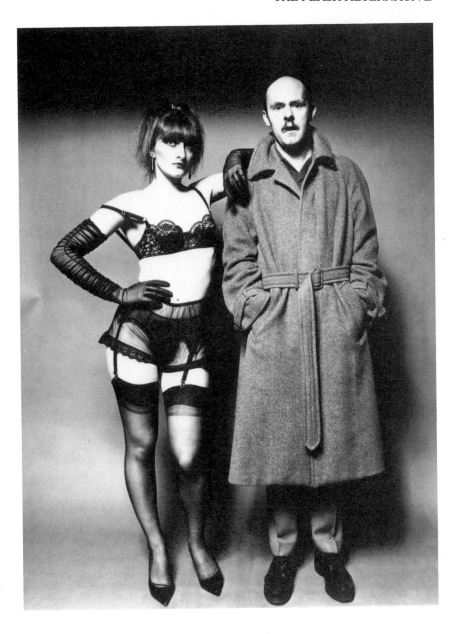

pression and firing the flash can take place almost simultaneously. It is even better to anticipate a smile and so be able to capture it as it moves towards its peak instead of when it is beginning to die away. This, of course, is the aim with tungsten light as well, but it is more easily achieved with the speed of flash – a subtle difference but one worth considering.

This technique hardly gives time for thought, either on the part of the photographer or the subject – what the photographer *sees* is what matters. At other times it is not only what the photographer sees, but what he thinks about what he sees which is significant. The speed of flash arrests all movement, resulting in clearly defined shadow edges, cleaner skin texture and a print that looks sharp overall. Of course, freezing all action can destroy the illusion of life and a subject can appear static – unable to move or speak. This may be overcome by giving him time to think before making the exposure – a technique similar to that used with continuous light sources and resulting in a portrait where the 'living' quality is more apparent.

The ease and speed with which exposures can

be made often results in shots being fired in quick succession, leaving selection of the best pictures to a later stage. To photographers accustomed to working only with continuous light sources this procedure alters the whole technique of studio operating. It gives the subject complete freedom of movement and the photographer a large selection of results from which to choose.

Advantages of flash-on-camera

One advantage of having the flash on the camera is that it is always available for making an exposure possible when daylight is fading. It is very versatile, especially if the camera is hand-held. It can also be used as a 'fill-in' for portraits, or groups, taken out of doors in strong sunlight, when otherwise the contrast is too great. However it is probably used most often indoors, or in poor light, for taking pictures of children and animals, whose movements are quick and unpredictable. The speed of flash 'freezes' all movement and secures a happy picture.

Disadvantages of flash-on-camera

As we have seen, the flash on the camera is useful as a fill-in light but as the main source, the key light, it is in the wrong position. The flat, shadowless light produced, if used head-on, will flatten the features and destroy all modelling. This can be overcome to some extent by considering the direction from which the key light should reach the model and placing the camera as near the angle as possible. The effect of hardness in the skin texture can be reduced by diffusing the flash. Freezing all action may produce a technically perfect print, but also one that is static and lacking the essential element – the illusion of life.

Flash or tungsten with colour

Colour films are manufactured to balance with particular light sources. They can only be made to give good colour rendering with other sources if a suitable filter is used, on the camera or on the light source itself. The correct film or filtration should be used whether the film is negative or reversed. Although it is possible to correct colour balance in printing, for practical reasons, this is best avoided. Corrective filtration changes the effective speed of the film, however; it is best if possible to select the appropriate film initially.

Besides moving the lights further away, two methods by which the intensity of a light source can be regulated are 1, using diffusers over the lights or, 2, dimming one, or all of them. With colour, this can introduce a complication. Dimming the flash does not alter the colour of the light, whereas the dimming of tungsten, if not watched carefully, will increase the red-yellow content and act rather like a yellow filter. By consciously observing the effect while dimming tungsten light, a point is reached when colour in the subject no longer seems to irradiate but to fold in on itself. So, while the yellow-red content increases, the change may be tolerable only up to a point. Of course, the ability to dim individual lights is very useful. It has a softening effect on the skin texture, while the modelling appears more pronounced than with the naked flash. However, in many cases it may be more practicable to use diffusers.

Young subjects

For children, and all young people, there is a certain charm and gaiety about the crisper presentation of direct undimmed light. There is no need to worry about the hard edges to shadows as there may be with the older person. A great deal of the beauty of fresh, clear skin and beautiful modelling is enhanced by flash lighting from a suitable angle.

Flash v tungsten

To my mind, the most important points of difference between lighting by flash or tungsten for portraits in monochrome or colour are:

1 Securing a significant moment in any action may be more readily achieved without signs of movement by using flash.

2 Revealing the inner character so that it can be permanently recorded is more likely to be achieved with the longer exposure demanded by low-power tungsten illumination.

6 DETERMINING CAMERA ANGLE

Few beginners in portraiture realize the difference that the height of the camera can make to the drawing of the face, to the subject's expression and even to the mood of the picture. It would be well, therefore, to study the question in some detail. If your subject will allow you to spend a little time viewing him or her from different camera angles and making notes of your deductions, you will learn far more in a shorter time than by just poring over text and illustrations. Using the key light to get the best drawing of the face, study the image on the focusing screen. A long focal length lens would enable you to get a fairly large head in the picture space without distortion. There is no need to make an exposure at this stage. Instead, move the camera up and down, view the effect on the drawing of the head and the facial features in the full-face, three-quarter and profile positions.

If your subject has well-proportioned features you will probably find that almost any camera angle can be used successfully. But the face will be presented in the best proportions when the camera is raised to a position slightly above the level of the model's eyes and tilted down. From this angle the emphasis is on the eyes, the forehead and the hair. The nose is well drawn, there being a tendency to lengthen it and, in so doing, to hide the underneath of the nostrils. The jaw contours to an oval and the neck is slightly shorter.

Returning the camera to the level position, note the flat, somewhat uninteresting drawing of the nose, with the emphasis now placed on the lower half of the face. This level position is quite useful for a profile but rarely for full-face or three-quarter views.

Bringing the camera low and tilting upwards results in a long neck, a square jaw, a short nose showing the nostrils, and a forehead which slopes backwards with very little hair being visible.

6.1 Camera angle: full face. Camera just above model's eye level. Result: good drawing of facial contours and features, including neck. Good proportions, emphasis on eyes. Top of the head oval, forehead slightly protruding. Hair is well drawn – concentration on eyes. Nose is well-shaped – underneath of nostrils hidden. Mouth is well modelled – top lip thinner than lower. Jaw line contours to oval, neck is shortened.

6.2 Camera angle: full face. Camera low – tilting up. Result: neck becomes overlong and an ugly shape. Facial contours are more square. Emphasis is on jaw and mouth. Top of head is square, forehead sloping back. Little hair is shown, eyes are inclined to look up, nose is shortened, widened at the tip. Underneath of nostril is showing, both lips fuller, jaw widened, neck both lengthened and widened – not flattering for a full face position.

6.3 Camera angle: three-quarter face position. Camera high – tilting down. Result: facial contours are more triangular – emphasis on upper third. Short neck gives hunched appearance, nose is longer, well-shaped, nostrils hidden: jaw is more gradually contoured to pointed chin. Expression – demure and withdrawn.

6.4 Camera angle: three-quarter face position. Camera low – tilted up. Result: neck is lengthened, but maintains a good shape. The model appears to look up. Emphasis is on the lower third of the face and neck, forehead slopes back, very little hair shown. Nose is shortened, underneath of nostrils very much in evidence unless hidden by shadow, lips are well modelled. A good angle for a strong personality.

6.5 Profile view. Level camera angle. Result: the only position for well-drawn contours and features from a level viewpoint. Useful for light or dark rim outline on well-proportioned features. Any profile position needs well-proportioned features. The level camera angle records them accurately.

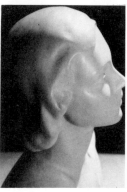

6.6 Profile view. Camera high – tilted down. Result: emphasis on hair, forehead and eyes. Neck is shortened and shoulders inclined to hunch. Features well drawn.

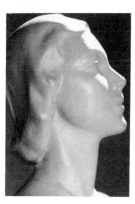

6.7 Profile view. Camera low – tilting up. Model appears to look up – emphasis on long neck. This can be a good angle for a model with well-proportioned features and a graceful neck. A turn of the head is needed, as a low angle view flattens the jaw line. The forehead slopes back and a small area of hair is visible on top of the head – a useful angle for men with receding hair!

Even a slight variation in camera angle is noticeable on this average, well-proportioned face but on an irregular shaped head, having also irregular shaped features, the camera angle can make the difference between a good portrait and one that is unacceptable.

The fact that all faces differ one from another is well known. No two faces are exactly alike, either in construction or in character – each is unique and each requires a different treatment. The photographer must be able to *see* the irregularities in the face and to know what corrective treatment is called for.

It is a comparatively simple matter to, mentally, divide a face up into thirds, by drawing an imaginary line horizontally across the hairline, across the eyebrows, across the base of the nose and across the base of the chin. In a well proportioned face, these spaces AB, BC and CD are more or less equal in size and we have already seen the effect that camera angle has on them. A regular face with irregular features can alter the spacing. For example, a long nose will increase the size of section BC. Using the camera from too high a viewpoint would increase the spaces AB and BC and further decrease CD. A good presentation would be from a camera angle level with, or slightly below the subject's eyes, but with a three-quarter view, not full-face.

If, after dividing the face into sections you find CD is much wider than BC or AB you will have to place the camera well above the subject's eye level. This will emphasize the eyes, drawing attention away from the overly large chin. Too low a viewpoint would result in a distorted appearance.

Irregular shaped heads

Heads not only vary in shape considerably but also have irregular features. To simplify matters I

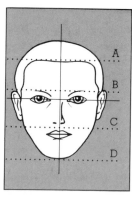

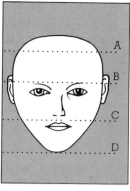

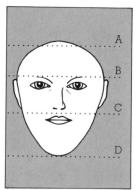

6.8 Division of the human head into thirds.

6.9 Irregular features divided at equivalent points.

6.10 Another irregular head, similarly divided.

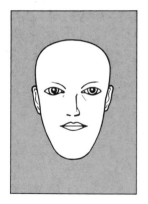

6.11 Long thin head.

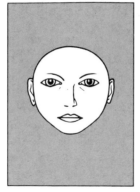

6.12 Round plump head.

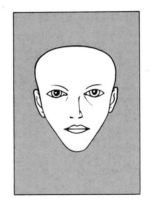

6.13 Triangular head.

6.14 Square head.

have divided them into five main groups, the long thin head, the round plump, the triangular, the square and the average oval. It should be fairly easy for you to imagine someone in each particular category.

Long thin face

Even when the division into thirds gives fairly equal proportions, you should still not use the camera from too high a viewpoint as this would make the face appear even longer. The camera level with the model's eyes, or slightly below, would give a more pleasing drawing. A long thin face usually has a long nose as one of its irregular features. When dividing the face into thirds the space BC would be greater than CD, which would normally call for a lower viewpoint. But, a long nose from a full face position, and a level viewpoint, looks ugly, as the tip is widened and the nose foreshortened. This is not so apparent in a three-quarter view. The profile would show the full drawing of the nose.

6.15 Long thin face.
Brightness ratio 1:4.

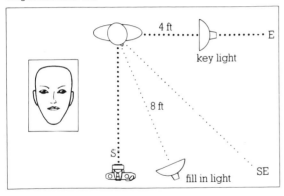

Round plump face

The irregular features you usually have to contend with in this group are a double chin and a short neck. A high viewpoint, while increasing the forehead space and minimizing the jaw, would entirely obliterate the neck. The head does not look well supported by the shoulders! A three-quarter view, the model facing one way with the head turned in the opposite direction, coupled with a low camera angle, will give a good illusion of neck.

Triangular face

The triangular face is not as common as the other four types. The forehead is high and broad, the sides of the face irregular in length, tapering to a pointed chin. The bone structure is, usually, well defined and the features fairly regular. A three-quarter or profile position would give the best drawing viewed from a camera angle on a level with, or slightly above, the model's eyes.

Square face

This is usually a strong, powerful face, which lends itself to a portrait being printed in rich dark tones that convey these characteristics. Dividing into thirds is most likely to give CD as the widest part, suggesting the use of a high camera angle. But, in fact, this would alter the shape of the face when all that is needed is to prevent over-emphasis of the square jaw. This jaw is an asset to a man, showing determination and a purposeful, strong nature. In a woman it may be too heavy in appearance and a higher camera level would flatter by bringing the shape of the face nearer to the oval.

A three-quarter face position would be the best aspect for either a man or a woman, a profile

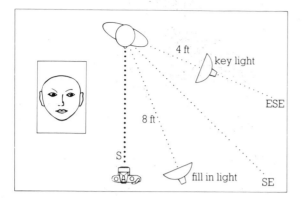

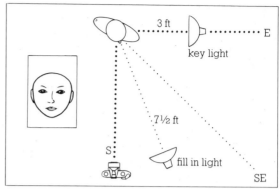

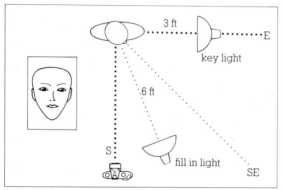

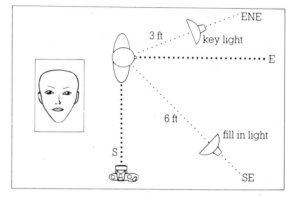

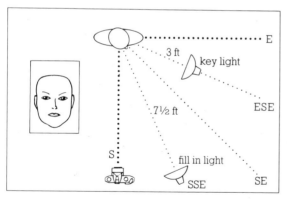

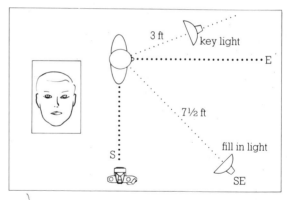

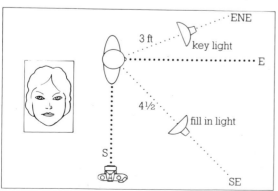

6.16 Round plump face. Brightness ratio 1:4.

6.17 Round plump face. Brightness ratio 1:6.

6.18 Triangular face, three-quarter view. Brightness ratio 1:4.

6.19 Triangular face, profile. Brightness ratio 1:4.

6.20 Square face. Brightness ratio 1:6.

6.21 Square face (male). Brightness ratio 1:6.

6.22 Square face (female). Brightness ratio 1:2.

25 Carpet factory. High viewpoint giving a foreshortened effect in combination with the use of a wide angle lens. Electronic flash balanced with existing daylight.

being used only if the nose is of a good shape.

To sum up the effect of camera angle on the shape of the head and features:

The higher viewpoint gives emphasis to the forehead and upper part of the face, especially the eyes. The nose is apparently lengthened, the mouth and chin appear smaller, the neck shorter.

A low viewpoint can be used for dramatic effect, emphasizing a powerful jaw in a man. In the case of a lady with a beautiful neck seen in profile, the low viewpoint enhances the graceful line. A low viewpoint draws attention to the mouth, the nose appears shorter, the eyes smaller, and the

26 Low viewpoint. In this case the distortion of the hand was an intentional effect. Umbrella plus daylight; strong sunlight through the window (falling on the background) was combined with the high side lighting from the umbrella.

forehead narrower. If you are working with a standard lens for a head and shoulders portrait, it is safer to work from a higher rather than level viewpoint.

We have already seen how the camera angle for the portrait of a young man, including the hands, taken on a 35mm camera with a standard lens, is high – really high. The example cited was taken with the camera on a tripod standing on a table – a camera angle you would probably never think of using for a portrait, until you realize that you are using a standard lens and hoping for a close-up shot. Your chief aim is to *avoid distortion* and keep the hands in correct proportion.

Here is another exercise that would be good for you to do yourself. Make two exposures of a subject, one from a normal camera angle with the tripod on the ground and the other with the tripod on a table and the camera tilting down. These results, if you study them well, will prove the efficacy of the technique.

Most of the examples shown so far, are demonstrated on a model head which is in a fixed position. They can, therefore, only be used as a guide to camera angle and may not take account of options available with a living subject. For example, take the low camera angle on a three-quarter face position, where the head appears to tilt back with little of the top being visible. This is a most suitable angle for a man with a receding hair line, but the backward slope is not attractive. In order to avoid this, and the overlong neck, the subject could lean forward turning the head towards the camera. The choice for a person with a short neck would also be from a low camera angle but avoiding the full face position as it is the least attractive. On the other hand, a model with an attractive hair style will need the hair shown to the best advantage. A higher than normal view-point would be chosen in this case.

We have been discussing the effect of camera angle on a close-up head and shoulder portrait. Taking full-length, single figures or groups, from a high camera angle will result in distortion – the bodies being dwarfed while the heads appear over-large in proportion. The opposite effect would result from too low a camera angle for full length portraits – the subject's height would be increased, making the head too small and insignificant compared with the rest of the body. A more suitable camera height for full length figures is when the lens is positioned level with approximately half the subject's body height. With the camera hand-held it is an easy matter to view the subject from various angles and to select the most suitable one before fixing the camera to the tripod.

7 CALCULATING EXPOSURE

One could say there is no such thing as 'correct' exposure. There is, however, the most suitable exposure for any given subject, to produce a predetermined result. The quality of any black-and-white picture depends on the quality of the negative. The type of negative most portraitists aim at is one which records detail in the shadow areas, while maintaining separated tones in the light areas. With too brief an exposure, the shadows will be devoid of detail; too long an exposure the gradations of tone in the light areas will be lost. It is sometimes thought that underexposure gives greater contrast. This may be true for colour reversal film but not for black-and-white. Underexposure reduces contrast; contrast is controlled by lighting, exposure and development time. Prolonged development can never record detail in any area that has not received sufficient exposure. Therefore the golden rule is, for average subjects, to never underexpose; it is safer to err on the side of slight overexposure.

The principal factors which govern exposure are:

1 The amount of light reflected by the subject.
2 The intensity, quality and angle of light.
3 The speed of film.
4 The lens aperture.
5 The shutter speed.

Light reflected by the subject
The question of colour and tonal contrast is recognized as being important when exposing a colour film but is often neglected when black-and-white materials are in use. Films are sensitive to colours to varying degrees. Choosing one colour in pre-

ference to another may give better tone rendering. The dark hues of purple, green, blue, brown and orange will all reproduce differently, and always, of course, reflect a greater percentage of light than black. The texture of the material also makes a difference. Those with a sheen, such as silk or satin, give better reflectance and therefore better tonal gradation than wool or velvet. Can you imagine a model with light brown hair, wearing a fawn wool jumper with a turquoise-blue skirt? Placed against a grey background she looks quite attractive, but the result in black-and-white is very disappointing – dull and insipid and lacking contrast. Had the model worn a satin blouse against a darker background the result would have been far more satisfactory. Black wool or fur absorbs most of the light falling on it, reflecting only occasional highlights from the surface of the fibres or sheen of their hairs. Black velvet reflects only about 1 per cent of light. This non-reflective quality of black velvet dress material provides the ideal setting for display of jewellery.

Intensity, quality and angle of light
Intensity of light depends not only on the power of the light source but also on the distance of light from the subject. As you have already discovered, the intensity of light diminishes, or increases, as the square of its distance from the subject. Doubling the distance means increasing exposure by four times or opening lens aperture by two stops.

A subject is most strongly illuminated when it faces the source of light. Illumination will be greatest when the light source is anywhere within a 45° angle either side of the camera. Beyond this angle an exposure increase of as much as one or even two stops may be needed. In practice this is taken care of by reducing the distance of the fill-in light to maintain the equivalent brightness ratio.

Speed of the film
It is obvious that a fast film requires less exposure time, under similar conditions than a slower one This presents no problems. An ISO 400/27° film re-

7.1, 7.2 A dark-coloured material with a sheen to its surface reflects light, while black fur absorbs all light, except for some small highlights.

27 Christiane von Faber. Intentional overexposure compresses tonal values in the highlight areas while small variations are clearly visible in the shadows.

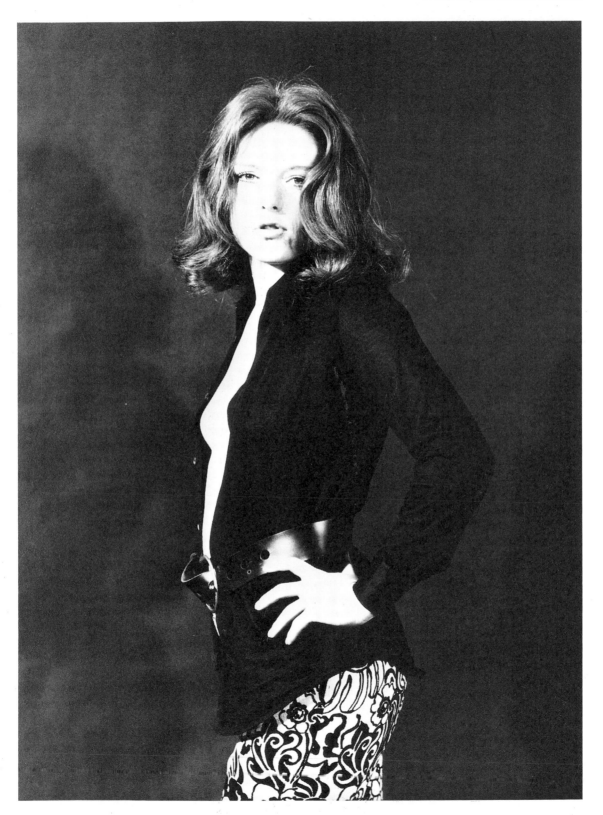

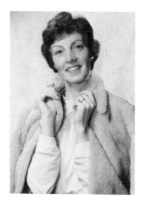

7.3 Brightness ratios.
Fair hair against dark
background.
Brightness ratio: 1:2
Result: average subject.

7.4 Fair hair against white
background.
Brightness ratio 1:2
Result: high key.

7.5 Dark hair against white
background.
Brightness ratio: 1:2
Result: predominantly light
in tone subject – not true
high key.

quires half the exposure of an ISO 200/24° and a quarter that of ISO 100/21°. The slower emulsion may have slightly less latitude in exposure, but requires less development and has a finer grain structure. For this reason it is advisable to use a film of slow emulsion speed whenever conditions allow, substituting a fast one only when speed becomes the deciding factor.

Lens aperture

The *f*-numbers marked on the lens are in a standard series – each *f*-number passes double the amount of light of the preceding one as the aperture is widened. Therefore, unless depth of field has to be taken into consideration, variations in exposure can be made by increasing or decreasing the lens aperture.

Shutter speed

Using lens aperture and shutter speed in conjunction with one another allows some latitude in choice of exposure. For example an estimated exposure of ½ sec at *f*/8 gives the choice of ¹/₁₆ sec at *f*/2.8 or 2 sec at *f*/16. The latter will give greater latitude in focusing because of the increased depth of field it allows. Any risk of movement in the subject would suggest choice of a wider aperture and shorter exposure.

7.6 Key light at 1.2m (4ft).
Fill-in at 2m (6ft).
Brightness ratio 1:2
Subject predominantly light
in tone.

7.7 Key light at 1.2m (4ft).
Fill-in at 2.4m (8ft).
Brightness ratio 1:4
Average subject.

7.8 Key light at 1.2m (4ft).
Fill-in at 3m (10ft).
Brightness ratio 1:6
Subject – predominantly
dark in tone.

28 Henry Moore.
Enlargement from a part of
the negative. Available
light in the sculptor's studio
consisted of strip lighting
plus daylight through a
plastic roof; rollfilm camera
on a tripod and very low
shutter speed.

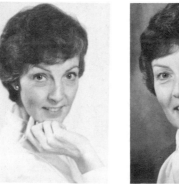

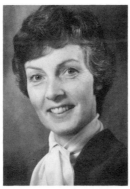

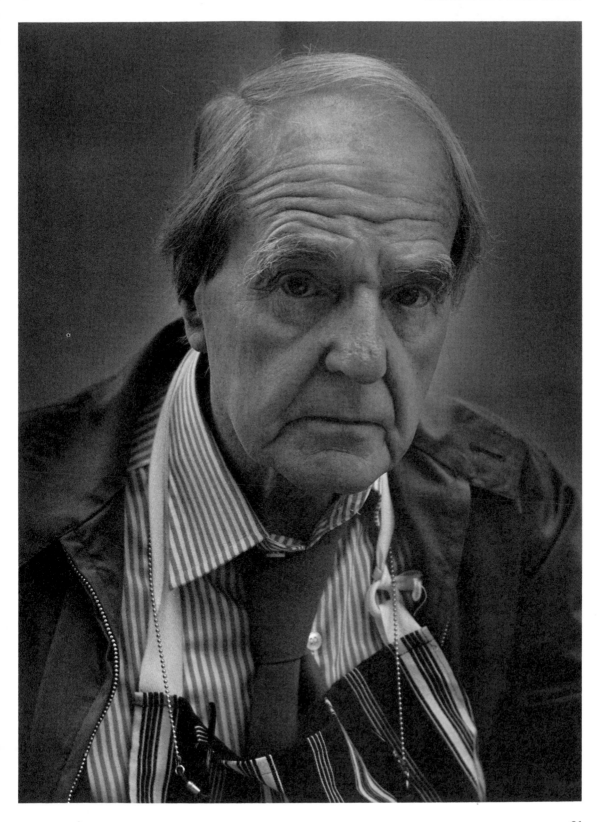

Calculating exposure

There are several types of exposure meter on the market and most cameras now have a built-in through-the-lens (TTL) metering system. However if the subject or situation you are photographing deviates from the average substantially, some compensation, or new calculations have to be made. There are still many advantages in having a hand meter to obtain readings, particularly in the studio. The method described here has been used over many years and found to be reliable. It is worth making several experiments with your own meter, always using the same speed of film and the same processing technique. Methods 1 and 3 can be applied with most built-in meters.

Three main ways of using a meter are:

1 To obtain a direct reading of light reflected from subject.
2 To measure the incident light through an incident light diffuser.
3 To measure the reflected light from an artificial highlight of standard brightness (or one of mid-tone.)

Methods

1 Direct reading (including TTL metering). All lights behind the model must be turned out, and a reading taken off the subject's face. The exposure is then doubled or the lens aperture opened by one stop. Alternatively a reading may be taken off the light area, followed by one off the darker tones, and an average between the two taken as correct exposure.
2 Incident reading. Fit or slide in the diffuser attachment on the meter and, from the subject position, direct the meter towards the camera. This will be correct for an average subject without any further calculations. Back lighting need not be switched off.
3 Artificial highlight reading. The artificial highlight used is a piece of white matt about 25 to 30cm (10 to 12in) square. This is held near to the subject's face and a reading taken from it. With the meter held about 15cm (6in) away from the card and at a slight angle, it is possible to avoid the shadow of the meter itself giving a false reading. For average subjects exposure is multiplied by 8 or the lens opened by 3 stops.

Any one of the three methods can be used for an average subject and the resulting exposures indicated will be the same.

29 The grain structure in the image is emphasized with extended development, especially with fast films which already have relatively coarse grain.

Subjects predominantly light or dark in tone

As all meters are calibrated for subjects of average tone or distribution of tones, a subject that is predominantly light in tone needs slightly different calculations, to avoid producing an underexposed negative or transparency.

Calculations for each method:

1 The direct reading ×2.
2 The incident light reading ÷2.
3 The white card reading ×4.

Subjects predominantly dark in tone.

1 The direct reading ÷2.
2 The incident light reading ×2.
3 The white card reading ×16.

You will find that for either subject the correct exposure can be be taken as that mid-way between a direct and an incident light reading without

further calculations. I find the simplest method is to use the white card and divide the film speed by 4, 8 or 16 before taking the reading. No other calculations are needed. Using this method, a film speed of ISO 100/21° is rated at 25/15°, 12/12° or 6/9° according to the subject – light, average or dark.

In hand with development
The quality of a final print depends on the negative from which it derives and you cannot divorce exposure from development – they are inescapably united.

Apart from the original choice of developer, some other factors governing development include:

1 Film speed and grain.
2 Dilution.
3 Temperature.
4 Agitation.

Film speed and grain
Although the differences are less apparent in present day materials, high speed emulsions have an inherently coarser grain structure, which grain size increases as development time is prolonged. However, high speed films do need longer development times than the slower, fine grain materials. Portions of the negative which have received too much light during exposure, develop first and can become really grainy in appearance. Hence the need for minimum exposure with fast films.

Slower speed films have less latitude in exposure but have a much finer grain structure and are more capable of producing clearly distinguished tones in both light and shaded areas than the high speed emulsions. If the exposure and development are carried out as recommended the grain structure is scarcely noticeable at all, even at considerable degrees of enlargement.

Dilution
For a normal negative to be printed on paper of normal contrast grade, it is advisable to keep to the manufacturer's formula. Diluting the developer results in a softer negative but at the expense of true tone values. The more concentrated the solution the higher the contrast of the result (processing times are, of course, also affected).

Temperature
Standard developer temperature should be 68°F (20°C). Temperature affects its activity. Any decrease in temperature must be compensated for by extra development time and any increase by reducing the time. Increase in temperature may result in coarser grain and even the risk of chemical fog. Keep to the recommended time for safety.

Agitation
Again, keep to instructions. Continuous agitation develops the film more rapidly, while intermittent agitation slows down the process. Agitation should be gentle but definite – quick jerky movements will probably only make the developer more energetic and result in increased grain size.

If a film is known to be underexposed, it should be processed in one of the developers which actually boosts the speed of the film. A film known to be overexposed should be processed in a developer which normally requires an increase in exposure time. One way of dealing with a subject of extreme contrast is to slightly overexpose and then cut the developing time given in an ordinary developer. A film which has received high intensity of light for a very short exposure time can develop more slowly. So an increase in developing time of up to 50 per cent may be needed for a film which has been exposed by electronic flash. A correctly exposed film of a subject with well-balanced lighting, should be developed in a normal fine grain developer, under the maker's specified conditions.

Where unusual conditions prevail, special processing might be called for. Variations from normal working procedure and their effects are discussed in detail in *Photographic Developing in Practice,* a companion volume in this series.

8 INTERPRETATION AND DESIGN

When we set out to make a portrait we are attempting to convey a likeness of a particular person and to express our emotional response to some character trait, or some physical feature, which has stirred our imagination. The source of our inspiration is a human being, animated by thoughts and feelings – a moving, breathing, alive personality. We have to describe our feelings about them, not by well chosen words but, in many cases, and for the purpose of the present discussion, by a black-and-white photograph – a two-dimensional drawing within a rectangle – without colour and without movement. Having studied the techniques of lighting, camera angle, exposure and development of the film, all of which contribute to the success of our endeavour, we must now consider ways of composing the picture. Composition deals with arranging the subject within the frame, the interplay of lights and shade, the vitality of line, and the required balance of all the elements into one harmonious whole.

The word itself – composition – has become increasingly unpopular over the past few years, perhaps because its importance as a technique has been over-stressed. No picture, portrait or otherwise, can be built up solely on composition or any other technique.

Some time ago I noted a quotation, 'Technical perfection means little unless it is guided by artistic conception and inspired by imagination'. I do not remember the author of these words, but you will surely recognize the truth encompassed by them. An artist must be free to make his own creations, not copies of another's, but he must also have the ability to express his ideas in his chosen medium in such a way that the message can be received.

Simplicity

One of the essential elements in composition is simplicity – the inclusion of only that which is necessary to convey the intended idea. It has been said that, when Michelangelo was asked to define art, he said, 'Give me a block of marble, and I will hew off everything unimportant'. Unwanted elements can be 'hewn off' at a number of stages in the making of a photograph. To mention but a few, there is the use of lenses of different focal lengths, the choice of viewpoint, darkroom techniques, enlarging only a portion of the negative, printing controls – also, the judicious trimming of the final print.

The essential truth to be learned is that nothing should be included in the picture that does not contribute in some way to the subject or theme.

We have suggested that an artist must be free to make his own creations; but there are two kinds of freedom. There is the freedom of expression when through ignorance no techniques are consciously applied, or the freedom of expression which emanates from a knowledge of technique so well understood that the sense of design and the relationship of shapes and lines become an inherent part of the artist's way of seeing.

The former freedom built on ignorance may be successful when the creator is a born artist, or on the rare occasion when chance, or luck, takes a hand, but the beginner in photography knows only too well how much time and material can be wasted, and how many pictures can be lost through lack of knowledge. The art of seeing, and the comprehension of the techniques of graphic design, can probably best be learned through the study of some of the other arts as well as of photography.

Cultivate the imagination

Some people are much more imaginative than others, but by consciously exercising your imagination, you will find yourself becoming progressively more able to visualize thoughts. Each

30 Composition based on a triangle – all lines converge at, or point to the apex and direct attention to the eye.

31 High contrast treatment, however strong the design, usually results in a static effect. Here the small areas of intermediate tone actually impart a sense of movement and mood.

person must choose his own form of art, or a particular artist on whose work to base his studies. A choice can be made from dancing, music, poetry, sculpture, painting, drama, ballet, ice-skating etc as well as from photography. There is a wide scope for your selection. Try to analyse for yourself why you have made the particular choice, what it makes you feel, and why. How has the arrangement of sounds, colours, shapes, or movements contributed to the success of the whole? If you like a phrase, or a movement, is it repeated? How often? Or is it used as a climax? What different feelings do you get when music is played loudly? Softly? Fast? Slow? If you are a lover of ballet or ice-skating, spend some part of your time, while in the audience, on analysing the movements – the lines of the body, the graceful curves, the exciting diagonals, the strong uprights and the peaceful horizontals. Notice the background music, how it harmonizes with the particular theme, how it crescendos as the tension mounts,

and then fades to almost nothing taking with it the excitement of the moment and leaving an atmosphere of peace.

Take a painting that appeals to you and try again to analyse your feelings about it. What effect do the colours themselves have on you? Do they make you happy, fearful, depressed, peaceful? Are the colours conveying the reality of the subject matter, the texture, the solidarity or translucence of the material, the mood of the picture? Ignore, for a moment, the reality of the subject matter and study the shapes – the shapes of the objects, the shapes of the background spaces. Are the shapes themselves pleasing to the eye? How are the shapes related to one another? Does the arrangement give a feeling of harmony, or discord, strength, or weakness? What about the direction of the leading lines in the picture. Are they mainly upright, horizontal or diagonal? What effect do these have on your feelings? Do the upright lines give a feeling of height, stability, strength or aspiration? Do the horizontal lines convey a sense of calm repose, unending space? And what about the diagonal lines? Do they convey to you the feeling of movement, of falling over, or

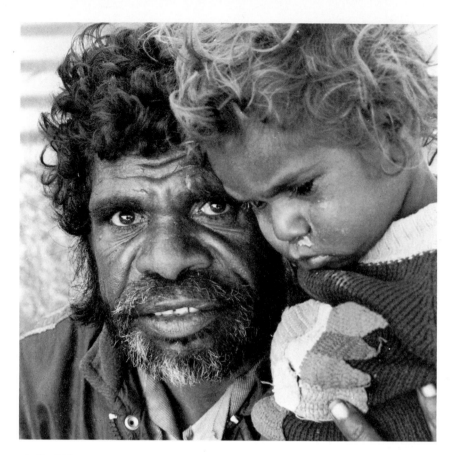

32 Aboriginals. The parent and child can be unified as a composition by the familiar formula of overlapping circles. Differences in skin tone clarify the effect.

33 Triple portrait. Classical composition applied in a farcical context.

vitality? Now consider the picture as a whole. How have these elements contributed to the mood or reality of the subject matter? Have you received the message the artist was trying to convey?

Now you can apply the same techniques to a monochrome photograph. You can study the relationship of the spaces, one with the other and consider the effect. You can analyse the direction of the lines and the part they play in conveying the mood of the picture. But, instead of feeling the effect of colour on your emotions, you must substitute the varying shades of grey between dead white to pure black.

Maybe it requires a little more imagination on your part to do this, because you are better acquainted with colour and its effects on your feelings in everyday life. But, if you persevere in the exercise, you will very quickly find you are able to see in terms of monochrome tone values instead of colour.

Return now to the photograph you have chosen to analyse. Once more, ignore the subject matter and concentrate only on the tone values. How do the various tones affect you? Begin with the darker greys. Do they appear to you to be rather heavy? Perhaps depressing or sombre? Are the deep

blacks more exciting? Is there a greater feeling of strength and solidity about them? Or, a richness which may not be evident in any other tone? What about the lighter greys? Are they not quieter? Perhaps rather nondescript, mysterious, spacious? And the pure whites. Do you you not find them bright and clean, but cold and unemotional in any large area?

It is difficult to visualize a large area of single tone without an illustration. We will side-track for a little while, and use sheets of paper instead of a photograph. Take three pieces of paper – one white, one grey and one black, to represent the monochrome tones. Let your imagination arouse in you some emotional response to each tone, such as the white giving a feeling of emptiness, the grey one of dull monotony, while the black becomes impenetrable and suffocating. In each case, but above all with the white, you are most likely to feel a strong desire to put some mark on it, to introduce some other tone, in order to create interest – a focal point. It is this placing of one tone upon another, in varying shapes and sizes and the addition or subtraction of the intensity of tone, which creates the design or composition of a pictorial photograph.

Building your own composition

The following exercise may take a little time but it is a sure way of teaching yourself the techniques of composition. Not only is it a fascinating experiment but it will give you endless ideas of design and arrangement with varying shapes and suggest to your imagination ways of using the tone values to convey such things as distance, proportions, scale, mood, impact, vitality, etc.

You will need a small quantity of black, grey and white paper. From each shade cut several circles of varying diameters, also a number of triangles, squares and rectangles of assorted sizes. A few long strips are needed to represent straight lines and some curved strips shaped like an elongated figure S are useful, as well as any other shapes made up of straight or curved lines which appeal to your artistic sense. Any number can be cut, and you will probably keep on adding to the collection as new ideas come into your mind. You also need three pieces of card, one of each colour, black, grey and white to serve as the picture base.

The exercise is to so arrange the various shapes and lines on the cards as to form pleasing compositions, ie, pleasing to you. Beginning with a few simple arrangements try to analyse why they satisfy you, what interpretation your imagination can construct from the way in which you have used the various colour tones and shapes. Using a horizontal format, which gives a feeling of restful-ness and continuous space, vary the width of the black, grey and white shapes to suggest different viewpoints. Try leaving out the grey and you will find the resulting feeling to be stronger and harder, with greater impact. Leave out the black, using only grey and white and at once a more restful, quieter mood is felt. Use narrower strips, interspersing the white with the black, and the result becomes more exciting, but could be discordant. Leaving out the white and having only black and grey in the arrangement, creates a heavy, sombre mood.

Make similar arrangements in the vertical format, and you will find that this format gives a feeling of solidity and height.

8.3 Horizontal format. The three pieces of card – white, grey and black – are useful for experimenting in methods of conveying impressions and ideas.

8.1 A small black circle is placed in the centre. It is a geometrical arrangement. Spaces A B C D are equal in size and shape. The composition has impact but lacks variety. The object is static.

8.2 The subject is placed at the intersection of thirds. There is much more vitality in this arrangement. The object is no longer static.

8.4 The vertical format. An unsatisfactory arrangement, as the grey and white extend to nothingness. The design is overweighted and lacks balance.

8.5 The design elements have been arranged in a more satisfactory way. Note that the small additional angle in the black vertical appears to balance the black plus the grey on the left hand side.

8.6 Here an illusion of space and distance is indicated. There is implied movement. The triangular shape can give stability to a composition if the base of the triangle is level with the base of the picture.

Now make some triangular shapes, one of each, black, grey and white, but decreasing in size. Arrange these in an arrow-shape, having black at the base. This gives an illusion of space in depth.

The last shape is the circle. The circle, on its own, has no direction; it is enclosed within itself. One circle of each of the tones, black, grey and white can be arranged to give a sense of space and of an object floating away but this is limited as a design and has little or no meaning. Increase the number of circles, varying the size and tone of each and arrange them on the base in such a way that tonal interplay creates a sense of rhythm.

The study of shapes in an arrangement makes one aware of the importance of line. The upright line, which we have found to be a symbol of strength and height, is the only line which can

8.9 Movement and strength in lines. Upright lines need no support – they can stand alone. The darker tone has the greatest impact. Tall upright and short upright lines, used together, can give a sense of scale.

8.10 Illustrates how quickly the direction is altered when the line is intersected by an opposing diagonal.

stand alone in a composition. The horizontal line moves from a stationary dot in a sideways direction. The motion can be checked at any given point by intersecting it with an upright line.

The viewer's eye will always follow the strongest line in a picture, particularly the diagonal, which is used to express movement and radiation. It gives life to any composition as it leads from one point of interest to another. To give sta-

8.7 A satisfying design. There is a dominant element, repetition of shapes and of tones, variety in the size of forms and a sense of depth.

8.8 The circular line has a beauty and grace inherent in itself and can be satisfying as a composition on its own.

8.11 This is a tracing from a photograph. It shows remarkable variety of line, spacing and movement.

Practise these exercises until you develop a feeling for design and arrangement. Try translating ideas, moods and imaginary subjects into black-and-white tones – using composition as your descriptive medium. Analyse paintings and photographs to discover how the artist has used composition to communicate his ideas.

Select a portrait, or painting, which appeals to you. Cover it with tracing paper and pencil over all the lines and shapes which are visible. Transfer this tracing to a sheet of paper, of similar size as the original, and shade in the basic tones of black and grey, leaving the white as blank paper. The direction of the lines will then be clearly indicated and you will be able to note the size relationship of figure to background, the background shapes, and the predominant tone values.

It is well worthwhile spending some time in an exhibition of portraits or a portrait gallery where you can study the paintings and learn something of composition straight from the masters. Some of the conclusions you will probably come to are:

In nearly every portrait there is some, if only slight, difference in the direction of body and head. In many instances there are three turns, the body facing in a three-quarter direction, the head turned towards the camera and the eyes turned to look directly into the lens. This not only gives variety to the composition but an illusion of life and movement. The eyes appear to look in the viewer's direction from whatever angle.

Look for the flowing line in any three-quarter, or full-length picture. The lines of the body are kept unbroken, eg, the knee nearest to the camera is crossed over the other, the nearest hand placed over the other when folded together in the lap.

Notice how the backgrounds add to the picture by content or suggestion but never detract from the central figure. The size relationships of lines and spaces are important for balance and unity.

The composition of overlapping circles and the triangles in arrow formation, can be found in many pictures of groups of two, or more, persons.

bility, a falling diagonal needs an upright line to support it.

The circular line is not to be confused with the circle already described. The circle is enclosed. The circular line proceeds from a stationary dot in a circular movement, forming an ever-widening circle. It can twist and turn to form other circles. The flowing turn from one circle to another has become known as the 'S' curve and is commonly talked about in composition. The circular line has a beauty and grace inherent in itself and can be satisfying as a composition on its own.

8.12, 8.13 A study of one side of the face only, with the eye as the centre of interest and the tone values simplified. The background of black and white is so arranged that the shadow side of the face is seen against a light area. The whole forms a simple design which is easily analysed from the traced copy of the outlines. The shading represents the three tones, black, grey and white.

34 Ballet dancer. The body and arms form a kind of pediment on top of the studio box. A single super 'fish fryer' electronic flash and the dancer's hazy shadow on the background reinforces the theatrical background.

9 CHARACTER REVEALED IN THE FACE

In portraiture, you embark on a greater challenge than when tackling, for example, a still life subject. You are dealing with people – each one a unique personality and each presenting individual problems. Your next step, then, is to learn something about the subject before your camera. Skip this chapter if you are not interested in studying faces, features and wrinkles which, while contributing to the outward form, reveal inner characteristics. But – if you do, you will deny yourself one of the most exciting exercises and one which will add a third dimension to your portraiture. A study such as this will enable you to visualize your picture quickly, to select the most attractive features and positive character traits and to decide on the appropriate camera angle and descriptive lighting.

Many books have been written on character reading from the face – one analysis often contradicting another! My advice is to read as much as you can on the subject – not only read, but *study* and check your findings against people that you know well. The object is not, however, to rely on the statements of others but to prove things for yourself. It is *your vision* that creates your portraiture – inspired by others, but tested for yourself. People are so complex that one cannot make any hard and fast rules in the interpretation of facial features but the exercise of trying to observe can make you more aware of the character tendencies revealed in the face. You will realize that it is difficult to scrutinize a living face, so to make your task easier you can use a photograph. Select a model – you will probably find a number quite willing to take part in such an interesting experiment.

Seat the model square-on to the camera, making sure that the head is not tilted in any way and that the same amount of ear is visible on each side. Using two lights of equal power, one each side of the camera, position them to give a flat, even light over the whole face. Make an exposure, following with a profile from each side.

From the full-face negative make two identical prints and a further one from the same negative but from the reverse side. One print only is required from each profile.

One print from the full-face negative and the print from the reverse side must now be cut through the centre. This cutting must be accurate. The easiest procedure is to mark the centre point between the eyes, between the nostrils, the centre of the lips and of the chin. Rule a line through these points and cut. The two left sides of the face and the two rights can then be mounted together.

Immediately, the differences in the shape of the face and features and also the characteristic expressions, become apparent. You now have a face from which you can make an analysis of the various features, lines and wrinkles, using the suggestions listed below as a guide. Then check with your subject to see how accurate you are.

Dividing the face into thirds
First divide the face into three sections as you did when determining the most suitable camera angle.

If you find:	It could denote
Sections are of equal size	a well-balanced personality.
Upper section widest	intellectual.
Middle section widest	broadminded, philosophical, friendly personality, interested in spiritual matters.
Lower section widest	a strong, determined character with physical strength, but less sensitivity.

The most expressive features are the eyes:

Colour	Characteristics/associations
Blue	Affectionate, energetic, businesslike.
Grey	A colder nature, self-controlled, hard in judgement.
Hazel	Warm, affectionate, gentle nature.
Brown	Emotional, less self-control. Strong likes and dislikes. Artistic and moody.
Black	Passionate and emotional, quick to anger.

Size, slant, set and brightness of the eyes

Large	Wide open, rim of white below iris, upper eyelid curved. Emotional, sympathetic, often artistic and observant. Protruding eyes indicate a nervous disposition and lack of deep thought.
Small	Usually deep set under brows, observant, calculating, power of concentration. If set too close together may be secretive.
Upward-slanting	An alert mind, inclined to be selfish. Quick on the uptake.
Downward-slanting	Agreeable nature, talkative, desire to please.
Bright	Alert, intelligent mind, optimistic and happy.
Dull	Usually a sign of ill-health or a slow mind.

Eyebrows

Thick, bushy	Denote vitality and strength. If coarse and ruffled – irritability.
Thin, fair	A calm, sensitive disposition.
Upward-slanting	Changeable nature. If thick, rather unsociable.

Nose

	Generally speaking, the nose shows the force of character and energy. The 'best' nose photographically, is one which is well-proportioned, measures one-third of the face and protrudes slightly at the tip. This could be a person who has a well-balanced personality, is ambitious, intellectual and generous.
Roman	A fairly large nose with a bump high up on the ridge – suggests power to command, courage and physical strength.
Large Roman	More vivacity and love of excitement.
Large with narrow ridge	Gives a sharp appearance, peace loving, refined and quick to make decisions.
Grecian	This nose is straight and well-proportioned. It goes, perhaps with an even-tempered, artistic and courteous personality.

The last few noses are best seen in profile.

Straight or slightly concave	With wide ridge depicts strong powers of thought, serious and logical. Narrow at the bridge, broadening towards the tip, sound reasoning ability, but easily swayed by intuition.
Convex	Shows less natural force and energy. Usually short with an upturned tip – impulsive, cheerful, sociable, sometimes hiding shyness under an abrupt manner.

Forehead

	Viewed in profile.
High	An intellectual, analytical mind.
Low	Shows less capacity for thought, little imagination.
Narrow	A somewhat narrow-minded person.
Broad	A constructive mind, imaginative, resourceful, a leader.
Slightly receding	Denotes average intelligence.
Vertical	Suggests an inclination towards idealism and art.
Projecting	Above eyebrows – ability in precision tasks. In the centre – a good memory. At the top – logical reasoning powers.
Receding	If full and wide – a practical turn of mind with executive ability.

Mouth and lips

Small	In comparison with rest of features, implies a self-centred nature, if pursed up, severity and thriftiness.
Wide mouth, medium lips	Good natured and sociable but firm and decisive. If lower lip is full, the nature is more generous and sympathetic.
Corners up	Optimistic, happy, sociable
Corners down	A more serious outlook, sometimes pessimistic.
Straight	Gives good balance between the above.

Protruding	Denote an impulsive, moody nature, somewhat quarrelsome, emotional but kind.
Lips apart	Showing the teeth, go with a lack of self confidence.
Line of closure	Made up of curves – ability in acting and singing, inclined to be emotional.

Chin

	A good average chin is on a straight line with lips when seen in profile, or may be slightly receding.
Protruding	Determined, somewhat stubborn nature. Power of endurance.
Receding	Lack of firmness and self reliance.
Square	Physical strength, reliable, independent, courageous, usually an outdoor type.
Round	Easy-going nature, fond of comfort, sociable.
Oval	Reliable, artistic, capable.
Pointed	Carefree, unmethodical, cheerful.
Dimpled	Artistic, self-willed.

Ears

	The top of the ear is usually on a line with the eyebrows. If it is noticeably higher, it indicates an excitable nature.
Large	Well shaped, denote a physically strong person, with go-ahead ideas. Large lobes mean a friendly disposition.
Medium	Thin and finely shaped, a friendly person with artistic or musical talent.
Small	A more cautious nature.
Projecting	A courageous person.
Lying close to head	More cautious.
Pointed at the top	Changeable or witty.

Facial lines and wrinkles

Lines *across* the forehead caused by contracting and relaxing the muscles when in thought indicate a logical mind, able to concentrate on problems.

These must not be confused with the slightly wider lines which traverse the forehead of a younger person through continued perplexity or worry.

Vertical lines beween the eyebrows – there may be one, two, or three such lines, caused by contrasting the brows in concentration. The characteristics usually to be found are: precision, a love of justice and notable sense of duty. These attributes are the stronger where the lines are more marked.

Horizontal wrinkles from the outward corner of the eye are the laughter lines and show a happy personality.

A horizontal line across the bridge of the nose denotes a person able to command, a natural ability to lead.

A horizontal wrinkle under the eye, more than the full length of the eye, indicates the passionate or emotional.

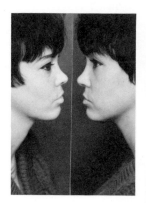

A curved wrinkle under the eye may show a good speaker.

Oblique wrinkles from the inner corner of the eye can betray a selfish, greedy, rather spiteful nature.

A downward line from the base of the nose to the mouth – the normal position for this line is one which starts at the curve of the nostril and ends a little way out from the corner of the mouth.

If the line is short it implies less power of concentration, if long, continuing below the corner of the mouth, greater determination.

A vertical line in the centre of the lower lip indicates a jocular nature.

A vertical line in the cheek running down towards the chin goes with a good talker or public speaker. If this line is short and shallow, it indicates merely a pleasant conversationalist.

A vertical cleft in the bottom of the chin shows a methodical person, fond of approval. A circular cleft (dimple) in the chin suggests possible artistic talent. A circular dimple near the mouth indicates a good-natured, sociable, probably artistic personality. A long dimple in the cheek is similar, but shows a more serious disposition.

9.1 Model A **A** Full face: flat lighting: level camera angle. **B** Two left sides of the face together. **C** Two right sides of the face together. **D** Right profile, left profile. **E** Emphasis on the left side of her face with softened contours. Attention is drawn to the impressive dark eyes.

In the following two sets of 'two lefts and two rights' I have analysed the features but left you to judge the character, going by the foregoing recommendations. Having the advantage of the subject's presence but *not* the result of the exercise(!) I summed up the characteristics as follows: Fig 9.1. The contours of her face are more attractive on her right side. The cheek and jaw bones are more clearly defined, the triangular shape of her face is distinctive. On the other hand, there is a certain angularity about the features and the expression is somewhat penetrating. There is a more 'puckish' expression in her left eye and the oval face with

9.2 Model B **A** Full face: flat lighting: level camera angle. **B** Profile: flat lighting: level camera angle. **C** Two right sides together. **D** Two left sides together. **E** Three-quarter face position: left side nearest camera. Strong back lighting to illustrate vitality and enthusiasm.

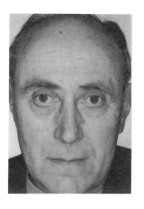
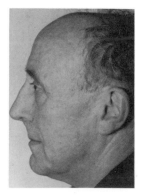

more rounded contours shows the more charming sociable side of her nature.

Here is a face and personality combined which is a joy to photograph. The positions and styles of arrangement and lighting are almost unlimited and you can use the softer or the more clear cut outlines to suit the mood of the picture. But, if you want a happy, smiling expression you have to capture it quickly–the moods change swiftly and her intense nature is shown in the moods.

Likewise in the serious, triangular-shaped side of her face, the intensity of the character can be shown with vitality and drama, or the introspective, withdrawn characteristics with an accompanying sullenness of mood.

The clear cut outline of the right side of her face can show well against a dark background. The oval chin and jaw line and the softer contours of the cheek bone, together with the good line of the neck are seen to advantage in the turn of the head. The hair style, being drawn away from the eyes, to reveal the height and breadth of the forehead, adds distinction to be a thoughtful, yet interested mood. (See Fig 9. A-E).

Fig 9.2 A-D This is a strong personality with an analytical mind and an ability to interpret, or to describe events in detail and is a good speaker. He is sociable, generous, kindly and artistic. The left side of his face shows these characteristics to the best advantage.

From a three-quarter face position, the left side of his face being nearest to the camera, a fairly low camera angle emphasizes the power and determination in his character and, by lengthening the neck, separates his head from his shoulders. Strong back lighting illustrates his vitality and enthusiasm and, if the eyes are directed towards the camera, better conveys his desire to communicate. To overcome any apparent self-consciousness while being photographed, it would be good tactics to have soft music playing and encourage him to talk about some recent event. (Fig 9.2 D).

When a person comes to you for a portrait you might now be better equipped to read, or at least make your own interpretation of their personality traits, and to judge which side of their face is the most appealing, and which the most characteristic.

A few examples might be useful to show how I have attempted to portray the character that I have read into the different personalities.

9.3 Prof. John Yarwood
Tall, slim and distinguished-looking, Professor Yarwood is a physics lecturer and author. The forehead in this picture suggests an intellectual disposition, with a precise, exact type of mind – and one which is habitually brought to bear on problems. An interesting forehead which is shown to the best advantage in a three-quarter face position, with his right side towards the camera. The 45° lighting emphasizes, and subdues where necessary, the feature shapes and character lines and draws attention to the steady, kindly eyes and firm, generous and good-humoured mouth – both of which are attractive features. This is a strong portrait which suits a vigorous, intelligent and kind personality.

9.4 Betty Gardiner. A vital personality, outgoing and friendly; displaying a keen interest in people and having much insight into character. A peace-loving, kindly, generous nature – but not easily persuaded against her will; a good speaker, a strong sense of humour, courageous and affectionate. These are some of the characteristics that I wanted to incorporate in the portrait. By profession, as well as being a wife and mother, Betty is a successful journalist and, in this field, her acute powers of observation and ability to analyse stand her in good stead. In the portrait the emphasis is on her warm and friendly disposition. In order to keep the lights soft, to obliterate reflections in the spectacle lenses and frames and to give freedom of movement, all lights are either diffused or reflected – by surrounding her with a kind of butter-muslin tent.

9.5 Dame Barbara Hepworth. The characters of famous people can be partly accessed through published articles on them. It is helpful to find out as much as possible about a personality and to form some sort of mental image of them before taking their portrait. I had admired Dame Barbara's sculptures for many years, and after learning something of her life, I imagined her not only as a distinguished artist but also as a wife and mother. Already world famous and with five-year-old triplets, she spent the first three years of World War II running a nursery school and a small market garden during the day while pursuing her own work each evening. I had great respect for her.

When my husband and I visited Dame Barbara in her studio at St. Ives, the first thing she said to me was, 'Is this to be a photograph of me or of my work?' 'Firstly of you' I replied, thinking of the caring personality I had already associated with the great artist.

It seems incredible that such a slightly built person had the power to carve from such massive blocks of stone. Her strong, capable hands had, undoubtedly, to form a prominent part of the picture, although obviously of first importance were the facial lines and wrinkles which revealed a wealth of character and charm, expressed in both the sensitive mouth and the thought behind the eyes.

9.6 When this portrait was taken, Col. Hew Renwick had retired from a successful army career – the major part of which was spent in India. Recent severe illness had reduced his physical stature but, although time had left its mark upon his features, it had also contributed to his distinction. It was this strength of character, this inner spirit, which had to dominate the portrait. The three-quarter face position and 45° lighting emphasize the character traits which are inherent in a military leader – the love of justice, sense of duty, sound judgement, ability to cope with difficult problems, courage and an understanding nature. The expression in the eyes and mouth speak of his strong sense of humour, his courtesy and affection – a living portrait of a great personality.

9.7 My impressions on meeting Doreen Yarwood for the first time were of a charming, vibrant personality, both intellectual and intelligent. Doreen is the author of several well-known books on architecture – buildings and furnishings – and, more recently, on historical costumes. She has illustrated the books herself with very detailed pen-and-ink drawings and watercolour paintings. Doreen has travelled widely on the Continent and in America, and, having the gift of speaking clearly and fluently, has lectured and appeared on television. An interesting subject for a photograph, her appreciation of beauty in nature and art, her acute powers of observation, her enthusiasm, firm nature and decisive opinions, are obvious characteristics revealed in her facial features and lines. An intimate portrait suggesting a warm, friendly personality.

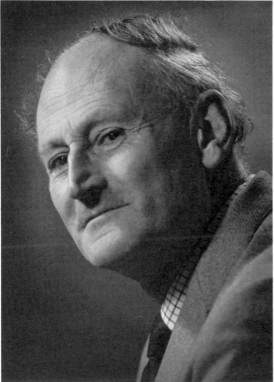

9.8 Jared Armstrong's main interest is music. Formerly a chorister and later an organ scholar, he is now actively engaged in all aspects of music making and teaching. A positive person, determined and responsible with fine powers of observation and concentration, it was this strength of character that I wanted to stress by taking the portrait from a low camera angle. The well-drawn features suggest to me courage, sensitivity, conscientiousness, a love of the outdoors and freedom of movement.

10 PSYCHOLOGICAL APPROACH TO PORTRAITURE

We have been studying the techniques of lighting, camera angle, exposure and composition. We have analysed some different types of face, noting the characteristics depicted in the head, the features, the predominant lines and wrinkles. The lighting has been demonstrated on an inanimate head, the character lines discussed using photographs and diagrams, all quite adequate means for describing the purely physical aspects of the subject. We must now look beyond the interpretation of facial geography and deal with a completely new dimension – human personality.

Character through the features

The two facial features which express emotion, and through which we can get a glimpse of the individual personality, are the eyes and the mouth. As we have seen from previous illustrations there are many different types of eyes – eg, deep-set eyes with the somewhat penetrating glance – sparkling, laughing eyes that seem to dance with the reflected lights – wide, affectionate eyes with emotional appeal. The eyes can speak a language all their own – the emotions of love, hate, joy, sorrow, interest, endeavour, boredom, can all be expressed in them. Emotions which have been felt deeply enough remain buried in the subconscious mind, a reflection of which can be seen in the expression in the eyes.

Mouths, too, can be varied in shape. They can be large or small, have full relaxed lips, or the thinner variety more often tensed with concentration. But whichever shape the mouth may be, it has no inner depth of character to be revealed, such as can be seen through the eyes. Although the mouth can move to order, it will not show emotion unless it has moved voluntarily to co-ordinate with the eyes.

Inner emotion is reflected through the eyes. If the mouth is smiling while the eyes remain serious, the model is self-conscious and unnatural. If the eyes are dancing with merriment with the mouth remaining firmly closed, the subject may be trying to stifle his or her inward feelings and is, again, unnatural.

Character through personality

The model head, used for the demonstrations, is an inanimate object, and no amount of different lighting techniques or camera angles can make it

anything else. It can neither feel nor reflect any emotions. Having no personality it can reveal no character traits. At best it can only reflect an image which has been created in the mind of the photographer, aided by various accessories.

The live person, on the other hand, is a very complex individual and in order to make a true character portrait of him, or her, we must try to understand their psychological make-up.

Referring back to where we discussed individual characteristics as revealed through lines and wrinkles, you will realize that little mention has been made of the negative traits in any one character – yet there must be some. There must also be some lines in the face to denote their presence. This has been done intentionally. It is easier to learn to recognize only the positive traits and to be able to emphasize these, than it is to

35 Billy Graham. Taken while the subject was actually talking. Studio umbrella light from front, with white reflector shadow fill and clip light from ¾ position behind. Erase make-up under eyes. Medium format camera, 150mm lens.

learn the complete sum, and then have to decide which to eliminate.

Unlike the inanimate head, which has been mass produced, every single person who comes before our camera is unique. A wonderful thought! Yet within each person is a mixture of positive and negative character traits, which, in varying degrees, add up to a complete whole.

Each positive has its negative, such as courage–fear, generosity–selfishness, love–hate, kindness–cruelty, justice–unfairness, energy–laziness, pride–carelessness, happiness–sorrow, etc. The list is endless and so is the degree to which any one element is found in any one person's make-up. Experiences through life develop the personality, altering the balance between the positive and negative traits.

A just portrait should reveal as many positive characteristics as possible. You must start looking for evidence of these as soon as you meet the subject and decide on the techniques which will show them to the best advantage.

Character through mannerisms

The inanimate head has no body or limbs, no hands, and no ability to move in any way.

The live person is more or less continually on the move. In fact he is probably known and remembered as much by his actions and mannerisms as he is by his facial features.

Even though you do not intend to photograph the full-length figure, it is wise to notice every movement of the body and especially of the hands. This is an additional clue in reading character, and will help in posing the model naturally. It is good fun as well as being instructive, to sit in a café by the window and watch the passers-by. Observe how a person walks. Is it a jaunty walk with the head held high, or a slow casual amble with hands in pockets? Perhaps it is the nervous quick step or the impatient rush of someone always in a hurry. Some couples walk arm in arm, some (especially young lovers) hand in hand, some talk as they walk along, some remain silent. While still in the café look around at those sitting at the tables. Some have their elbows on the table allowing their faces to rest on their hands. Many perhaps have their elbows on the table but few will be adopting a similar position for the hands. Some have their faces resting on the whole palm of the hand, some on the back of the hand, in some cases only the finger tips touch the face. Some people have two hands to their face,

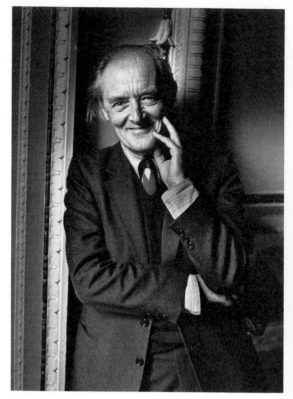

36 Sir Hugh Casson. The subject took up this pose without any prompting. Window light only, no fill, 35mm camera with a standard lens, hand-held 1/30 sec.

some have the two elbows on the table and the two hands clasped together, or the fingers of one hand touching the palm of the other. There are some people who do not sit forward at the table at all, but are inclined to lean back in the chair resting their hands in their laps.

Make a mental note of the positions you think would make, or assist in a good composition because it is not only a natural pose that is needed but one that will look pleasing in a photograph. An over-large hand, distorted by its proximity to the camera lens, can detract from the character instead of adding to it.

In the studio, study your subject's movements. Note the way he, or she, stands or sits. Some people are more natural standing up – a head and shoulders portrait can still be made – providing your tripod has sufficient extension! Does he stand with his arms folded, or with one hand in his pocket? Does he rest one elbow on the other hand with the finger tips touching the face – a natural position and good to photograph too. Many

37 Glen Cooksley, broadcaster. The picture, though posed, appears casual and is appropriate to the subject's age group. The fingers were adjusted repeatedly to find the most natural arrangement.

people gesticulate with their hands while talking, make a mental note of what they do. When sitting, some sit well back in the chair, others lean forward, some rest both feet on the floor, others immediately cross one leg over the other. Place a table by, or in front of, your model and note the use they make of it. Remember your time spent in the café. While studying the hands and their most photogenic positions, it is as well to realize that the hands themselves – their shape and type – reveal some characteristics, and including hands in a portrait adds another dimension to the interpretation. Let us look in closer detail, at a few that are reasonably easy to recognize.

Practical hand

This is a thick-set, strong hand with rather thick fingers and a short broad thumb. The thumb is often double jointed and can be bent backwards I have called it the practical hand because it belongs to one whose work involves the use of his hands. In course of time the hand has become

firm, sometimes hard, but strong and dependable. The hand can grip well, and the owner gives a really firm handshake. This type of hand is seldom used for gesticulating during conversation, not being sufficiently pliable. Nevertheless it is worth including in a character portrait.

Artistic hand

The artistic hand is much more pliable. The hand itself can be of any size but is usually long and thin. The fingers are long and tapering and bend easily at the top joints. All the fingers bend backwards, slightly, from the base, which gives the hand freedom of movement. This hand is often used in gesticulating and, being very pliable, presents few problems to the photographer. The owner of such a hand may be of a nervous disposition, highly emotional, practical in the arts or crafts, but may have little knowledge of mechanics.

Short square hand

The short, square-looking hand, with the short fingers usually belongs to a person who loves to organize everything and everybody. This person is efficient, neat and orderly, and is intolerant of any who fall below these standards. The short hand is not quite so easy to arrange in photography, sometimes because of the shortness of the fingers but often because the owner is self-conscious about the hands, terming them 'dumpy' and unattractive.

Small hand

Perhaps the easiest hand of all to photograph is the one which appears small in proportion to the rest of the person, and has beautifully shaped fingers and a small, well-shaped thumb. The

38 Arthur Askey, comedian. A record shot taken in his living room. The idea came from the subject. Daylight, from a large window at right; 1/15 sec exposure.

10.1-6 Changes of clothes or accessories can suggest various personalities, even with a static model bust. In addition to a purely physical alteration in appearance, the living subject feels different and this, in turn, can influence his or her reaction to the camera.

owner of this small hand may be an idealist, more imaginative than practical but possibly nervous and self-conscious in the presence of other people. This nervousness is only superficial and, unlike the highly-strung person, he has an inward calm and his features rarely lose the look of composure. Such a person will usually co-operate well with the photographer.

As you continue your study of hands you will find other types which seem to fit specific personalities. You will also find that a number of hands are a mixture of two or more types, which is really what you would expect, as character is a complex matter.

Psychological effect of clothes

In the accompanying illustrations you will see the model bust given a variety of hats and dressed in a blouse or sweater. Although the model is incapable of feeling any difference, she certainly looks different. She can be made to look attractive, sophisticated, young, old, intelligent, athletic etc just by being suitably clothed. She sometimes looks almost human! Through these accessories, a character is being imposed on the model at the

whim of the photographer.

A similar thing can happen with a live person. A model can be dressed in any clothes to depict a certain type of character, which is, of course, what happens in the theatre. But normally the clothes worn befit the person. People are made to look more attractive, more sophisticated, younger, older, more intelligent or more athletic, etc, according to the type of clothes they wear, in the same way that the model head does.

But although the model head does not *feel* any different, the live person does. Clothes have a great bearing on feelings of self-consciousness, of inferiority or of superiority. Clothes can make one *feel* younger or older, stiff or free, old-fashioned or modern, attractive or just plain, formal or informal. Even the neckline to the dress or sweater can make a difference. Ask any woman what she feels about it and in every case she will express some preference.

One may say she prefers the high neck line as it gives her poise and self-confidence. Another might feel more attractive in a round one, with, perhaps, a collar or scarf. Others, still, favour a V-neck as it makes for a slimmer outline. The type of

garment, too, makes a difference whether it be formal or informal. One person will be self-conscious and very difficult to photograph when wearing say, a dress, but having changed into trousers and sweater, immediately becomes natural and readily co-operative.

Although by no means all models feel self-conscious, even with a completely natural person it is advisable where possible to portray him or her wearing a variety of clothes. It is not only the question of whether or not a certain garment suits the wearer best, or that it is more photogenic, but that it reveals another side to the character. If a man changes from his city suit to an open neck shirt or polo-neck sweater, he is sure to show, automatically, different aspects of himself.

Although a photographer can guide a sitter as to the suitability of a certain style of dress – the colour and the texture of the material and whether it is patterned or plain – the essential point is the effect the particular garment has on the model. It is the right one if the model feels happy and self-confident wearing it – it is the wrong one if it has the opposite effect. However photogenic the garment itself might be, you are not interested at the moment in fashion pictures but in a character portrait in which the person inside the clothes matters more than the clothes themselves.

Before passing on to something more interesting than clothes, we must give a thought to hats. From the illustrations of the model's head it can be seen that a hat does add a distinctive quality to a suggested characteristic. A hat can lend elegance, dignity and charm to its wearer. It also has an effect on the personality, especially of a woman. It has been said that if a woman feels depressed she should go out and buy herself a hat – it can boost the ego.

Hats, then should not be neglected as an accessory for the portrayal of character. Also, a hat, as well as making a plain person look distinctive, can turn a somewhat ordinary picture into one that is exciting and has greater impact than normal.

Now let us turn our attention from the clothes which are on the outside of the person, to the self which is on the inside.

There are a great number of adjectives pertaining to the word 'self' but one most often used in connection with photography is 'conscious'.

Self-consciousness

It is the fear of feeling self-conscious in front of a camera that prevents a number of people from

39 John Snagg, veteran broadcaster, on a launch preparing for a boat race commentary. The most successful picture was taken when he was testing the mike for his producer. Sometimes the fact that a picture is unposed is not enough in itself – the subject must be actually *doing* something.

ever being photographed. The appearance of any suggestion of self-consciousness in a picture can ruin its vitality and appeal. The word 'self-conscious' really means to be aware of oneself. One can be fully aware of oneself, one can act, make a speech, sing or 'impersonate' in front of a mirror, being fully aware of every movement and yet be perfectly natural *provided that one is by oneself.* The moment we are observed in our actions we become nervous through fear – the fear of being ridiculed, the fear of destructive criticism, the fear of insecurity, the fear that one's self-command is lost. This is what self-consciousness has come to mean, the awareness of oneself coupled with the fear of being observed by others. In the studio there can be a twofold self-consciousness, the subject on the one hand and the photographer on the other, because the photographer can be almost as self-conscious as the subject.

There is no harm in both the photographer and

the model being aware of themselves, aware of what they are doing and saying provided that there is the harmony between them which makes each feel as natural as if they were alone and un-observed. This harmony is the essential ingre-dient for success – the 'something' which exists between model and photographer; moreover, this is a link which, once formed, must not be bro-ken throughout the whole session.

It is the creating and the maintaining of this 'something' that needs such careful handling in the studio.

The more sensitive a subject is the more he or she will suffer from nervous self-consciousness and it is this very sensitivity which, rightly used, is at the heart of our pictures.

Lack of sensitivity in the photographer can have the opposite effect to that intended. The subject's personality, instead of being drawn out, can be-come increasingly withdrawn until little more than a mask remains and the features may appear completely unnatural.

Psychology applied in the studio

Let us imagine you are about to photograph a female subject you have never seen before. You have to make all your initial observations without the model being aware of any scrutiny what-soever. To enable you to do this you will have a short time prior to the studio session just sitting down talking with your subject to become ac-quainted. A cup of tea or coffee will help both of you to relax. The conversation can be turned gradually towards topics which are of interest to your subject – holidays, hobbies, achievements, children, etc. You must appear to be relaxed but all the time be really alert – taking part in the con-versation but simultaneously making mental notes of the subject's mannerisms and as many charac-ter traits as possible. If you have put enough time into studying people's behaviour and deciding on possible compositions, then it should not be long before you have visualized a few positions, at least enough to make a start in the studio.

If the studio looks attractive the model may even remark on it. Always try to make the studio a cheerful, comfortable room, not like the dentist's surgery which so many people seem to expect! Put flowers on the table, several pictures round the walls and have a record or tape playing a selection of musical pieces very quietly.

Ask the model to select the type of chair or stool she prefers to use for the first picture. As she tries

several, note the effect produced as this will be found handy later on. As you already have an arrangement in mind you can suggest the position and arrange the lights quickly and confidently. As the pose is a natural one, the model will probably adopt it easily. But if she is unable to do so the idea can be demonstrated. She can then try again. If it should still be unsuccessful, either pretend to make an exposure, or drop the idea until later. Anything which has taken too long to arrange will look stilted and artificial.

Never be tempted to touch the model by mov-ing the hand or fingers to suit your requirements. If you do not know your model sufficiently she may be someone who objects strongly to being touched and, if so, your link would be broken right at the beginning of the session. So, it is better to play safe. Also, the model must never get the idea that she is awkward and cannot do exactly what is needed. Rather, you must encourage her to think that she is an excellent model and is being very co-operative. This will give her confidence in her-self. Flattery is cheap and should never be in-dulged in, but sincere encouragement, and praise where applicable, will always boost the ego, and prevent nervousness.

Consider the model's comfort at all times. The studio must be warm in winter and cool in sum-mer. If you are using tungsten, the lights must be switched off occasionally to prevent everyone from becoming overheated. The glare of the light must be kept off the model's eyes, either by diffus-ing the lamp or by reducing its power. Do not keep your subject in a fixed position for too long or she will become stiff and self-conscious. For this reason it is always good to give her a moment's relaxation before making the next exposure, un-less it is a spontaneous position or expression which you must lose no time in capturing – such as a genuine smile with the twinkle in the eyes. It is almost impossible to immediately repeat a happy smile – saying 'cheese' may produce a beautiful 'grin' but, at best, will be purely superficial.

During a short break the model can change her clothes. You may re-arrange the studio, alter the background, make any necessary alterations to the lighting equipment and be ready to welcome her back for another series. A refreshing drink before she starts again will not go amiss. You can now compliment her on the colour, style, etc, of her dress and indicate that her new appearance has given you fresh inspiration. You should, by this time, show real enthusiasm about everything you

40 Lorna Charles, actress. There is an intimacy between two personalities when taking a portrait, which may be visible in the eyes. Conversely, the eyes would immediately betray lack of contact.

are doing and enthusiasm is catching! Once the model reaches this stage in co-operation, there is no self-consciousness left and model and photographer can work on in complete harmony.

Perhaps you will say that all this sounds too simple, and that we have been discussing an ideal subject. Also that there must be a number of people who would react very differently to the same treatment.

I agree with this to a point. There are many differences in people and we cannot treat any two in exactly the same way and get a similar response. You meet a number of people who are self-confident, happy and relaxed at the very beginning of a session but others may take a long time to

reach that stage. We tend to think of self-consciousness as being something which makes a person nervous – somewhat shy and timid. But this is not always the case. It can do the opposite and make the sufferer arrogant, boastful, domineering and brusque. Self-consciousness can make a quiet person talkative, a serious-minded person jocular, a kind-hearted person appear hard and thoughtless, an intelligent person appear morose and dull and even a public speaker can be made to lose normal composure.

In all these more difficult cases, the preliminary treatment is the same as before, ie, a time for relaxation, refreshment and conversation is allowed before the sitting commences. This custom is dispensed with only when circumstances are such that the sitter has little available time, all of which must be spent in the studio.

In spite of all our efforts to relax the tension, we

41(A,B) Pair of portraits from an unpublished photo-essay. Street fashion emphasized with wide angle lens and striplight normally used for lighting backgrounds.

may sometimes have to commence work in the studio before the barrier of self-consciousness has been broken down. If this should happen we may be thankful that we have had the forethought to ask our subject to bring with them something in which they are interested. This could be something pertaining to their career or hobbies, such as a guitar or other musical instrument. An artist for example could bring some of his paintings – these would be both a subject for conversation and for inclusion in the picture. An animal lover could bring a dog or even a cat!

The wearing of a uniform or dress relating to his or her normal occupation will assist in giving greater self-confidence, particularly if any rank or qualifications are denoted.

With the aid of various accessories, but chiefly with the confidence, understanding and enthusiasm of the photographer, tension will be relaxed and creative co-operation begin to take over.

There is a danger that a self-conscious negative atmosphere emanating from the subject will influence the photographer also. This can easily happen when the photographer does not feel sufficiently confident to deal with the situation.

Here lies the difference between portraiture and any other branch of photography. Portraiture is a two-way interchange between two complex personalities; it is one of the great arts that deals with the unseen as well as the seen. There is an intimacy between two personalities, a sometimes silent communication. Portraiture resembles the medical profession in this respect, that the photographer is often entrusted with intimacies which he cannot reveal to any other person but which may sometimes be revealed through the portrait and find an echo in the heart of a viewer. Portrait photography is a very personal practice. A portrait can often be liked or disliked according to the effect the subject has on the critic, especially if that subject is unknown. On the other hand, if the subject is well-known, the feelings of like or dislike of the personality can be the deciding factor.

The more books a photographer can read on psychology, and kindred subjects, the better will he understand the complexities of human nature.

11 LOWER POWER LIGHTING TECHNIQUES

Your introduction to portraiture in these pages made use of ordinary tungsten room lighting, which is certainly of low power compared with studio lights or flash. The results, you will agree, were not only successful but portrayed a wealth of character which is missing in portraits which are, so often, over-lit.

In this chapter we will discard all lamps of high power and use only those of low, household wattages. As they are ordinary household lamps they have the distinct advantage that they are easily obtainable. (It is advisable, if possible, to use them in the proper reflectors made for photographic lamps and fixed to telescopic stands.) Their disadvantage is they are suitable mainly for black-and-white work. Tungsten-balanced colour film, if available, is of course intended for use with photographic tungsten lamps which are considerably less 'warm' in tone than the normal household type.

Let us first consider some of the more usual conditions under which the lower power light has a distinct advantage.

Working in a confined space

A common fault among amateurs practising portraiture at home is the use of too bright a light in a small room. The lamps have to be placed fairly close to the model, with the disastrous result that skin tones are 'burnt-out'. A simple remedy is to exchange the lamps for others of lower power. This does not necessarily mean an increase of exposure time over that required for the higher powered lamps at a reasonable distance. Applying the inverse square law the effective power of the light diminishes as the square of the distance, so that a lower powered lamp placed closer to the model can result in a similar level of illumination to the higher powered one at a greater distance. Hence, the general rule should be that the smaller the room space, the lower should be the power of the light used.

Lamp stand of insufficient height

In order to obtain lower contrast in modelling the features the light has to be moved away from the model and, simultaneously, raised to a greater height. Frequently, the light cannot be raised sufficiently owing to either **1**, the limitations of the stand or **2**, lack of height in the room. The

changeover to a lamp of lower power enables the light stand to be moved closer to the subject, yet preserves the modelling without excessive contrast between highlight and shadow areas.

Subjects suffering from weak eyesight

In the course of our study of various types of people, we are sure to come across someone with poor eyesight, who is incapable of facing a bright light without the eyes watering and becoming sore and inflamed. A diffuser placed over the reflector helps to minimize the glare but it is very much better to change the lamp for one of lower power. If necessary the diffuser can be used as well. It is possible, of course, to use the higher powered lamps and bounce the light off white reflectors. In this way no direct light will shine on the model, but the lighting technique becomes very restricted and often results in lack of modelling in the features.

42 Sir Ralph Richardson in his London home. Daylight from the left combined with low-power fill-in flash from a frontal position.

Portraying the older woman

The lighting of an older face, engraved with a network of lines and wrinkles, presents certain problems. The high powered lamps with frontal lighting iron out the wrinkles but, at the same time flatten the modelling. If they are used to one side, the wrinkles become emphasized and the skin appears coarse. There are times when this technique may be advantageous, especially in a male portrait. But it is unsuitable if we want to portray the face with full modelling and maintaining all the character lines, but softened so that although no essential line is omitted, the lines themselves are unobtrusive. Placing a diffuser over the bright lights softens all the lines but in so doing the light is spread from the highlights into the shadows at the expense of some of the vitality in the final print. The surest way to maintain the full quality of the light in the highlight areas, while avoiding the deep black shadows, is to switch over to lamps of lower power. They give a clearer, cleaner and brighter result than that obtained by diffusing a more brilliant light. If the model's temperament will allow a moderately long exposure, the low power lighting will give even greater detail in both the highlight and shadow area.

Lighting the hair in a confined space

It often happens that the light used for the hair is too powerful when positioned close to the model, resulting in highlight areas becoming too dense on the negative to allow good enough tonal quality in the print. The highlight tones, instead of remaining separated are, with overexposure, forced to merge.

A lower powered lamp would overcome this difficulty.

The effect of light on some temperaments

We soon find when we start taking portraits of different types of people that not all of them react to light in the same way. There are some, of course, including the trained model, who react successfully under any lighting conditions. There are those who appear to become even more alive and free under the influence of strong artificial light than under normal lighting conditions. But others react quite differently. People who are more reserved and not used to being in the limelight often become self-conscious and awkward as soon as the powerful lights are switched on. For this latter group, low powered lighting often leads to success.

Getting greater depth of character

Naturally, if low powered lighting is used at the same distance as photofloods the exposure time must be drastically increased. But we have already seen that in practice this is not always necessary. If the portrait is taken in a small room with light walls the exposure may still be very brief. But, supposing our aim is to give a very much longer exposure in order to get *greater depth of character* then lights of low power become essential.

Long exposures are an important part of this particular technique and worthy of consideration. The theory behind this long exposure technique is based on the fact that we are photographing a live human being and not a still-life subject.

A photographer can capture an instantaneous expression, however brief its duration, by using electronic flash; but, with the brevity of the exposure of approximately only 1/800 sec, the expression can easily appear frozen and the skin texture be rendered as a hard surface. The outward features are clearly presented but the inner personality of the model remains hidden.

The human brain is continually at work, the heart is pumping the blood to all parts of the body all the time – life is going on – thoughts are going on. It seems reasonable to suppose that the longer the exposure time the more of the personality will be captured and the more lifelike will be the resulting picture. It is well known in other branches of photography, that a really long exposure in dim light will reveal details in the shadow areas which are scarcely visible to the human eye. You must have heard the story of the photographer with the half-plate stand camera, and the slow speed film, who set up the camera in a dimly lit church, focused the picture on the ground glass, set the lens aperture at approximately f/64, inserted the film, opened the shutter and left the church, locking the door behind him. After a good lunch and a stroll around the town he returned to the church, closed the shutter and replaced the sheath in the plate holder. The resulting picture showed perfect detail in every part, in fact more than could possibly be determined with the naked eye. This may be a slight exaggeration but the principle remains, and if it works for architecture it will work

43 Barbara Hepworth, sculptress, in her studio. Two lamps of very low power were used for key and fill-in. She was sitting on a settee with her hands resting on the arm.

for portraiture, as the two subjects are very much akin.

The main difference between the two as far as the photographer is concerned is the question of movement. In the case of architecture, however long the camera shutter remains open, there will be no movement of the subject. But this cannot be said of portraiture. There is a definite limit to the time during which a person can remain sufficiently still yet remain natural and relaxed. For any exposure time over one second there is always likely to be a scarcely perceptible movement due to the natural beat of the heart and the rise and fall of the chest in the act of breathing. This very slight movement during an exposure time of say eight seconds is an asset – it results in a realistic effect of soft skin as opposed to the hardness of stone.

The character lines in the face have softened edges which make them appear more natural but the most remarkable thing is the depth of character revealed in the eyes. There is a quality about the eyes which gives one the impression that real thought is going on behind them. This living quality, in which we really see the eyes as 'the windows of the soul' cannot be so readily obtained by any other means.

You can prove this point to yourself by making two portraits of the same model, using the normal lighting and brief exposure first, followed by a change to low power lamps and a long exposure, of 6-8 sec. It is as well to stress here that long exposure does not mean 'overexposure'. The position of the lights must be controlled to make 6 or 8 sec the correct calculated exposure. Both pictures should be exposed on the same roll of film to ensure identical processing. Choose for your subject someone of a fairly serious disposition as they will be the better able to sit still naturally. The technique is unsuitable for children, or any highly strung individual, whose varied expressions flit across the features so rapidly that only the briefest exposure will capture the personality.

In both cases the subject is to be relaxed, comfortable, and seated in a completely natural position. It is unfair to expect anyone to sit still for any length of time if their muscles are being tensed, or if the pose is not one that they are in the habit of adopting. The subject should be asked to blink the eyes quite naturally during the long exposure. This ensures that the expression in the eyes does not become fixed and staring. If the model were to blink during an instantaneous exposure the resulting picture would show the eyes closed but several blinks during an exposure of 8 sec are still too brief to register and are a definite aid to obtaining a more natural appearance.

To make a fair comparison you should ask the sitter, in both cases, to co-operate with you by concentrating their thoughts on a particular subject during the exposure. This is because the human brain is incapable of thinking about two things at the same time and, if the thoughts are elsewhere than on the camera, there is less chance of a self-conscious expression.

Comparing your results, you are likely to find that the long exposure technique has given a greater feeling of serenity due to the softening of all edges, both of the contours of the face and features and of all shadows. The light areas have well separated tones and merge quietly into the shadows, instead of producing the jump from light to dark which happens with the brief exposure. The eyes have greater depth, better colour rendering and appear to have more thought behind them. There is an apparent inward aliveness, an emotion so often missing in otherwise technically perfect portraits, mainly because the eyes are underexposed, especially brown eyes. Another noticeable difference is the amount of detail in the dark areas.

Soft focus

We have already seen that a long exposure results in a more realistic effect of soft skin texture, due to almost imperceptible movement. This soft focus effect can be used for portraying character. It shows a sensitivity which is lacking when everything is in sharp focus. It displays the tender emotions and gentle, affectionate characteristics and gives an added flexibility to the features. A man's bald head, or a forehead with receding hair, is often overlit, thereby losing some of the character lines. Low power lighting is a sure way of overcoming this.

The subject's thoughts

We have agreed that longer exposure time, coupled with low power light, softens all contrasts, harmonizes all tones and gives greater depth of character to the eyes. You may wonder why the character in the eyes is not lost in a self-conscious expression, resulting from the subject staring fixedly at the camera for as long as 8 sec.

The apparent naturalness is due partly to the normal blink of the eyelids, which we have already seen is permissible but mainly to diverting

the model's thoughts to any subject other than the camera. As I said, the human brain cannot concentrate on two things at once, so if the model is thinking of something which is of real personal interest he need not be aware of the photographer, or the camera, or even of the time of exposure itself. This is where the co-operation between model and photographer becomes so essential. It requires an effort of mind and will to turn one's thoughts elsewhere than on the camera when one is sitting looking straight into the lens. But it can be done, and it is one of the secrets of success with the long exposure technique.

In my opinion there are times when the wisdom and serenity within a personality cannot be captured by any means but a long exposure.

If during the same sitting we need to vary the power of all lights in use, we shall find it impracticable to keep changing the various bulbs. Using a dimmer will overcome this problem. Any light which is plugged in can have its power varied at will by the turn of a knob. The light can be used at full power if necessary, then dimmed very slightly or considerably, with continual adjustments being possible through all intermediate stages. This quickly and easily ensures the correct balance of light without moving the lights yet still allows the photographer freedom of choice. The ability to reduce the power of the light while watching its effect is of great benefit when photographing coloured people, especially those with dark brown or black skins. The attractive soft, velvety appearance of the black skin is completely lost with the harsh contrasts of high powered lighting. The moment that any light is thrown on a black face extreme tonal contrast is created. We have already seen that low power lighting tends to reduce contrast so, where possible, the low power light and long exposure technique will give the most pleasing results.

44 Paul Jones, actor, in conversation, photographed in an ordinary office. Light from a small flashgun bounced from the ceiling.

Using the same two lights (of equal power) that we have employed throughout these experiments, we connect the key light to the dimmer and then position it for modelling the face. The fill-in light is distanced for the 1:2 ratio. By dimming the key light while maintaining full power for the fill-in, we are able to expose for the shadows without grossly overexposing the highlights. Thus, we can increase the modelling effect and reveal the true skin texture without altering the position of the lights.

12 TRAINING OURSELVES TO SEE

Although inward emotions are visible in the expression on the face and in the eyes, people are sensitive to criticism and would become embarrassed by the searching glance of a photographer. How, then, can we study the face in front of the camera without the knowledge of the person concerned?

This is something we have to train outselves to do. It takes time, and a lot of thought, but gradually our powers of perception become stronger until we find ourselves able to see a person's face with greater clarity of understanding and also to recognize various mannerisms and attitudes of behaviour which give a clue to certain character traits.

This initial study takes place, not in the studio, but out in the world, among ordinary men and women going about their daily business. On the train, or, again, in a café – in fact wherever you can sit and watch people – you can select and perceive them without being observed. Take a notebook and write down everything you can about their characteristics and firmly think out the

best way of making a photographic portrait of them. This may sound a waste of time, as the chances of your ever being able to photograph that particular person are extremely remote.

On the contrary, you will find that, after several months of conscientiously examining and writing about different faces, it will become progressively easier to do, and gradually you will find yourself developing a new insight into people – a fresh interest in the exciting variety of types, and a deeper realization that each person requires different treatment in the studio.

As long as we use people as pieces of still life, our portraits will be dull and uninspiring. People are not dull. They are full of many surprises, even a very plain face can be transformed into one of beauty by a happy expression! What a tremendous difference clothes, surroundings and atmosphere can make to each individual's character! Take you, yourself, for example. Are you exactly the same type of person always – every day – every hour and sometimes even every minute? Of course you aren't. We are all continually changing

45 A museum in Italy. Observations from life help you to develop a fresh insight into people.

46 In the paddock on Derby Day. Recorded reality – a source of ideas for a fresh treatment of portraits.

as our thoughts alter, these changes being shown in our expressions and actions. Basically, our characteristic traits remain the same and are revealed in various ways to the observant on-looker.

The way we walk, dress, sit, speak, and so on, can all categorize us as certain types. If portrait photographers would make greater use of the ever-increasing number of techniques at their disposal to picture more of the exciting diversities in the character traits of the men and women in front of their camera, the phrase 'stereotyped conventional portraiture' would cease to be so current.

Now let us look at a selection of people, noting all we can about them and finally suggesting at least one way in which to photograph them – imagining them to be before our camera. We can only take quick glances towards our target in order to avoid embarrassment.

Case I: middle-aged lady

Suppose, to begin with, there is a lady sitting opposite us in the train – a subject for a distinctive portrait.

Description

A middle-aged lady, wearing a striking dress. Her fair (maybe bleached) hair, swept back and up off the face is dressed in an immaculate style, and long earrings are dangling from pierced ears. The texture of the skin appears somewhat hard, matching the expression in the eyes. Her movements are quick and jerky. The natural tilt of the head seems to be slightly backward with the chin up and the eyes looking straight ahead or in a downward direction. As she has no one to talk to we cannot see the change of expression brought about by contact with another personality.

Facial characteristics

A long, thin face terminates in a square jaw. The forehead is high, the nose long and well shaped. The rather large ears are pointed at the top and the bottom, with the top of the ear well above the

eyebrow line. The somewhat small, oval-shaped eyes are light hazel in colour, the cheeks slightly sunken, and the small, firm mouth has the top lip dipped in the centre and protruding slightly over the lower one. Dividing the face into thirds we find that A:B is the widest area, while B:C and C:D become progressively narrower.

Suggested treatment

First let us consider the effects of the available techniques.

Camera angle. A high viewpoint would be unsuitable in this case because of the hair style and the high forehead. Also, the tendency of this angle to portray quiet, demure, characteristics would not fit this lady's personality. A level viewpoint could be used with a profile position of the face. A low viewpoint would emphasize the determined, forceful, positive characteristics of the square jaw. From a full face position, however, the low camera angle would exaggerate the shape of the jaw which would then overrule the character. Our choice of position for the face, therefore, must be a three-quarter view – the camera being fairly low, and a spotlight, or flash with silver lined umbrella, used for modelling from a 25° or 45° angle. The brightness ratio would be 1:4 or even 1:6 and, for effect lights, one on the hair close enough to give correct colour rendering only, and one used diagonally across the dress to render the texture and colour of the material. The eyes turning in the direction of the lens and a serious expression would admirably portray the slightly haughty, critical, determined, direct and positive characteristics.

Background A dark one would be most suitable.

This picture could be a starting point from which other suggestions would reveal themselves as the lady relaxed and conversed with you, the photographer.

Case II: youngish lady

Now look across to the lady on our right. At a guess she is in her thirties.

Description

An attractive woman, not slim, with an oval, well proportioned and well modelled face, framed by thick, short greying-brown hair. Her almond shaped eyes, hazel in colour, are very expressive. They twinkle when she smiles, have a natural dewy, kindly expression, and show a loving tenderness when she glances across at her com-

panion. Her nose is fairly long with a bump in the bone. Her mouth is large, with well formed lips, and her flashing smile is really arresting.

The left side of her face is longer than the right, and she has a long, nicely rounded, neck. Her skin has a soft, peachy look, the make-up on her face has been carefully applied and her eyebrows well shaped.

Suitable techniques

Camera angle. A low camera angle would *not* be suitable in this case, partly because of the already long neck and large mouth and partly because she is not a domineering, forceful type of person, nor does she need to be given any extra self-confidence or power.

A camera position slightly higher than her eye level would be most appropriate, thus increasing the forehead space and concentrating attention on her expressive eyes.

Position. A full or three-quarter face view would be our choice. Do you notice that she has a natural tilt of the head to her left? This is important and we must remember to sit her with the right side of her face nearest to the camera. This is so that for a full face position she can turn her head to the camera using a natural tilting movement (the other way would be unnatural and therefore slightly stiff).

Lighting technique

Modelling light. This should be a floodlight – at a reasonable distance, or diffused, in order to retain the softness of the skin texture. A brightness ratio of 1:4 or 1:6 to give the strength in the tonal quality which will help portray the depth of character as well as the strong physique. The spot effect lights from behind the model can give the brightness and gaiety needed for a happy personality.

Background. Dark, so that the effect lights show against it.

Case III: young lady

A third type of person, this one very different from either of the other two. A young woman, aged about 25, and on the plump side. Her short, straight, rather unruly hair, thin and straggly, frames a roundish face; she wears spectacles on a short pointed nose. The other features include fair eyebrows, a small mouth with the top thick lip protruding slightly over the lower thin one, a double chin and a short neck. (The division into thirds gives the space between the nose and chin as the largest). This lady has a cheerful expression

and is wearing no make-up. She appears to be a frank, open, happy personality. Difficulties to overcome are: short neck, double chin, glasses. The point to emphasize is the happy candour of her expression.

Techniques

Camera angle. Too high a viewpoint should be avoided because the top rim of the spectacles would throw the eyes into shadow. Otherwise you would choose a fairly high viewpoint to lengthen the nose and give increased width to the forehead. A level viewpoint would be unsuitable for head and shoulders because the already wide area between the nose and chin would appear distorted. The solution would be to get the camera further away – in other words take a three-quarter length portrait, placing the camera level with, or slightly below, the model's eyes. Alternatively you could use a longer focal length lens. A low viewpoint could be used with discretion for a three-quarter face position.

Lighting. The modelling light should be a flood, diffused or low powered, to be kind to the skin texture. A brightness radio of 1:4 would retain an impression of the frank, happy nature which has, as yet, none of the depth of real maturity. The spot effect lights can underline the gaiety. It would be best to use them across the clothes and on the background rather than on the hair, as the wispiness on the hair should not be emphasized.

Background. Dark-lit by the spotlight.

As a starting point we could have the model with her back towards the camera, leaning forward to bring her shoulders into a diagonal line. Her head could then turn slightly towards the camera.

Modelling light at 25° to the right of central.

The majority of arrangements would include the three-quarter length figure and full face or three-quarter face position, with full use made of the diagonal line to keep the feeling of alertness. Does this lady not remind you of a bird, with quick jerky movements and bright beady eyes? Kind, friendly, dependable, vivacious, inquisitive and understanding are some of the adjectives I would use to describe this personality and yet physically one would not call her attractive.

Case IV: teenager

The girl sitting in the corner seat opposite us now would make a good model. Quite young, around 20, of slight build, with long, medium-fair hair, a

47 Linda Lovelace at Royal Ascot. Spectacle and spectator – a situation observed and captured on the spur of the moment.

pear-shaped face and clear cut features. The face is well made-up – groomed eyebrows, pale complexion and no visible lipstick, which draws extra attention to her rather 'overly-made-up' dark brown eyes with long black lashes. Her nose is of medium length, her mouth well shaped, and her dimpled chin long and pointed. Wrapping her black fur coat around her she leans back in the seat with her elbow on the arm rest, a cigarette between her fingers. Note how she bends her wrist back – she must be double jointed! Probably her general movements are supple and she would be able to pose quite naturally. Although her body is turned towards us, her head is leaning back and turned in the opposite direction in a rather affected, posed attitude. Large brass circular earrings dangle from a pair of small, well-shaped ears mostly hidden by the long hair.

This girl obviously likes glamour. She might be vain and moody though generous and lively at times but could equally well be cold and aloof. She is not sophisticated in any real way but is trying to emulate such a person.

To photograph her as she is sitting now would be quite characteristic, for one pose anyway.

There is no need to describe the necessary techniques because with this type of face and personality you are free to use any camera angle, or any power of light and even any background you wish, to suit the mood of the picture you wish to obtain. If the mood you choose is not strongly characteristic, it will be one that she acts at various

times so you could not go far wrong. I think she would respond to glamour treatment rather than anything too serious.

Case V: middle-aged man

As a contrast to all that we have studied so far let us take someone more difficult – the middle-aged gentleman over there looking like a business executive.

Description

Of large impressive build, dressed in a well-tailored black suit adorned with a gold identity bracelet, gold signet ring and gold wrist watch with matching metal strap. A commanding figure, opulent, intelligent, self-controlled, determined, ambitious, somewhat vain and used to good food and comfortable living. He is accustomed to giving orders and being obeyed but he is not a hard man – in fact the mouth shows generosity and an affectionate nature. The ears are large with fullness at the top. The blue eyes are centred behind large black-rimmed spectacles. The Roman nose is of an impressive size, with deeply marked lines from the outer part of the nostril to the mouth. On his left this line ends below the corner of the mouth but on his right it stops 1.25cm (½in) above the mouth. This would suggest that the sterner attributes of character are likely to be found in the left side of his face, while the benevolent, sympathetic, kindly attributes might be found in the right.

In repose the mouth appears to turn down at the corners, but the lips are not thin, which implies that he is not a bad-tempered individual. His complexion is pale, his skin smooth. What little hair he has is white and brushed back in an attempt to cover his head.

The shape of his rather large head is rectangular but rounded at the top. Dividing the face into thirds gives fairly equal spacing, but the jaw line is undefined.

Points to watch

1 Spectacles with heavy black rims can cause reflections in the eyes, and dark shadows from the rims.
2 The sagging jaw line can make the face and neck appear to be on the same plane unless the head is leaning forward and is also turned to one side.
3 The black suit will need extra light.
4 His stature must not be dwarfed.

Suggestions for positions

As a business executive he could be seated at a desk, the desk being diagonal to the camera. The left side of his head should face the camera, his arms on the desk holding papers or pen, etc. His head must then turn towards the camera to an almost full-face position and his eyes must be directed to the lens. The camera will need to be fairly low to reach into the eyes and retain the power of his personality, a spotlight rim-lighting the face and as much of the black suit as it will reach. Another small spotlight must be used across the clothes but the beam must be small enough to avoid lighting any part of the face. In order to reduce the contrast between the pale complexion of the face and the black suit any light from the front which reaches the face must be soft and of low power.

The light should be shielded from the top of the head otherwise detail will be lost in the thin white hair and the texture of the skin.

A man or woman of this stature is often more natural in a standing position. Then comes the difficulty of the height of the lights. A way round the problem is to have the rim lighting from the back created by spotlights and all the light in front reflected or bounced. Bouncing the light off white walls or white polystyrene boards, or using the special lamps giving reflected light, will not only give reasonable lighting, but will allow the model freedom to alter his position without the lights having to be rearranged. (This is quite an asset in the case of a very busy person with little time to spare for being photographed.) Another small spotlight from the side can give extra light across the clothes.

It is not necessary to make the photograph full length just because the model is standing. A three-quarter length or a head-and-shoulders portrait can be made with equal success.

Background

A black background would have to be well lit to prevent the picture appearing too dark generally. It would look rather good with a panelled wall background, or a door, or bookshelves, or part of a window. Otherwise a light grey background with all light kept off it except for one small light immediately behind the subject to give the necessary relief.

Shading the edges can be done (but preferably not overdone) during enlarging.

48 Italy. Everyday life often provides the best characterizations.

Available artificial light indoors.

Case VI: elderly gentleman

Take a look at that man over there dressed in the dark coat and hat.

What a lovely low key picture he would make. If he were to come to the studio to be photographed he would probably remove his coat and hat before you had a chance to see him. Make a note then to ask your subjects to bring their outdoor clothing with them into the studio or you could miss a golden opportunity for a good picture.

Description

As he appears to be lost in thought and oblivious to everything going on around him, we can look more closely at his features with no fear of being observed.

He has a squarish-shaped face with almost equal divisions when divided into thirds and a short neck. The features comprise the following:

Dark eyes set underneath dark bushy eyebrows and behind dark-rimmed spectacles. Large ears, well shaped nose of medium length, thin firm lips, dipped in the centre and square jaw with slight double chin. The skin is rough and swarthy – there is a deep crease between the eyebrows and down each cheek.

Some characteristics

A man of character. I would say he has strong powers of concentration, strong likes and dislikes and he is a great talker and fond of the outdoors. He can be melancholy at times – has an ability for serious thought, is courageous, and interested most probably in mechanics.

Techniques to use

With his dark skin and dark clothes, he would, as I have already said, make an admirable low key study. A face such as his, so full of character lines and expression makes a suitable subject for the low lighting, long exposure technique. This model looks as though he could sit still quite naturally for at least 20 sec, or longer if it were required of him.

If you are going to try this technique you will find it helps to have the subject's arms resting on a table. This gives support to the head and shoulders and prevents movement. The modelling and effects lights can be used as required but all

should be regulated for distance and brightness to allow for an exposure of at least 8 sec. You may have to close the lens aperture to $f/11$ or even $f/16$. The question I am sure you are waiting to ask is 'Why not give a shorter exposure with wide lens aperture instead of stopping the lens down?' The answer, you will find fully discussed and illustrated elsewhere. A similar, although technically different, quality of detail is revealed when a really long exposure is given for the interior of a building, although a shorter exposure might be adequate for recording easily visible objects.

Another point is the softness of all the edges of the lines in the face due to the fact that the subject is alive, breathing and probably invisibly trembling!

It would be worth trying out for yourself a comparison of the two techniques. Take the same set-up twice: one with a wide aperture and the shorter exposure, the other with the lens stopped down and the exposure extended (with the lighting reduced in power if necessary).

To return to our subject – the old man in the dark hat and coat. There are many techniques you can experiment with on him. The coarseness of his skin would register almost like cement with the spotlight from an oblique angle; or lighting with a flood in the 45° modelling position and brightness ratio of 1:6. A profile with rim lighting would be effective without his spectacles. You would not be at a loss for pictures if you were fortunate enough to have him in front of your camera, especially when he became animated in conversation.

Case VII: youthful middle-aged lady

The well-groomed lady sitting opposite us now fortunately has a friend beside her with whom she is conversing. This give us a much better opportunity of watching her expressions as she speaks, smiles or listens.

Description

The short dark hair frames a well-modelled face set on a medium length neck. Dividing the face into thirds, we find the middle third slightly narrower than the other two. The features are fairly regular, the complexion fresh and the slight double chin is enhanced by a well-marked dimple. Behind spectacles, topped by narrow black rims, are a pair of confident, thoughtful hazel eyes. The right side of the face would appear to reveal the more character, but the left side seems thinner with a more definite, clear cut outline.

Little make-up is visible on the face and the lips are outlined with a quite pale lipstick.

The lady, whom I can well imagine being an efficient chairman or executive, is wearing a stone-coloured coat and pale green jumper.

Characteristics

As you will realize by now, in our summing up of personality traits, we are merely suggesting possible characteristics deduced from our perception of a person during a very few minutes. This can only be a *guide* to the type of portrait we judge to be suitable and suggests a choice of technique to use for the first few exposures. Other facets of the character should unfold as we continue to search for them.

This is a very pleasant person, talented in some form of art – probably literature. She has a methodical, analytical and self-confident nature. She is interested in other people, is a very good listener and is sympathetic and courageous.

Technique

A conventional portrait with lighting to show good modelling would be my choice and, probably, the most acceptable to her. A dark background would give the greatest contrast against the grey tone of her clothes. The strength of character could be depicted by use of the 1:6 brightness ratio and a rich print quality. A three-quarter face position with the right side of her face nearest to the camera would allow for defining the more clear-cut left side against the dark background.

To visualize this more clearly by the diagram we can place the model facing SW with the head turned towards SE and tilted very slightly upward. Focusing the eyes on a point directly in front of her will portray to the best advantage the keen interest she displays towards everything in which she is engaged.

Suitable lighting would consist of two floods, one for modelling, placed at 25° to the right of central (roughly ESE) with the second at SSE to give a ratio of 1:6. A diffused spotlight for the hair and another spotlight to outline the shoulder against the dark background completes the set-up.

One of the important factors to remember in this case is that the clothes, although attractive in colour and well suited to the wearer, will assume an all-over grey tone when rendered in monotone. Unless contrast is given by the lighting and suitable choice of background the whole effect could

be monotonous – face, clothes and background appearing in only slightly varying shades of grey.

Case VIII: middle-aged lady
At first glance, this well-dressed, middle-aged lady, with the slightly sagging face, may not appeal to you as an exciting person to photograph. But let us look at her more closely.

Description
A short, dumpy figure with a short, lined neck, double chin and a sallow complexion. She has greying, wiry hair, a lined forehead, thick dark eyebrows and small dark blue-grey eyes behind dark-rimmed spectacles. Her well proportioned features are set in a squarish face with a rather pointed chin and a pointed tip to her nose. By the division into thirds she is a well-balanced personality. She is married, is wearing pearl earrings and is smoking a cigarette. Notice her practical hands – rather thick with short fingers. Deep nasal labial lines (lines from nose to mouth) extend below the mouth.

Characteristics
This is a pleasant personality, with strong likes and dislikes. Mentally alert, ambitious and determined she is sometimes rather abrupt in manner but is capable of clear, logical thought and is used to talking.

Key to lighting references.

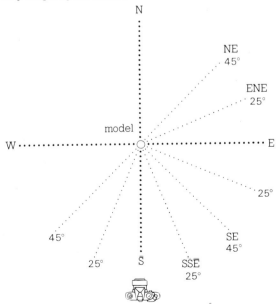

Possible techniques
A three-quarter length figure would be the most suitable, giving more stature to a short person. The way she is sitting at the moment, reading the newspaper, will do well for a start. By the chart, her body is facing SSE and we will ask her to turn her head towards SSW. This gives a turn to the neck which helps to obviate the double chin and the shortness of the neck. Also, the left side of her face – the longer and thinner – is then nearest to the camera. The camera angle being slightly below eye level allows the eyes to be seen behind the spectacles.

Lighting
Modelling light, a flood, diffused and 25° to the left of the central position; secondary, fill-in light also a flood diffused. Or, this second flood could be replaced by reflected light to help soften the deep lines in her face. A spotlight from NW level would add a touch of brilliance to the lighting and a second small-beamed spotlight over her left shoulder could be directed across the clothes only. Keep all stray light off the newspaper or it will need printing in considerably during enlargement.

Background
This is another instance where a natural background of bookshelves, or a corner of the room would add to the picture. It needs to be dark, intermingled with lighter tone, rather than solid black.

Case IX: young man
We are indeed fortunate to find such a variety of types among a comparatively small number of people. The young man upon whom we will now focus our attention is representative of his generation and will make an exciting picture presented in a contemporary manner.

Description
This youth, probably in his early twenties, is wearing a three-quarter length fur coat. His wiry hair is thick and wavy, and is medium fair in colour. His regular-shaped head terminating in a long chin, makes the lower third division of the face wider than the upper two. The bone structure of the face and features is well defined. The ears are small and lie back close to the head. The well-shaped nose is short, and there is a wide space between the nose and the firm mouth, with its slightly protruding top lip. His eyes hold our attention – they

are dark brown in colour, very expressive, and framed by long eyelashes.

Characteristics

What can we deduce from this analysis? He probably has a warm, affectionate, carefree nature and is ruled by his heart rather than his head. He enjoys life, is fond of change, but inclined to be lazy.

Not naturally very intellectual, he can nevertheless achieve his goal with perseverance. His conversation is often witty, he takes considerable pride in his appearance and is, most likely, very popular.

Techniques

We now have an opportunity of using a male model for some glamorous effects. His attractive features, coupled with his character traits and mannerisms, give us plenty of scope for some originality in posing, brilliance in lighting and crispness of definition which are some of the keynotes of modern portrait technique. It might be a good idea to start with the journalistic approach.

As our model leaves the train, he puts on his hat, picks up his immaculately rolled umbrella and steps out on to the platform, slamming the carriage door behind him. His coat still unbuttoned swings outwards from his slightly sloping shoulders as, hand in pocket, he walks jauntily down the platform. He turns back to look in our direction – does he sense we are watching him?

In that moment the picture is visualized. Full length, to be taken out of doors with, if possible, white buildings out of focus in the background. The figure, walking away from us, and then pausing and looking back over his shoulder. The point of the umbrella and the swing of the coat making diagonal lines in the composition. A crisp, glossy print will help the atmosphere.

In the studio, too, we can utilize the hat and coat for some of the pictures. As a starting point, for a head and shoulder or three-quarter length position, the backward glance will do well, and make

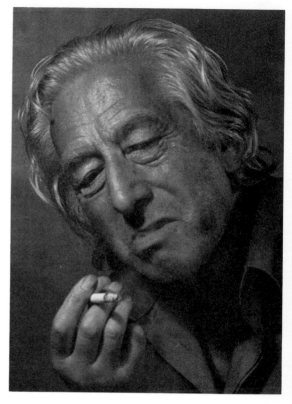

49 Recreated in the studio from a scene observed outdoors. Low key, to suit mood of subject.

an interesting comparison with the outdoor shot. To give the required crispness of definition, we could use the spotlights, both for modelling and for effect, with a brightness ratio of 1:6. A low camera angle and the model's eyes glancing towards the lens, suggest a feeling of isolation and happy superiority.

A more delicate high key effect can be produced by using floodlights instead of spots and, if necessary, placing diffusers over the lights. This will soften the shadows as well as giving an overall softness to the skin and to the texture of the fur coat.

We will, of course, need a white background and the model must be asked to remove his hat which is dark in colour.

13 CHILDREN

If you are a parent and an amateur photographer you are probably interested in taking occasional snapshots of your child. Every parent wishes to keep a record of a childhood that passes only too quickly. This intimate snapshot, which means so much to both parents when viewed in happy retrospect is important for the subject matter more or less regardless of the quality of its photographic technique.

Snapshot v portrait

On the other hand, a child's studio portrait must be a true character study and also record a natural expression, whether smiling or serious. It must be well composed, well lit, suitably exposed and processed and attractively presented.

The latter techniques present no problems to a student of portrait photography. The important skill to master is the ability to make a child completely happy and natural. This may not be difficult in the child's own home but in the studio where everything is strange to the child, it is another question. For this reason I suggest that

you should make some study of child psychology to help towards a greater understanding of the child's mind.

The essential question to ask yourself before embarking any further on the project of child portraiture is 'Do I love children?' 'Love' in this context does not just stand for a sentimental feeling towards all the attractive babies and toddlers but a sincere affection which embraces an understanding of the working of their minds. It means feeling with them, knowing when to ignore them and when to play with them. It means being able to make up stories and to enter their world of make-believe. It means making sure that they can trust you. A child never forgets a broken promise. So, when you say you will do anything you must be sure to do it – if you say you will give him anything you must do so. If you do not intend to, then refrain from saying anything about it in the first place. To understand children and to photograph them suc-

50 Girls at playschool. A completely spontaneous picture – the subjects are surely unaware of the camera, or have lost interest in it. Window light.

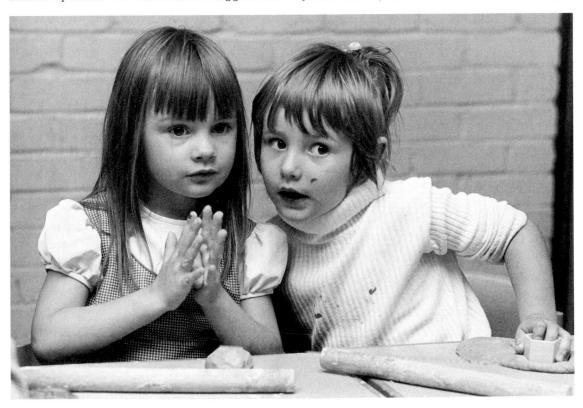

cessfully means having endless patience – patience to wait for that elusive smile, patience to deal with the child who thrusts a hand out for every toy the moment you show it, allowing you no time to make an exposure and patience with the lively youngster who will not remain in one position for more than a moment.

A child is as sensitive as an animal towards atmosphere, and will usually know instinctively whether an adult is a child-lover or not. A child will react to expressions – if you want the child to smile and be happy you must show a cheerful happy countenance yourself. If you are tense, or impatient, you can be sure the child will behave in the worst possible manner.

If you do understand children, you have the key to success in child portraiture and you will very quickly discover your own ways of creating harmony and happiness in the studio.

Some methods of applying psychology

As I have said, the subject of child psychology is so vast, that even skimming its surface is outside the scope of this book. It is, therefore, something which we cannot study together in these pages. But our individual experiments will result in a bet-

ter understanding of children and this will become obvious in our relationship with them in the studio. This understanding becomes the silent communication of mutual trust, and is the inexplicable chord of harmony which must be kept intact throughout the whole photographic session.

The child is attracted by someone who obviously responds to his unspoken thoughts, his fears are dispelled and all barriers come down.

Each photographer must work out his own techniques, expanding his ideas as his experience widens. The recounting of some of my own methods of applying psychology in the treatment of children is, therefore, more in the nature of interest than instruction, although the techniques have been well tested over very many years and have proved successful for me.

Booking the appointment

At the time of booking the appointment I make a note of the child's sex, name and age. I suggest the appointment is made at a time of day most suitable

51 Peruvian village children returning from school. Responding simply to the presence of a camera, they formed themselves into a group without prompting (or invitation!).

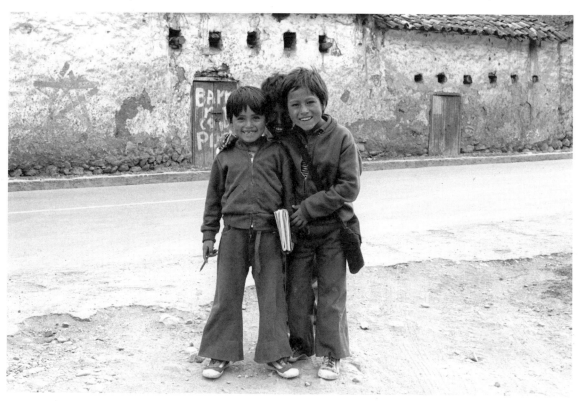

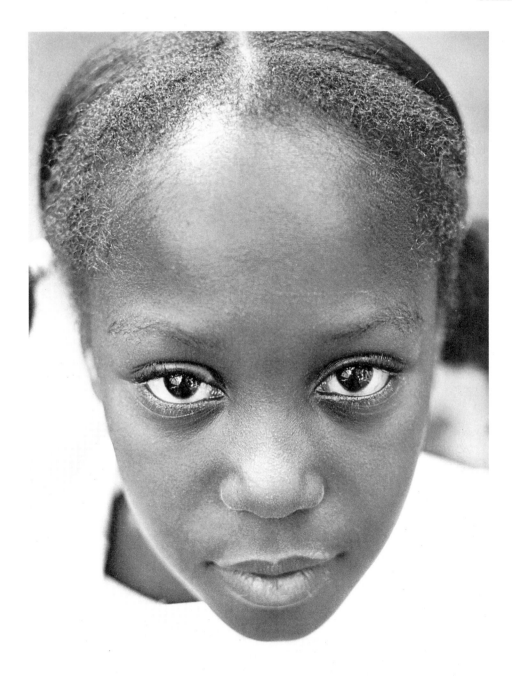

52 A girl in New York.
Cooperation without
pretence or self-
consciousness.

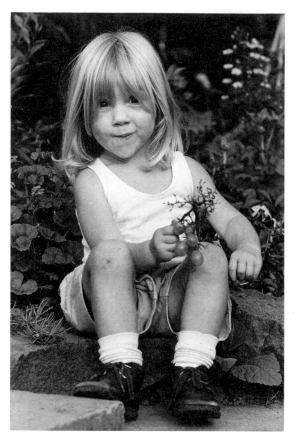

53 Playing to camera. The camera can bring out the actress or clown in a young child.

for the child, that is, when he is unlikely to be tired or hungry. The mother is advised not to tell the child he is going to be photographed, but rather that he has been invited to come and see some of my toys and perhaps he would like to bring one or two of his own to show me. This prevents any fear of the unknown building up in the child's mind.

For a child of school age I suggest that a change of clothing should be brought to the studio. A different type of picture, showing other aspects of his or her life, can be made when the child is wearing sports clothes, school uniform or party dress. An insight into a younger child's favourite toys or an older one's hobbies is also useful when I am preparing the studio, selecting props, background, etc.

On arrival
A child is greeted by name and taken to the studio where his eye immediately alights on a large teddy bear sitting on the box, surrounded by

either cars, or a doll's tea set or some other toy likely to appeal. If tungsten illumination is to be used, one floodlight is already switched on, making the room look bright and cheerful. For ten minutes the child is allowed to get acclimatized while I discuss the required portrait with the mother. By this time the child is usually playing quite happily and it is comparatively easy to encourage him to sit on the box and see what other surprises I have in store. Techniques obviously vary according to the age of the child. With some young children the sooner I start work with the camera the better, while others take longer to become accustomed to strange surroundings.

Parents in the studio
Whether or not the parent should be allowed in the studio during the session is a problem which each photographer must sort out for himself. For me, the solution lies in the answer to the question 'How will it affect the child?' If the child is happy and likely to be less self-conscious in the studio with me alone, the parent can relax in an anteroom, where, if so desired, the proceedings can be overheard but the child is unaware of being watched.

When photographing a baby or young toddler I find the presence of the mother in the studio a distinct advantage. One of her main tasks is to sit on the edge of the box or on a chair at the side and be ready to grab the child in the event of a likely fall, or to replace her lively youngster in the required position. Parents can also help in attracting the child's attention. This works well, provided it is done at the photographer's request and not in opposition to his needs! It is nothing short of chaotic for two or more people to try and attract the child's attention at the same time – the child merely becomes bewildered and the adults frustrated. It is also a fallacy that noises, such as rattles, bells, handclaps, etc are indispensable. These have their uses, but there also times when silence is preferable. In the silence even a faint sound, such as a clock striking in another room, or a small click, is enough to make the child look towards the sound.

For a young baby the most useful props are gaily coloured (especially red) moving toys, balloons, a red scarf to wave, a rattle, and a small squeaky toy (both to be used sparingly!) and soap bubbles, etc. A baby is either waving his arms around or keeping them straight down by his side, neither of which is particularly photogenic. To

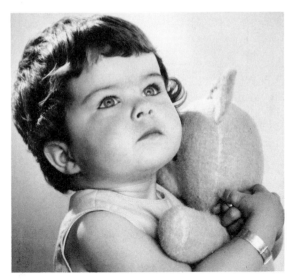

54 Melanie, clutching her teddy for comfort and security, watches a plane being 'buzzed' by her daddy.

meet this situation I keep a supply of small, plastic brightly coloured teddies. The baby can hold one without it being obtrusive in the photograph. I know it will almost immediately find its way to the baby's mouth, so the opportunities to click the shutter must not be missed. Of course, any plastic toys that the baby is likely to chew must be washed immediately prior to the sitting and kept in a plastic bag in the interests of hygiene.

For toddlers, there are endless ways of attracting attention – the main thing is to do something that will not only induce the child to turn his head in the required direction but will produce a suitable expression. It is all too easy to entertain a child and to be rewarded with an interested stare and the mouth wide open! Hardly the expression required for a portrait! Some of the props I have found most successful are a clay pipe and soap bubbles, puppets – a monkey puppet and Punch and Judy (these require the make-believe stories to accompany them) and small dolls and teddies, which can be hidden down the hood of a reflex camera and can be made to come out when called. Dolls have had to get smaller in recent years to keep pace with the diminishing size of the camera! But if the 'doll' is merely a bead on a long piece of thread, the idea will still work! A doll's tea set, small aeroplanes and a musical box are all useful – in fact any toy which can be operated with one hand is useful – the other hand being left free to press the shutter release immediately the ex-

pression is right. Picture and story books, crayon books, stencils and cut-outs together with pencils, crayons and scissors and a simple jig-saw puzzle are all kept in the studio to occupy the hands of the older child while sitting at the desk.

Some children are more interested in flowers, shells and even stones, than they are in toys. One small boy of four years old delighted in the feel of stones – the smoothness of a sea-worn pebble. Another little three-year-old girl was more interested in flowers and amused herself by plucking the petals from a marguerite and gave me a beautiful smile as the last remaining petal was pulled off.

Some children do not need entertaining in any way but are quite at home chatting about various things, their school days and holidays, their hobbies and recreations. With the intervals for changing clothes and backgrounds and a refreshing drink half way through, the time passes quite happily. Nevertheless, the photographer must be able to sense the child's feelings and have a variety of things at hand to use if the need arises.

The studio set-up
The studio has a large window facing north and both the walls and ceiling are white. When the

55 Susan quietly watching a puppet; a lovely child with appealing big blue eyes and a gentle mouth.

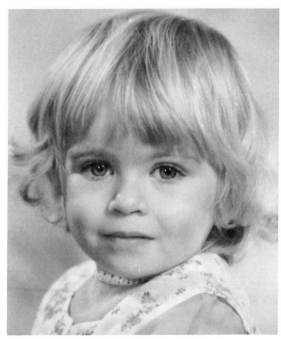

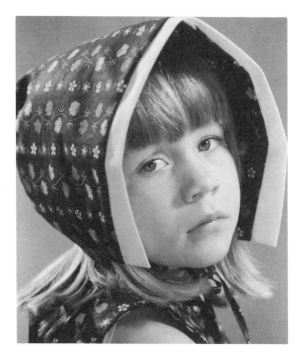

56 Katie. I'm ready! Katie, proud of her new sun bonnet, poses this picture herself.

This lighting set-up is very versatile, reasonable results being obtained whichever way the child faces and whether sitting or standing. A daylight studio is often more acceptable to a child. It appears little different from a normal room. There are no bright lights to dazzle the eyes, and, if the window looks on to a garden it promotes a feeling of freedom – there is a way of escape! Conversely, a studio lit by artificial light, with a background covering the window area, can give a sense of being imprisoned – the subject can feel caught within the glare of lights. To some children this is unnatural and can give rise to a feeling of apprehension, if not outright fear, until they become acclimatized to it. The daylight set-up allows for high spirited youngsters, who are incapable of staying in the same place for more than a few minutes and gives reasonable lighting from most angles.

Should the quality of the light deteriorate, as it is quite capable of doing in, for example, the UK, the curtains are drawn across the window and white paper background unrolled down to floor level. See fig 13.2 for the layout.

A is a low power, and B a medium power (ie, twice the power) spotlight, both diffused and directed downward; C is a medium power flood, diffused, used as the key light; D and E are floods of very low wattage each directed on to a 1.8 x 1.2m (6 x 4ft) sheet of white polystyrene placed at an angle and well behind the camera. These act as the fill-in light but are stationary. F is another flood, placed behind the child and directed towards the ceiling to reflect light back onto the hair. If a high key picture is required, turn the back spots round to illuminate the background, and use an extra light if required. If the meter reading for the face is 1/30 sec, the reading for the background should be 1/125 sec (4x that of the face).

Diffused tungsten light contributes to the appeal of many child portraits. It creates definite, but soft and pliable modelling in the young face, renders fair hair with beautiful texture and reveals liquidity and a wealth of expression in large, wide-open eyes. In this set-up, all light is reflected and each light is stationary with the exception of the key light. With only that one to think about, the photographer can concentrate his full attention on the child.

It may be useful to describe the box. It is 1.2m x 60cm (4 x 2ft) and stands 45cm (18in) high. It is made of white painted hardboard, the top and

light is good there is every opportunity for taking portraits by daylight, which is always more suitable for babies and children. It is a more natural light, creates softer looking skin texture, is kinder to the child's eyes and allows more freedom of movement. To prepare the studio takes very little time. Fig 13.1 shows the simple layout.

The white box, on which the child sits, is placed at an angle between wall and window. AB and CD are 1.8 x 1.2m (6 x 4ft) sheets of white polystyrene, leaning against anything available to support them. Between them is a medium power spotlight, high on its stand and directed downwards. If the reflected light from the ceiling is insufficient, a flood light in a wide reflector can stand at the back pointing upwards. This gives added diffused top light. The distance between the window, the box and the polystyrene reflectors depends on the quality of the daylight and the exposure required. 1/30 sec at *f*/8 or *f*/11 is usually fast enough to stop movement. This also allows sufficient depth of field for reasonable focusing. The meter reading is taken against a white card held where the child is to sit. (Meter adjusted for a x4 or x8 reading – see 'Calculating exposure'). Adjust the position of the box accordingly and set the camera lens and shutter ready for the daylight series of pictures.

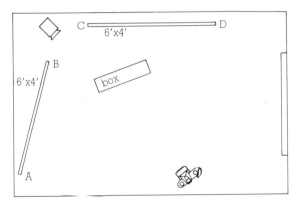

13.1 Studio layout for photography by daylight (for key, see text).

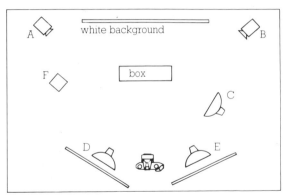

13.2 Studio layout for photography by tungsten

or other continuous light sources (for key, see text).

front panels being reinforced with wood. The top is covered by a soft white blanket to give greater comfort to a toddler. A mattress can be slipped under the blanket and raised at one end by a firm cushion enabling a baby to lie flat and yet at a slight angle which is more photogenic. For a

57 Katie pauses for thought! A contemplative study.

Modelled by a spotlight from behind.

change from the box, there is a small red desk and stool to match and three or four other stools of varying heights, one of them being long enough to seat two children side by side, yet low enough for their feet to rest on the floor.

The flash option

If we wish to take a picture by a single flash gun in place of the modelling light, the set up would be the same as for tungsten with the omission of the flood C.

The distance from the child at which the flash must be used, depends on the guide number (GN) supplied by the manufacturer for the equipment in use when coupled with the appropriate lens aperture.

The flash should be attached to the camera by an extension lead, enabling it to be placed on a separate stand or held in the hand at a height to give the required modelling to the child's face.

If two flash units are to be used, the second one, which can be either fixed onto the camera or on a separate stand, takes the place of the fill-in light. The reflectors and the lights D and E are then no longer required.

Electronic flash with three, or more, units connected to a central control allows a variety of effects to be produced without any additional lighting. The built-in modelling lights are a great asset, enabling the correct balance of light to be visualized. But experiments must be made to standardize the most suitable positions.

A softer, shadowless result can be obtained by directing the flash towards the ceiling. The photograph is then taken by reflected light only which gives greater freedom to both photographer and child but at the cost of any pictorial effects.

Composition

The arrangement of the figure within the picture space is just as important as in an adult portrait. Arranging for the body to face one way while the head turns in another direction always gives a greater feeling of life and movement. If the arms and hands are included, make sure that the arm furthest away is visible at the shoulder, otherwise the forearm may protrude from the body without, apparently, having any connexion with it. Sitting a child sideways, rather than full on to the camera avoids any distortion of the hands and arms and allows for greater variety in the lines and background shapes.

Unlike adults, children are not self-conscious about their hands. They use them continually and naturally. Their hands are pliable and well-modelled and, provided that they are positioned suitably, always photograph well and add a further touch of character to the picture. If the hands are occupied in holding a small toy, they are likely to be together and to look quite natural.

Although a child cannot really be posed for a

58 Christopher relaxes full length on the box, cupping his face in his hands.

photograph, he can be placed in a position where he is likely to adopt an attitude similar to one that the photographer has in mind. The child seated on a stool, with the appropriate size of table or desk in front of him will almost certainly, at some time, put his elbows on the table and cup his face in his hands or use the hands in some way that makes a good composition yet appears completely natural. In the print, the elbows can be trimmed off to give greater concentration on the face and hands.

When two lines, such as the opposing diagonal lines of the arm, are obviously going to meet, it is not necessary to show the point at which they do meet. Trimming should not occur at either the elbow joint or the wrist but anywhere in between which will maintain a feeling of implied continuity. Watch for distortion and, although f/8 gives reasonable depth of field, try to keep face and hands as near as possible on the same plane. In the picture of Joanna, the cat is on the box, while Joanna kneels on the floor putting one arm around him. She leans forward, which brings her head to the same level as the cat, waiting for the squeaky noise which will alert the cat's attention. Joanna is completely unselfconscious as she is only thinking of the cat and whether he will be good and sit still. Joanna did not want to be photographed at all but she did want a picture of her pet, so her mother had to phone for permission to bring him and Joanna came too!

All children differ, one from the other, and all need individual treatment, both in photographic technique and in the type of entertainment provided in the studio. It does not take long to discover which kind of toy, or what action will amuse the young subject, but you must find out soon, or you will get the bored expression and lack of co-operation which are fatal to success.

It is in photographing children that the flash technique can be a particular advantage. The knowledge that all movement will be arrested by the very brief exposure, allows the photographer to take more pictures of children in action than he would be likely to do with either tungsten illumination or daylight. Also, the use of a smaller aperture gives greater depth of field and consequently overall sharpness which is a requirement on some occasions.

Home environment

There are times when you are asked to photograph children at home. The main difficulties to

59 Joanna. Her attention is focused on activity out of shot and she was unaware of the camera.

be overcome are usually **1** Lack of space, **2** Unsuitable backgrounds, and **3** Unknown light conditions; all of which can be surmounted with a little ingenuity.

A room with a bay window, covered by net curtains offers very suitable diffused light with a reasonably wide spread. A white blanket on the floor across the bay acts as reflector as well as background. The baby is placed on the blanket while the mother kneels beside him. Before the exposure is made, the mother 'scoops' the baby's head and shoulders away from the floor and leans her head against his; turning to look in the direction of the camera. This makes an interesting picture compositionally – the heads representing two overlapping circles of variable sizes. The only light used is the available daylight, the only reflector the white blanket on the floor. The camera is hand-held above them. Should you have a portable flash outfit with you, or a single flash head on a lead, you can take a picture using the flash as the 'key' light and the available daylight as 'fill-in'. One suggestion for a young child is to seat him on a parent's knee in the centre of the room – well away from any wall. With the camera on a tripod, you can hold the flash above and to one side of the camera and get good modelling in the face. The flash being nearer to the model than the camera, will result in an attractive dark rim outline on a three-quarter or profile position. Many parents are under the impression that children are happier when photographed in their own home. I do not altogether agree with this as, after the initial shyness has worn off, a child enjoys a visit to the studio. The exciting lights, and the many varied toys with which to play, make a happy time for any youngster, so long as the photographer is fond of children.

14 UNDERSTANDING COLOUR

No study of portrait techniques would be complete without the inclusion of colour. Many amateur photographers concentrate on colour transparencies and seldom expose a black-and-white film. If you are among this number and your subject is portraiture, you will quickly realize that this chapter cannot be divorced in context from the rest of the book but that it is a study of an extra technique – essential if we are to understand the detailed search for character and personality in portraiture.

You will soon realize that we are attempting to use colour creatively – as a technical tool – and not only scientifically, when correct colour rendering would be the main incentive. To illustrate my meaning, let us imagine that we have a charming, attractively dressed model in front of our camera. We follow the film manufacturer's instructions regarding the light sources, the brightness ratios and the exposure and, finally, send the film away for processing.

The resulting transparency proves the exposure to be correct and all the colours to be faithfully reproduced.

In this instance we have recorded our subject quite accurately in colour but have made no attempt to use colour creatively.

In this chapter we are going to explore colour and try to discover ways of exploiting it to interpret personality, mood and atmosphere, with even greater clarity than is possible in black-and-white. We shall consider the psychological aspect of colour, the relationship of one colour to another, and the mixture of colours, as applied to light. We shall discuss the lighting and exposure techniques where they differ from those already described in previous chapters. Finally, I shall suggest a few controls which may be a starting point for future experiments.

Psychological aspect

In everyday life we are surrounded by colour. We like, or dislike, certain colours. We use colour to express our emotions. We choose colours for house decoration and dress materials according to our temperament and the effect that colour has on our personality. We have become so involved in colour that all too often we accept it without understanding much about it or, sometimes, without really seeing it.

Colour characteristics

Let us refresh our minds by investigating the five main colours, red, blue, green, yellow, purple, separately, considering some of the qualities which are associated with each.

Red. Red is the most powerful, active, exciting, assertive colour of all. Red has 'impact', hence its frequent use as a focal point in a picture. Red is universally used as a signal for danger because of the sharp brilliance of its colour when contrasted against any other colour.

Red can be horrific through its association with blood, and dramatic through its connection with fire. In these illustrations red is hard, domineering, intensely active and indicative of anger, rebellion, danger and extreme heat.

The positive characteristics of red are excitement, gaiety and joy. We think of red decorations, of holly berries and robins associated with Christmas festivities. The bright cheerfulness of red makes it attractive to children, even to babies.

The red ray is strong and powerful. It may sometimes help to lift depression in a strong type of person, but its violence is too overpowering for anyone who is nervous or weak.

Red may be used to symbolize the erotic.

Blue. Blue is quite the opposite in character to red. It has a calming, cooling influence, and is less assertive.

Blue is a positive colour and belongs more to the spiritual side of life.

We talk of 'a heavenly *blue*'. Church decorations are often in blue, probably adapted from the painters who robed the Virgin Mary in blue and white.

Blue denotes freedom and expresses a joy of life. We think of the lark soaring in a bright *blue* sky, or the pleasures of swimming in the deep *blue* Mediterranean.

Blue is the colour of honour and of royalty. We talk of being 'true blue' and 'blue-blooded'.

Negatively, blue denotes depression and extreme cold. We speak of 'feeling blue' and of being 'blue' with cold. We also associate an extremely cold atmosphere with 'ice blue'.

Coloured light rays are used in the art of healing, and the blue ray is said to have great antiseptic power, to be electric and to have a calming effect on the patient. It can also relieve pain to a certain extent.

From the foregoing we learn that blue em-

phasises the spiritual and is a colour of poise, serenity and joyous freedom. It calms the mind of a worried, excitable or fearful person but it can also make one feel physically cold, and mentally aloof.

Green. A positive property of green is its luxuriousness – the 'green' of the Emerald Isle and the trees turning green with fresh leaves in spring. Thus we associate green with renewed life and energy. It is not vibrant like red. It steals upon our consciousness rather than bursting in on us as red is inclined to do.

Green is neutral; it is neither hot not cold. It is a harmonious, peaceful, soft colour. Green will advance when related to yellow and recede when related to blue.

Green is the colour of nature and, to keep healthy, everyone needs the green of the trees and fields. Were it not for parks and commons town dwellers would need to visit the country to be re-vitalized by it. Negatively, green stands for withdrawal. A person is said to 'turn green' before fainting, to 'look green' with fear, or with sickness. Green is also used as a descriptive term for an inexperienced person who can be imposed upon too readily. Jealousy and envy are also both associated with green.

Yellow. Yellow is a joyful, uplifting, golden colour. It is associated in our minds with sunshine, with spring flowers and fluffy chicks – the colour of Easter and new life.

The yellow light ray is known as the 'Ray of Wisdom' – the reason, perhaps, why a golden crown represents kingship, and a golden halo adorns the saint's head in religious imagery.

Although yellow is predominantly positive and uplifting by nature, it does have its negative side. Yellow is suggestive of cowardice and disease. We talk of 'a yellow streak' and of 'yellow jaundice'. A green plant may be sickly when the leaves turn yellow.

Yellow, when it is related to red, becomes more active, and suggests autumn and falling leaves, with eventual decay.

Purple. Purple is associated in our minds with royalty and with all kinds of pomp and ceremony. It conjures up pictures of rich velvet, or satin fabrics in folds of deeply saturated colour, or the flowing robes of honour as worn by royalty. Purple has a solemn dignity. Being composed of blue and red it acts as a balance between the two. It can be said to be active in a slow, majestic way and passive in its dignified solemnity.

Purple has also been used to symbolize the decadent.

The paler shades of purple have a softer dignity, and a sense of noble serenity. Negatively, purple is associated with death and funerals, but even so, it maintains its royal dignity.

Colour relationships

A valuable aid to any student of colour is the Munsell colour wheel, which shows the five principal colours, fully saturated, and all the intermediate hues in steps of decreasing saturation. A greatly simplified form of the Munsell wheel is shown in the diagram (14.1) which will serve as a visual aid to study.

Let us look again at each of the five principal colours in relation to other colours. Red is one of the complementary colours. Its opposite or contrasting colour on the wheel is blue-green. Red is

14.1 Colour wheel. Each colour harmonizes with the one on either side of it. The most strongly contrasting colours are those opposite one another. Equal areas of neighbouring complementary colours will clash. Desaturating one will help to achieve pleasing composition. A picture can be composed using colours shown at the three ends of an equilateral triangle; desaturating one or more of the triangular combinations gives endless arrangements. Warm colours advance; cold colours recede. Additive primaries apply only to coloured *light* – red, blue and green add up to white. Subtractive primaries apply to pigments and dyes. Magenta, yellow and cyan add up to black. All colour processes are based on these colours.

a warm, advancing colour, while blue-green is cold and receding. Red is related to purple-red on the one side and red-yellow (orange) on the other. The temperature is cooled by the purple-red and its excitement modified by the red-yellow. Vivid colours of these two relatives will clash and give a loud, noisy, effect. Desaturating one of them will give a more peaceful effect and make a pleasing arrangement.

Red, blue and yellow-green are connected by the equilateral triangle, which means that red will compose well with either or both, particularly if one, or two, out of the three are desaturated.

Red, desaturated to shades of pink, has all its characteristics modified and becomes more self-effacing and delicate.

Red has the greatest impact of any colour. It is also the warmest colour and adds warmth to any other colour mixed with it. In strong colour it can be garish and hard.

Blue is the coldest, most receding colour and cools down any other colour which is mixed with it. The opposite colour to blue and the one, therefore, to contrast most strongly with it is red-yellow.

Blue is related to blue-purple on the one side and blue-green on the other. Both are cold colours because of the blue content but are obviously slightly warmer than the blue alone.

As we have already seen, blue composes well with red and yellow-green if one or more are desaturated. The more desaturated blue becomes, the more ethereal and the more icy cold its appearance.

Green, as we have mentioned before, is neutral. It neither advances nor recedes, it is neither warm nor cold. In order to make green advance and be warmer it must be mixed with its relative, yellow-green. To enable it to recede and become cooler it must be mixed with its other relative, blue-green.

The equilateral triangle links green with blue-purple and red-yellow.

The colour to contrast most strongly with green is purple-red.

Green harmonizes with all colours and has a calming effect.

Yellow is an advancing, warm colour and the mixing of any colour with yellow will create a feeling of warmth.

Yellow contrasts most strongly with blue-purple.

Yellow is related to red-yellow (orange) on the one side and yellow-green on the other, both of

14.2 Complementary colours of light
Red + Green = Yellow

Red + Blue = Magenta
Green + Blue = Cyan
Red + Blue + Green = White

which are warm colours but the red-yellow is the more active.

Yellow harmonizes with blue-green and purple-red. Desaturated blue-green enhances a passive yellow subject, while desaturated purple-red creates a more active atmosphere.

Yellow light is formed when green light is added to red light.

Purple is more active, warm and advancing than blue, but less active than red.

Purple contrasts most strongly with yellow-green.

Purple is related to the active purple-red on the warm side and the more passive blue-purple on the cold side, although the blue content of purple will make it always cold in comparison with red, yellow and green.

Purple harmonizes with red-yellow and green. Equal areas of purple-red and blue-purple will clash and give a noisy, discordant effect.

To sum up our findings, so far, in respect of the colours illustrated on the wheel, we can tabulate as follows:

1 Each colour contrasts most strongly with the one immediately opposite it. Saturated colours of

60 Near-total saturation with a single colour may be achieved with filtration or by exposing the film by a light source for which it is not colour-balanced.

both in one composition give maximum brilliance and maximum impact.

2 Equal areas of strong contrasting colours, or of strong unrelated colours, clash. Desaturating one or more of them makes a pleasing arrangement.

3 Each colour is related to the one on either side of it.

4 Colours at the three ends of an equilateral triangle within the wheel compose well together.

5 Warm colours – from red to green on the right of the wheel – are advancing colours.

6 Cold colours – from purple-red to blue-green on the left of the wheel – are receding colours.

7 All colour characteristics are modified by mixing with other colours or by desaturating.

Effect of light on colour

We now come to the more practical aspects of taking portraits in colour. We need to think first of the effect of light on particular colours and then of transferring the effect to colour film. Provided that we select the correct type of film, the one balanced for the lighting effect we wish to repro-

duce, we shall find the technical details as easily understood as those applying to black-and-white photography.

Let us begin by considering the effect of light on colour. It will be helpful to return to Chapter 2 'Portraiture Out of Doors' and refresh our minds on the effect of light on colour out of doors – to observe again the apparent colour change of objects seen first in sunshine and then in shade; to see once more the reflected light from a deep blue sky, from a grey sky and from an evening sky when the sun is really low and to realize that the colour of the reflected light has passed through many subtle changes from blue to yellow-orange. We are so used to seeing colour by daylight that, until we really make an effort to note the colour variations of a particular subject under each condition of reflected light, we will continue to accept it all as just 'daylight'.

Coming indoors and seeing colour under artificial lighting we more readily notice a difference. Colours of dress materials, for instance, can change quite perceptibly when viewed first in the

light reflected from a daylight fluorescent tube and then under that of an ordinary low power household lamp. A red dress appears a much colder, bluer shade of red when seen in the relative bluishness of daylight and a warmer, brownish shade when viewed under the more yellowish-red artificial light. The intensity of light, too, has a great effect on colour. If the light is very bright, as from a high-powered spotlight, giving sharply defined shadows, even strong colours lose some of their tone by being too bright in the highlights and too dark in the shadows. The cone-shaped beam of light from a flood emits a much softer light, giving more transparent shadows. The intensity of light can be controlled by the distance of lamp from the subject. The nearer the light the harsher, more brilliant may be the colours but beautiful depth of tone will only be achieved by increasing the distance of the light from the subject and softening its quality. You can discover this for yourself by selecting a subject of strongly saturated colour, such as, for example someone wearing an emerald green coat and hat – a difficult colour to photograph. Beginning with a light of full power close to the model, note how the colour seems to splash out in all directions, throwing a green cast onto the lower part of the face. While watching the effect, keenly, move the light further away and, if possible, dim the power. Should you not have a dimming device, place a diffusing screen of muslin or translucent paper stretched over a frame between the light and the subject. This will soften the brilliance without dulling it.

The dimmer is preferable to the screen in that you can watch the effect very carefully. You should be able to see the actual colour reach a point where it apparently folds in on itself and ceases to spread. This is the light with which you will get the greatest possible saturation of colour with no visible colour cast elsewhere. Any secondary light required can be reflected off white polystyrene or white paper. Pastel shades – such as pale pink and pale blue would lose all colour and be rendered mainly white if subjected to too much light. Dimming, or diffusing, the light enables you to judge the effect and reproduce the true, subtle shade. A word of warning should be given here. Excessive dimming of any light will

61 The warm sunshine on the child's face contrasts well with the cold, blue of the snow.

62 Studio representation of strong sunlight outdoors.

63 Overcast day; strong colour, even in shaded areas.

alter its colour, making it warmer, until it becomes badly out of balance with the film in use. However, you will discover that, in order to control the spread of colour, as mentioned above, the degree of dimming is too slight to affect the colour temperature of the light.

A soft, overall illumination can be obtained by bouncing light off reflectors. These may be made of aluminium foil (dull side) or pure white paper, stretched over a 1 x 0.5m (3 x 2ft) piece of hardboard.

A reflector made of bright coloured paper

64 Felicity. A dark blue background accords well with the dark dress and centres attention on the light area, the face and blonde curls.

could be useful for certain effects – when an overall colour cast is required.

Colour film material

Before considering the control of colour by means of exposure, it would be as well to give a little thought to the colour film material we need to use. There are two main types of colour film:

1 Reversal which produces positive transparen-cies by a single process of reversal during development: and

2 Negative film, requiring processing to a negative and then subsequent printing.

Prints can be made from a colour transparency with excellent results but are more expensive than those from negative film unless you process your own.

Both reversal and negative colour films are available in versions designed to give good colour rendition when exposed by daylight (Type A) and others for exposure by artificial light (tungsten). (For this purpose, flash may be categorized as similar to daylight, requiring Type A film.) As extremes in exposure time given can also affect colour rendering some films are designated as suitable for short exposures, Type S (eg, less than $1/15$ sec) and others for long exposures Type L (eg: longer than $1/15$).

Between the relatively bluish light of a noonday sky and the yellowishness of, say, a candle flame, lies a wide variety of qualities of light which may be categorized as ranging from 'cold' to 'warm' and, according to their blue or red content, may be calibrated on a scale of units known as Kelvins – the so-called colour temperature scale.

If a film designed or 'balanced' for daylight were used with our unsuitable light source (such as one of those on the lower end of the colour temperature scale) the resulting pictures would exhibit an overall yellow-orange cast. Conversely, a film balanced for say, photographic lamps when used in daylight would produce results with a strong blue cast overall. Subject to certain practicable limits, adjustments can be made where necessary between film and light source by means of a filter placed either over the light source or, more usually over the camera lens.

Colour temperature of light sources

Source	Colour temperature in Kelvins (K)	Mired
North sky, blue	10,000–20,000	6–4
Mean noon sun	5,000–6,000	20–17
Electronic flash	4,800–6,800	21–15
Fluorescent daylight tubes	4,800	21
Fluorescent warm white tubes	3,700	27
Overrun lamps photoflood	3,400	29
Overrun 500 W tungsten	3,200	31
100 W household lamp	2,850	35
60 W household lamp	2800	36
Candle flame	1,500	66

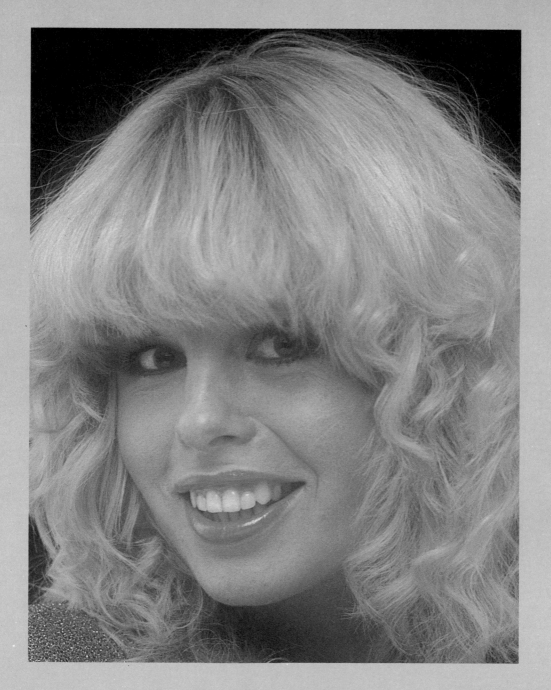

65 The colouring of the subject as the theme of a picture. The effect is enhanced by very slight diffusion; the highlights are spread into the areas of shadow and soften the borders of contrasting tones.

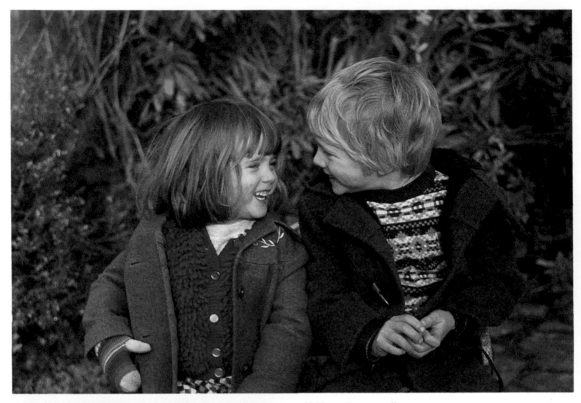

66 Natural surroundings can provide pleasing backgrounds for portraits, particularly if they suggest a sense of space beyond the subject and are free of obtrusive detail.

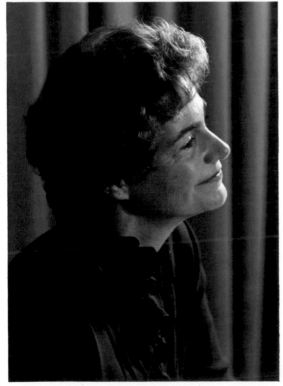

Use of filters

It is as well to remember that the film which is correctly balanced for the light source in use, will always give a better colour rendering than the wrong type corrected by means of a filter. Nevertheless, there are times when it becomes necessary, for example, to use a daylight film with artificial light, or vice versa, to use artificial light film in daylight.

Unfortunately, the Kelvin scale, not being a linear one, has practical shortcomings. A filter will produce a different change in colour temperature

67 Home surroundings can be filled with distracting details. Here, the folds of a curtain, though varied in tone, do not break the profile of the subject.

68 An aggressive background may be incorporated with the subject – overall diffusion adds to the ritzy effect without loss of colour.

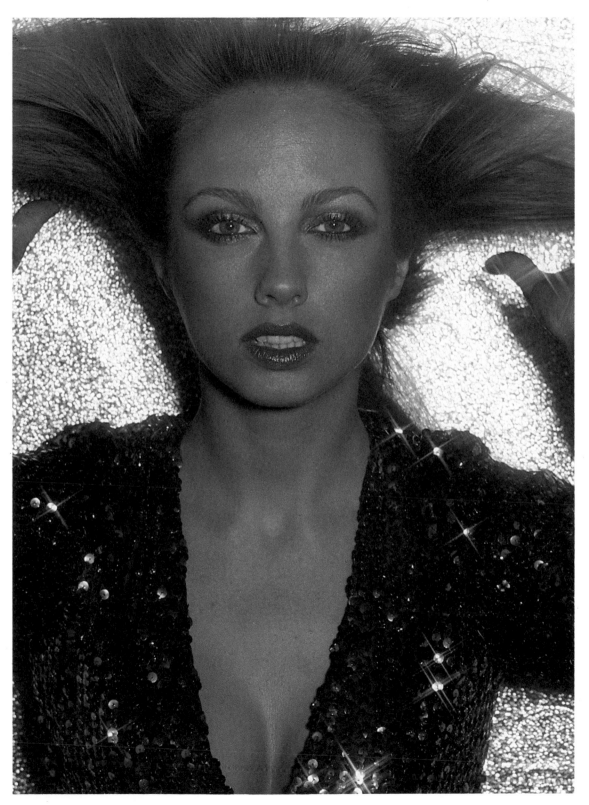

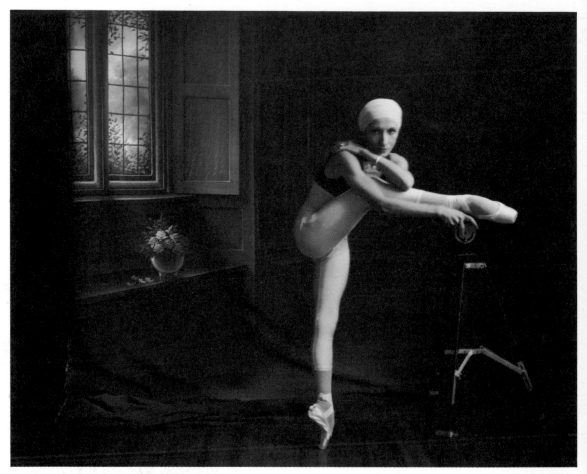

69 Natalia Makarova. An exposure lasting several seconds, against a Victorian portrait studio background cloth. The print was selenium-toned – selectively, to suggest 'daylight' through the 'window' in the background, perhaps with more from another window falling on the subject herself.

at different places on the scale. A more convenient system (mireds), calculated from the colour temperature thus:

$$\text{Mired value} = \frac{1,000,000}{K}$$

produces a scale of values representing regular differences in red content. Thus it becomes possible to assign to each filter a change in mired value that the filter can effect at any point on the scale. The amount by which the filter changes the colour is known as the *mired shift*. The yellow/orange filters which lower the colour temperature (and thus *raise* the mired value) are given positive values (+); bluish filters, which raise the colour temperature (and thus *lower* the mired value) are assigned negative values (−). The mired system or *decamired* scale (mireds divided by 10 for convenient calculation) may be used to classify the colour temperature value of light sources, film or filters.

The decamired value of the particular light source is shown in the last column of the colour temperature table. The decamired values of certain colour films are, for example:

Type S	(daylight)	decamired value 18
Type L	(tungsten) (3,200K)	decamired value 31

To find the correct light balancing filter, it is only necessary to calculate the difference between the decamired value of the film you wish to use and of the type of light in which you wish to use it. The resulting figure is the decamired value of the filter required. If the light has a higher number

than that of the film, you need a blue filter and if lower than that of the film, you need a yellow-orange filter. The decamired values give the correct filter densities. The filters are usually pale in colour, some appearing almost colourless, unlike those used for black-and-white photography, which have strong saturated colours. All filters require a certain increase in exposure, usually between ½ to 1½ stops. Two or more filters can be combined to give approximately the right value if the correct one is unavailable.

The colour of direct light is always that of its source but reflected or filtered light changes with the colour of reflector or filter. It follows that the colour temperature of the light source can be increased or decreased by filtering the light through blue or yellow-orange gelatin sheets or 'gels' but it must be remembered that all the lamps in use at any one time should be of the same colour temperature.

Filtering light through colour gels is a most useful method of creating effective backgrounds, which play an important part in any portrait but perhaps more so in colour than in black-and-white.

Backgrounds

An unlit background appears dead, and the subject is made to look static. Coloured background paper can be used but it is difficult to retain a sufficient variety of colours to suit every picture, or to control the light and shade on it. A more comprehensive and satisfactory way is to have three rolls of background paper – one each of black, white and grey, together with a variety of pieces of coloured gelatin for use over the background lights.

Black background

Any colour, seen against black, will appear more saturated and luxurious, and in a transparency more brilliant and luminous. It is most effective for low key subjects and subjects containing only one strong colour. This background lends itself well to the addition of colour by passing light through a selected piece of colour gel.

White background

White, being a mixture of all colours, appears to reduce the intensity of each separate colour when used as a background in a transparency. It also attracts attention to itself by its brightness, which again, weakens the picture. A glow of col-

oured light can be produced by the coloured gelatin, which will enhance instead of weaken the colours of the subject. If a mixture of colours is required on the background, a separate light for each colour must be used. This will add one colour to the other on the white background paper. In a colour print white is seen to be 'white' as opposed to 'bright', and therefore will not weaken the colours as it does in a transparency. Instead, it makes them appear more saturated and isolated, more clear cut and emotionless.

Grey background

Grey is neutral colour and will quieten or tone down any colour that is mixed with it. Grey paper, then, is very useful as a background because it does not draw attention to itself. Light of the required colour can be directed on it where necessary in the same manner as that described above. By this means the interest is centred on the subject and the softly echoing light on the background lends harmony to the theme of the picture.

As a precaution, all other lights are switched off while the background light is being positioned. This insures against the risk of unwanted coloured light straying across the subject's face.

Exposing for colour

In some respects the exposure calculations for a colour film are simpler than those for black-and-white. Correct exposure is essential in the case of a *reversal film*. With a maximum contrast range of 8–1 (three stops' difference if measured with an exposure meter) the control comes mainly in the arrangement of the colours and keeping them within the contrast range of the film. Remember that the positive transparency will be viewed by transmitted light and that overexposure renders the picture pale and weak – sometimes almost completely drained of any colour. It is much safer to err on the side of underexposure than over. Keeping the colour contrast low will give more latitude in exposure. For certain subjects we may wish the colours to be rendered darker in tone than the normal 'correct' exposure would reproduce them. Reducing the lens aperture by ½-1 stop achieves this. Alternatively, opening the lens aperture by a ½ stop will desaturate the colours more than average. The suggestion of only ½ stop in this direction is because the lighter colours in the picture so quickly lose their delicacy of tone. In measuring the contrast, always ignore both

black and white – you cannot underexpose black nor overexpose white in a reversal film. At times it may be possible to substitute black for a dark colour. This would give a much brighter effect allowing the exposure to be calculated for the light colours, ignoring the dark.

Colour negative film has more exposure latitude than that of the reversal, partly because slight errors in exposure can be rectified at the printing stage. The film has a contrast range of 16-1, or four stops, if measured by an exposure meter. If contrast cannot be reduced by adding or subtracting light, the exposure should be measured for the shadow areas, as for black-and-white film. The highlights may lose a bit but at least the shadows will retain colour and detail. If a compromise were made and an exposure given between the two, neither the light tones nor the dark areas would be correct, making the whole unsatisfactory. When in doubt, it is better with this film to err towards slight overexposure rather than under.

Exposure calculation can be executed in the same way as described previously for black-and-white films. The main difference is that when a white card is used, the reading is multiplied by a factor of 5 – or, alternatively the film speed divided by 5, resulting in only one adjustment for the whole film. This gives the correct average colour density, and controls for darker or lighter results can be applied as described above.

Control by composition of colour

If our picture is to be a sincere attempt at conveying a definite message graphically we must arrange the colours with equal care to that lavished on the differing tones in a black-and-white photograph. The fundamental requirements are similar to those for any other art form – ie, a knowledge of the techniques which will satisfactorily reproduce a preconceived idea in the mind of the artist.

We can aim at simplicity or chaos, harmony or discord, surface or depth, brilliance or dullness, hardness or softness, strength or delicacy, etc. The themes are endless but so are the mixtures of colours from which we can choose the most suitable to convey our meaning.

Let us have a quick look at some of the ideas that have been suggested and consider how we may express them in terms of colour.

Simplicity. Simplicity can be created by monochrome, that is, by using one colour on its own, in varying shades, composed if desired with black and/or white. Alternatively, a certain colour composed with one or two of its related colours can be the main theme and a very small area of contrasting colour used for emphasis. Lighting, whether provided by spotlight or flood, diffused or reflected illumination, should be simple but effective.

Chaos. All strong colours in close proximity, in various jagged shapes and opposing sizes, help to achieve a feeling of chaos. Colours are separated one from the other rather than blended. Lighting is strong, directional and precise as even chaos must be ordered to appear chaotic! A wide lens aperture is used to allow differential focusing. A confused background containing a few blobs of opposing colour, especially red, appears very discordant when out of focus.

Harmony. Harmony, as opposed to discord, is produced when either one colour is used alone in varying shades or when several related colours are intermingled. The colours are blended together rather than separated. Any repetition of coloured shapes should appear progressively lighter in shade as they decrease in size. Colours between the blue-green and the yellow-red on the colour wheel merge together naturally and, in their darker tones, are soft and restful. The colder colours on the opposite side of the wheel will also blend harmoniously if the colours are muted to soften their somewhat harsh characteristics.

Soft lighting and differential focusing allow the colours to blend more easily but care must be taken to ensure that the background contains no distracting colour.

Discord. The use of equal areas of highly saturated unrelated colours in close proximity produces discord. Harsh lighting and sharp focus intensify the feeling.

Surface and depth. These can be taken together because either is obtained by a careful balancing of the warm, advancing colours with the cold, receding ones. The fact that the colour which advances most is red and the one most prone to recede is blue, suggests that the greatest possible feeling of depth will arise by placing a highly saturated red subject against a desaturated blue background, while a highly saturated blue subject against a desaturated red background will tend to be static.

Depth is easily obtained by placing any highly-saturated colour against a colder, more desaturated one. When, however, the subject is a highly saturated blue – which is the coldest colour –

depth can be achieved by making a background of progressively desaturated shades of blue or black.

Brilliance. All colours show their greatest brilliance when highly saturated, sharply focused and lit by undiffused directional light. The brilliance is intensified when seen against a black background in a transparency but it is a white background which gives impact to the brilliant colours in a print.

Red, by nature, is the most brilliant colour, closely followed by its relatives red-purple and red-yellow.

Dullness. Colours are only dull if they are muted with grey, or are dark in shade and unrelieved by any lighter shade of the same, or contrasting, colour.

Any dark shade of colour gives a subdued effect, but particularly those colours related to blue – blue-green and blue-purple – the opposite colours to those which give the greatest brilliance. Diffused flood lighting, or reflected light on dark colours, helps to create a cheerless mood. Dullness, however, should not be confused with 'softness' (see below).

Hardness. Most colours are said to be 'hard' when they have a bright, metallic appearance but red is the colour we associate more often with a hard temperament. A large area of highly saturated colour, in critically sharp focus, spotlit and contrasted against a large area of equally strong contrasting colour, such as blue, will make the red appear hard and emotionless.

The warm red-yellows, yellows and greens should not be used, as hardness is contrary to their nature.

Softness. All too often colours are used in their strong shades and sharply focused to intensify their brilliance. By so doing the emotional and mysterious mood is overlooked; the beauty of 'softness' is particularly suitable when applied in pictures of young women and children.

Any chosen colours can be used, either desaturated or in dark shades, according to the desired mood of the picture. In both cases the colours should be related to one another and should blend together harmoniously. Diffused or reflected light heightens the effect and so, too, does slightly soft definition.

Strength. The deeper shades of colour give a feeling of strength and power, particularly if they are composed with black. Small areas of light colour are needed for contrast and for these it is better to substitute white for colour to allow for the correct exposure of the dark tones. Pictures composed of only one strong colour with black and white, are very effective and certainly powerful in their simplicity.

By closing the lens aperture by a ½ stop you can strengthen the colours somewhat.

Delicacy. Desaturated colours are preferable to characterize a dainty, sensitive nature. Compositions can be made of the triangular combinations (on the colour wheel) of contrasting or harmonizing colours but all the shades of colour used are of a similar desaturated quality. A picture may be soft or hard, simple or chaotic, have surface or depth, be brilliant or dull, etc, meanwhile maintaining its delicate nature. The feeling is conveyed by the colours themselves as well as their arrangement. If you can imagine compositions of colours such as **1** pink, grey and white, **2** mauve-pink, pale green and white, **3** yellow, brown and white, **4** mauve, orange and white, **5** blue, mauve-pink and white, etc, you will agree that each conjures up in your mind a picture of delicacy. You will also realize that each composition contains white. In the same way that black adds strength to a composition of highly saturated colours, so white adds delicacy to one of paler colours.

As we have said, the themes are endless but these suggestions may be a starting point for your own adventures in the control of colour.

To gain a deeper knowledge of colour, it is a good plan to train yourself to *see* colour, wherever and whenever you can. One source of study is the advertisement on the hoarding, or in the magazine; another is the illustration in a book – photographic or otherwise. If you: **1** analyse the colour combinations in each case, **2** assess your emotions regarding them, **3** try to discover the underlying reason for the selection and arrangement of the colours, and **4** imagine your attempt at conveying a similar message by a different composition you will learn to understand the use of colour far more quickly than by merely reading about it. Train yourself also to become aware of the colours worn by individual people, the colours in which their homes are decorated and furnished and endeavour to connect these colours and shades of colour with some of the known or imagined visible characteristics of the owner.

We, as individuals, must assess our own response to colour and not rely on what others say. The response to colour is as individual as personality.

15 ENLARGING TECHNIQUES

We must now study ways of reproducing the selected character traits on photographic paper, using any of the enlarging techniques which seem to be appropriate. Here, the darkroom work becomes exciting and original. Only the photographer who has taken the picture can really know the type of personality he is trying to portray. The subtle differences in contrast, in depth of tone, in surface texture and in colour all play a part in defining character.

Selecting the negative
Perhaps the selection of the negative is more important than any other stage. It is always a temptation to glance through a strip of film and select one that looks the best. This practice may be satisfactory in landscape or still-life photography but is of little use in portraiture. The almost imperceptible differences of expression, impossible to see on the negative, only become visible in the print. The wisest procedure is to:

1 Make contact prints of the whole film. These can be produced in one strip, if preferred, as the correct exposure for each separate film is not so important at this stage.
2 From the strip of contact prints select the few most successful for enlarging.
3 Study the selected prints and, with the help of a mask made from two L-shaped pieces of card, decide on the tilt and the shape most suitable for the mood of the picture. Outline the area to be printed with pen or pencil.

If you find it easier, you could make an enlarged print of the whole of the selected frame and mark the correct trim on that. The larger print makes it easier to decide which printing controls are necessary. By drawing on the print itself or by sketching on the back of the print, determine the areas to be controlled, either by shading-in or holding back. This is the time to decide on the aim of the finished print and to make a note of the appropriate technique to be used.

The enlarger
What concerns us most about the enlarger is the type of illumination and the effect this has on the quality of the print.

Broadly speaking, there are three types of enlarger illumination system: condenser, diffuser and cold cathode (fluorescent). Of the three, the condenser system, which focuses the light source in the lens, gives the greatest contrast from the negative. Diffuser enlargers, which give much softer illumination, require a black-and-white negative of higher contrast in order to produce a similar print (on the same contrast grade of paper) to that made with the condenser type. (Colour film, with its non-light-scattering dye image does not suffer the same loss of contrast.) Exposed black-and-white film, therefore, should be processed to provide a contrast that suits the type of enlarger illuminant to be used. Cold cathode enlargers, though producing a highly actinic diffused source are suitable only for black-and-white work.

For the practices that follow, I have assumed that we have at our disposal a condenser type as well as a diffuser or cold cathode type (or a condenser enlarger with the option of inserting a diffusing plate in the light path). We are, therefore,

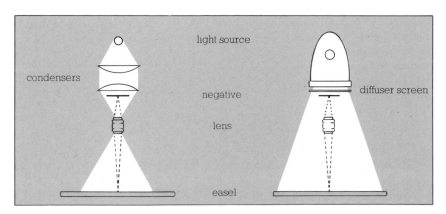

15.1 The light source in the condenser enlarger is focused on to the enlarging lens. In the diffuser enlarger, the negative is illuminated by a diffuse light source. Most enlargers have characteristics of both systems.

light source

condensers

negative

lens

diffuser screen

easel

able to make use of the enlarger as another tool for defining character. The greater brilliance and clarity of the condenser enlarger will convey the feeling of vigour and vitality, as opposed to the quieter more gentle rendering of the diffused source. All character lines will be more clearly defined on a print made by the condenser system. In the (nowadays rather infrequent) event that retouching has been done on the negative, this work is less likely to show on the print if the cold cathode or diffuser illumination system is used.

While on the subject of enlargers it is appropriate to mention here a few routines which help maintain good print quality.

1 Keep the enlarger covered at all times when not in use to keep out dust.
2 Clean the two glass plates in the negative carrier with an anti-static cloth and the lens with a lens tissue or brush before commencing work.
3 Make a mask to fit the negative area to be enlarged, to prevent any unwanted light from reaching the printing paper.
4 If the enlarger has chromium columns, shield them with black paper or card to prevent light being reflected from them onto the printing paper (enlargers with matt-black fittings are preferable).
5 Check for any stray light issuing from the enlarger lamphouse or from any source in the darkroom.
6 Make various sizes of oval, square and circular shapes from strong black paper, and fix these to 30cm (12in) lengths of thin wire with pieces of black adhesive tape covering the incision holes in the paper. Small lumps of modelling clay on the end of thin wire are also useful. These are to be used for control in printing.
7 Cut out some large pieces of black card and make a hole of varying shape and size in each, just off-centre. If preferred, two cards only need be used – one being placed over the other to vary the size of the hole.

Focusing

A focusing magnifier is most useful, especially one which focuses on the grain structure of the film. This is most effective when the negative has slightly soft focus or when the projected image is too dark to be seen clearly. If no such magnifier is to hand, the simplest way to adjust the final focus is to replace the negative in the carrier with an old one, which has been deliberately scratched. Focus on the scratches (eg, where two scratches cross) and replace the original negative, with great care, to avoid any further movement. It is advisable to set the lens aperture before focusing and lock any adjustment that can be locked.

Paper

We now come to the point where we must choose the most suitable printing paper. To begin with, we will discuss some of the types of paper available and then look at the value of each in reinforcing a mood or facet of character. We are concerned here with black-and-white paper and techniques insofar as they interest the portrait photographer. Colour printing techniques which are beyond the scope of the present work, are described in detail in the companion volume *Colour Printing in Practice.*

15.2 Colour enlarger. 1 Colour head 2 Reversible illumination system for condenser or diffuse illumination 3 Filter controls 4 Negative carrier 5 Focus control 6 Vertical column with offset base 7 Scale 8 Transformer 9 Probe 10 Colour assessment system.

Initially, it is better to select a certain make of paper and use it strictly according to the manufacturer's instructions until its peculiarities are well understood, rather than to switch from one make to another. It takes time and much practice to know how to get the best out of each type of paper, and it is unfair to judge between them without sufficient practical knowledge.

Although the choice of printing papers is by no means as great today as it once was, there is still quite a selection available, and this choice is widening with the resurgence of interest in fine printing and older or traditional processes. Two main paper types for use in enlarging are, 1 bromide paper with its clean, cold-black image, and 2 warm-toned (chloro-bromide) paper whose eventual colour depends on exposure and choice of developer and developing technique.

Bromide paper. This is a paper of high sensitivity with relatively little latitude in exposure time, giving pure black image tones and delicate rendering of detail. The rich quality of the blacks depends on the print being developed to finality. As exposure and development times are interrelated, the exposure should be such that the print is fully developed, typically, in 2-2½ min according to the developer and temperature combination. The rule is – minimum exposure for maximum development. (A fully developed bromide print can be toned to a rich sepia by use of the sulphide toning process, see page 138.)

Bromide paper is, characteristically, clean and crisp, owing to the clarity of the well-separated tones throughout the whole scale.

A portrait print using the top end of the scale only (eg, high key), will give an impression of lightness and delicacy but the cool colour of the greys tends to make it appear somewhat cold and detached.

The use of the full range of tones, from maximum black to maximum white could be said, perhaps, to imply the exact, the formal, or the scientific, while the lower end of the scale (eg, low key) may suggest more vigour and vitality, but the pure black tones lack the warmth usually associated with human beings.

Bromide paper is eminently suitable for presenting a portrait in only the two 'tones' of black, and white. Here the purity of the tones is essential and success lies in the correct exposure and development to obtain the maximum quality at both ends of the scale.

The two-tone portrait lacks intimacy but may be recognizably characteristic in costume, position, or mannerisms.

Warm tone paper. A warm tone paper (ie, a paper with significant chloride content) may be less light-sensitive than bromide but usually offers greater latitude in exposure time. The general rule here is for adequate exposure and minimum development. The development time is usually between one and two minutes, to obtain the normal warm black image colour. Prolonged development will make the tone progressively blacker and will eventually destroy the warm tone which is one of its chief characteristics. This paper is unsuitable for sepia toning by the sodium sulphide process but varying colours ranging from warm black to brown can be obtained by lengthening the exposure time and altering the constituents of the developer. Developer formulae will be given later in the chapter.

All warm tone prints look lighter under the safelight than they really are, so development must be stopped just before the desired depth of tone is reached. The prints, especially those done on the matt-surfaced paper, appear darker when dry than they do in the wet state. Allowance must be made for this too. A warm tone paper will also lose quality in the highlights if the print is left in the fixing solution for too long, indeed, all prints can suffer from over-fixing.

Some of the beauty of a warm tone paper lies in the rich, warm quality of the shadow areas. A glance at a density step-wedge shows that this type of material exhibits more distinctly separated tones at the lower end of the scale, thus making the paper suitable for low-key pictures having broad areas of dark tone. Warm tone is especially suitable for portraiture. It lends a naturalness to skin texture and to the personality as a whole. Any picture with large areas of light tone will have vitality and daintiness but will lack the crisp cleanness of a similar picture printed on bromide paper. The choice should be made according to the interpretation you wish to put on the subject.

Resin coated (RC papers)

This range of papers for a time replaced many of the fibre-based varieties. It is a completely different type of photographic paper. Being based on plastic material (polyethylene) instead of fibre (paper fibre with a gelatin-baryta coating) means that chemicals are not absorbed by the paper

itself, only the gelatin emulsion layer coated on its surface. Because processing chemicals are quickly absorbed and as quickly washed out, this allows considerable saving of time in processing, eg, for maximum quality a typical paper should be given an exposure which allows for full development in one minute at 20°C (68°F) followed by half a minute in a stop bath and 90 sec in fixer at 20°C (68°F). Washing takes only two minutes. The paper, obtainable in bromide and warm tone emulsions and both glossy and satin surfaces, dries quickly but at the same time remains perfectly flat. The glossy surface dries with a ready glazed finish. Careful adjustment of exposure and development will produce good quality tones throughout but overexposure or forced development tends to result in chemical fog. It is advisable always to read the maker's instructions carefully and follow them closely, otherwise you may not obtain the best quality.

On account of its speed, the RC range of papers is among the most popular but manufacturers still include many fibre based materials in their lists and have in fact, recently introduced improved versions of such papers.

One example of the RC range is Agfa Record Rapid.

The fibre-based bromide paper is the most suitable choice for sepia toning – a warm tone paper can only achieve brown tones by special development. Sepia toning, at one time a very popular process, is now enjoying a revival and details of these techniques will be found later in this chapter.

Paper surfaces

There are three main paper surfaces, produced by most manufacturers, which are of use to us as part of our technique: glossy, lustre and matt.

Glossy. The glossy surface reproduces the longest range of tones, especially when it is glazed. Because of the deep blacks it reproduces shadow detail better than any other surface. These deep blacks, contrasted with pure whites, give great impact to any print. A glossy print is always used (though not always glazed) for reproduction purposes. The glossy surface will emphasize grain, scratches, retouching marks and any blemishes.

Lustre. As its name implies, this paper has a slightly rough lustre surface. It is not a smooth surface such as a glossy or semi-matt, but it has a sheen, which gives it a good reflective quality. A lustre surface tends to hide the image graininess in the print, and absorb some of the marks and blemishes.

Matt. A matt surface does not have a long contrast range. It is more inclined to absorb light than to reflect it. For this reason a wet matt print will show well-separated black tones, but when dry some of the darker tones tend to merge into one another. A matt print is easier to retouch without showing obvious signs of handwork.

Unless a print is especially required for reproduction the paper surface should be chosen according to the character of the person, or the particular mood we are trying to convey. If we consider a glossy surface to have not only impact but a clean, vibrant, strong, arrogant and even flamboyant nature, we shall begin to understand how we can use a paper surface as a technique for portraying character.

A lustre paper perhaps, represents a good average. It does not appear as forceful as the glossy but is much more 'direct' than the matt surface. It has a cheerful simplicity, but no very great depth. For the latter property we turn to the matt surface, especially when used for a low key portrait. There is a serenity, a mystery, an unassuming power suggested by this surface and the harmony is maintained throughout its tones. We shall be applying this technique in a practical way at a later stage.

Paper grade

Paper manufacturers have tried to ensure a good quality print from each negative contrast by supplying paper in several different contrast grades, extending from 'soft' through 'normal' to 'hard'. It would seem that the choice of paper grade for a particular negative should be a simple matter. But this is not so.

It is true that a negative which appears thin and flat requires a hard paper to produce as much contrast as possible from it and that a strong, high contrast negative needs a soft paper to shorten the tonal scale. But in this calculation we have omitted the essential factor – the subject matter itself.

Some photographers have a habit of producing portraits in, almost, the two tones of black and white. These may be critically sharp, very blurred or with exaggerated grain. Many of the pictures are produced in this style for a purpose. The particular technique is chosen as a means of expression but some are similarly produced merely for impact and in this case, the photographer has pro-

jected his own image rather than that of his subject.

If we are concerned with the expression of personality, character, or mood as the subject of our picture, our choice of paper grade should be one which will convey this to the best advantage.

Let us consider the apparent qualities inherent in the two opposing grades of paper, hard and soft, when used in conjunction with a normal negative.

Hard paper. A hard paper, paired with a normal negative, will emphasize the sterner qualities within the subject. It may suggest a dynamic, forceful personality, or a person with a strong, powerful physique. It can also indicate a cold, aloof, temperament.

Pairing a hard paper with a negative already strong in contrast will emphasize these characteristics to an even greater degree, possibly to the point when they can no longer be termed true. Even if the picture gains attention because of this, it has lost all trace of its communicative power.

It is occasionally possible that the use of a hard paper with a normal negative will transform a picture of a rather colourless personality into one that is far more alert and exciting.

Soft paper. The soft grade of paper, when paired with a normal negative, has the opposite effect, placing, as it does, greater emphasis on the more gentle, quiet, thoughtful, benevolent characteristics.

We come to the conclusion, then, that both hard and soft grades of paper can be used, even with the same normal negative, to depict a differing mood or opposing character trait which, to some degree, is within every human being.

Tonal quality of print

As well as the character, or the particular mood, of our subject, we have to think of the tonal quality of the print we wish to produce. If the effect is to be in a delicate high key, a subject with a very short tonal range and with all the tones in the upper part of the scale, the print must be made on a soft grade of paper – a paper which is incapable of producing very deep blacks. The more ethereal we want the picture to be, the softer must be the tonal quality.

A print that is required to have the full tonal range – from paper base highlights to rich black shadows with as many intermediate tones as possible, must be printed on a normal paper – a paper which can produce a full range of tones.

At the other end of the scale we have the low key print, in which the subject contains large areas of dark tone. Our choice for this will be the hard grade of paper, because the greatest number of separated tones are at the lower end of the scale, finishing with a deep black.

To prove this for yourself it is a simple matter to make a step-wedge from three grades of paper, normal, hard and soft, from which you can see at a glance the particular paper's surface, grade and tonal distribution. For reference purposes, make a note of the exposure required to produce the first tone. Ensure correct time and temperature for development, according to the manufacturer's instructions.

Step-wedge comparisons

Normal bromide. The step-wedge made from the normal grade of bromide paper shows an equal distribution of tones throughout. This paper, if

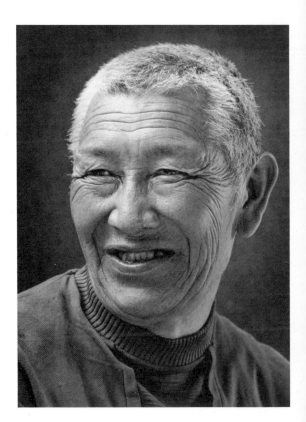

70 Bonomie. Maximum tonal quality in the print is achieved by a controlled process of exposure and development to produce a negative that is ideally matched to the (known) enlarger light source and paper characteristics.

used with an average negative, produces a print having a full range of tones from black to white.

Hard bromide. The hard grade of bromide paper has a shorter tonal scale than the normal. The intermediate tones are missing, making the step between each tone much steeper. The majority of separated tones are made up from dark greys. For this reason a hard paper is usually the more suitable for a low key picture having large areas of dark tone.

Soft bromide. The soft grade of bromide paper has a longer tonal scale than the normal – easily visible from the step-wedge. The steps are shallow, giving a greater number of intermediate tones – the majority of which are at the light end. This means that the soft paper will be the more suitable for all prints of a subject that is predominantly light in tone, such as a high-key subject.

Good print quality depends on the correct coupling of exposure with development. A fibre-based bromide paper is fast in exposure time, slower in development, but requires minimum exposure to reach maximum development in 2½ min at 20°C (68°F). Bromide and warm tone RC papers are also rapid in exposing and require the exposure to be so arranged that the print is fully developed after one minute at 20°C. The fibre-based warm tone paper, having a somewhat slower emulsion speed, requires a longer exposure and shorter development time compared with bromide. Generally speaking, the longer the development time the blacker the image, the characteristic warm tone being obtained by adequate exposure and the developing time not exceeding 2½ min at 20°C. Warmer temperatures will produce warmer tones.

Test strips

The method of making a test strip is the same whatever the make or type of paper.

Take a strip of paper, not necessarily very wide, but long enough to cross a portion of the background, the face – including one eye – and the clothes. This should encompass a sample of both the lightest and darkest tones. Expose this strip for 2, 4, 8, 16 and 32 sec, and develop for the time specified by the manufacturer. This strip provides a guide to the approximate exposure. Taking this to be, for example, 8 sec, make five further tests, each on a separate strip of paper, exposing each successively over the same portion, for 6, 7, 8, 9, 10 sec. Mark the time given on the back of

each piece and develop all together for the same time as before. From these, a truer estimate of exposure can be made and the amount of control required may be determined.

The solutions should remain at a constant temperature – 20°C (68°F) is a safe average. Hydroquinone, the chemical responsible for making good black tones in a print, will not work at all at temperatures below 13°C (55°F).

For a bromide print the recommended working temperature is 20°–21°C (68°–70°F) maximum.

For warm tone papers there is more latitude in the selected temperature but it must remain constant throughout the process. A temperature of between 21° and 23°C (70°F and 75°F) will ensure a warm image tone but the method makes it difficult to transfer the print from developer to stop bath at precisely the correct moment and even 1 or 2 sec error, either way, can be enough to spoil the print. It is safer to keep the solutions at 20°C (68°F) and to control the warmth of the image tone by giving increased exposure time and by developing for 1½ min.

Stop bath

It is not essential to use a stop bath for a bromide print to 'arrest development', though it is useful for conserving the fixing bath, especially with 'rapid' fixers. A warm tone paper, however, depends on the stop bath to terminate the development.

Controls in enlarging

Quite a number of controls can be used during the enlarging process to emphasize or minimize certain characteristics. For areas that are too light or too dark in tone, a piece of card can be placed in the enlarger beam to shade some parts of the picture and give greater exposure time to others. If it is kept in constant motion, it is possible to avoid any clearly defined edge appearing between areas that receive different exposure times. By darkening corners and edges of the print attention can be directed to the face – although this effect should be very subtle.

To darken an area where there is unwanted detail, it is often more satisfactory simply to fog the print. To do this, make the main exposure first, attending to the control of small areas such as 'holding back' (shielding light from) the hair, or printing the hands darker, etc (ie, 'printing in'). Then proceed in the following manner: Stop the lens down to the smallest aperture but one, turn off the enlarger light, remove the negative from the

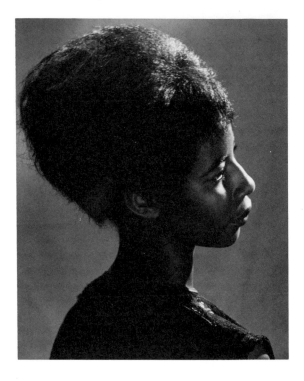

71 Jamaican girl. Rim lighting with weak reflected light from the front – a negative that calls for very carefully controlled printing to retain this distinction.

exposure to soften the image outlines but this does nothing towards the characterization of the subject.

A fine mesh screen placed half-way between the lens and the paper for the duration of the exposure will soften the contrast of a print by adding tone to the highlights. In so doing, it adds tone to the whole print, dark areas as well as light and removes the subtle intermediate tones from the dark areas. This technique, then, is useful for reducing the contrast in an averagely-toned subject, or in one that is predominantly light in tone but is unsatisfactory for a print with broad areas of dark tone.

A screen of tissue paper, draughting film, finely woven material, or anything of a similar nature, can be placed in contact with the paper to give various results.

The beauty of a picture treated in this way depends on the material used for the screen. Too coarse a texture, if placed in contact with the paper, will supplant the portrait by its own image. A piece of fine white material will give a very different result from a similar piece of black. It is worth experimenting with different screens in order to discover the one most suitable for the particular subject.

To make an experiment with the use of screens, select a portrait you have taken of someone that you really know something about. For an example I have chosen the late Frank Tyler FSA, FSG, Fellow of the Society of Antiquaries and Genealogists. A great proportion of his spare time was spent in studying and investigating the past.

He was a quiet, retiring, kindly and trustworthy personality, exuding a vital interest in his work, yet apparently having a deep inner serenity which enabled him to relax at will.

What techniques shall we employ to give as true a picture as possible of this man as a genealogist of the calibre described? The low key effect has been used when taking the picture to express thoughtfulness and serenity and the inclusion of books suggests the background of a study. It is left to us now to choose the style of printing. A hard grade paper, which would be the choice for large areas of dark tone, might imply a clever man in his field of work – which he was – but also an unapproachable person – which he certainly was not. An ordinary print on soft paper would not show sufficient vitality. The use of a screen would add a distinctive touch to the picture and would also soften the tones. A piece of tissue paper is placed in contact with the printing

carrier (replace the carrier to prevent any light leakage and remove the orange cap). Having a piece of card held ready over the facial area and keeping it continually on the move, switch on the light for a predetermined exposure. The test strip to find the fog level of the paper and the time required to darken it to the required tone, should be made at the same time as the normal tests.

This darkening of extraneous highlights gives a sense of harmony to the picture as a whole, and concentrates attention on the essential elements.

There are times when we would like to add a distinctive touch to the picture in honour of the renowned personality we are portraying – or, perhaps, as a more pictorial way of describing particular achievements, occupations or hobbies.

Screens

One way to emphasize a certain quality in the subject is to place a diffusing screen between the lens and the printing paper during the whole, or a part of the exposure time.

A piece of nylon stocking, or similar material, can be positioned over the lens for a portion of the

paper emulsion for the duration of the exposure. The grainy effect is quite pleasing and could suggest an interest in old parchments but in the overall textured surface the dark tones have merged together, simplifying them to the point of monotony. A screen of white chiffon gives a very similar result but one of black chiffon, with double the exposure, gives a very different one. The dark tones are now well separated, and the rendering of the eyes exceptionally good, and the power of communication strong. The lengthening of the tonal scale throughout enhances the deep serenity which is so characteristic and the textured surface gives a distinctive finish.

The picture illustrating the experiment is made on bromide paper for reproduction but, pictorially, a warm toned hard grade of paper would give a greater degree of contrast, expressing the vitality and suiting the subject admirably.

A print with a difference

If you experiment with your printing in this way sometimes the result is just interesting and sometimes it has real pictorial potential. As an example (Fig 15.6, page 132) a straight print is given 2 sec exposure and full development on resin coated (RC) paper. The negative is then reversed in the enlarger carrier and a print made through the back of the paper. The exposure needed was 60 sec (ie x 30 that of the original). On single weight fibre-based paper the exposure would have been nearer 10 sec (x 5 the original). The soft result was appreciated by the model – in fact she preferred it.

In looking for something different in print making, you might try an effect such as the one illustrated. Success depends on finding the right material to use. Experiments with grains of rice and seed tapioca were disappointing because they are both opaque and uniform in size and shape. Flaked rice, on the other hand, has neither of these disadvantages. The flakes are translucent and vary in size and shape, which factors make an interesting effect.

The method is quite simple. Set up the enlarger as for a normal print and determine the exposure required by test strips. Place the sheet of sensitized paper on the baseboard. Keeping the red safety filter in the light path and switching off the darkroom safelight so that you can see the image

15.3 Frank Tyler. Lighting from window.

15.4 Black chiffon placed in contact with printing paper, during exposure, gives a distinctive finish to the portrait.

15.5 A print with a difference. Straight print on resin coated paper.

15.6 The negative is reversed in the enlarger and a print made through the back of the paper. Standard exposure x30.

15.7 Fun in the darkroom. The design is achieved by scattering flaked rice on the printing paper just prior to exposure.

more clearly, sprinkle the flaked rice over the paper, leaving the face and part of the hands free. Expose and develop as usual. Whereas it would be difficult to get two prints exactly the same, the slight variations make for greater interest.

The double image of profile and full face was visualized in the studio. The profile was taken first, back-lit to outline the features. Very little frontal light was used as the cheek area had to be clear in the negative. A full face position was then taken, the body being turned in a similar direction to the profile. The camera viewpoint is slightly lower and a little further from the model to give a smaller image. After development, the two negatives were bound together and printed as one.

A print from this double negative was now sol-arized and used as a paper negative from which a contact print was made. The process could be re-peated time and again to give surprising results.

Solarization can occur when a partially devel-oped print is briefly exposed to white light before completing development. Success is precarious. It depends on all the factors being right – ie, the in-itial exposure, the time of first development, the brief exposure to naked light and the subsequent development.

15.8 Double image. The profile was taken first. The full face was then produced on a second negative. Lastly the two negatives were bound together and printed as one.

15.9 A solarized print made, by contact, with **15.8.**

15.10 This is a contact print made from the solarized print **15.9.**

Taking each step in turn, the following may be found useful:

1 Determine the correct exposure for a normal print by test strips. (This exposure would be slightly increased, perhaps by 25 per cent for the print to be solarized.)
2 Develop until the blacks have just sufficient density to protect those parts from the effect of further exposure to light.
3 Expose print, still in the developing dish, to a naked light – the print illustrated was held at about

45cm (18in) under a low power household lamp for 1 sec.
4 Without further rocking, allow the print to remain in the developer until the desired image appears. Too long a time in the developer at this stage will result in overall blackness and the effect will be lost.

This solarized print can now be used as a negative to produce a positive by contact. If no printing frame is available, it is quite simple to use the enlarger. Raise the head to give the required image size, and focus to give sharp edges. Unless the baseboard is already black, it is advisable to cover it with black paper to prevent unwanted reflections. Place the printing paper emulsion side up and cover it with the solarized print, face down. To keep both in complete contact, cover with a large piece of glass – plate glass if possible. (Determine the exposure by test strips as usual.) To avoid any grain structure being visible in the paper negative, it is advisable to use a smooth, glossy RC paper.

You will, no doubt, realize that the profile position with the features clearly outlined by light, makes the more exciting effect. The choice of subject, then, is all-important and one of good design, having clear cut lines emphasized by light against dark, is likely to give the best result.

A paper negative can be the means of making a very distinctive portrait. As with solarization, success depends on the quality of the original. Choose a subject with lively lighting and of reasonable contrast and make a print, full of detail but not too dark, on RC bromide paper. Using the enlarger as described above, make a contact print from that. This becomes the negative from which the final print is made, by contact, but this time on warm tone paper. The distinctive quality of the print is obvious – in depth, colour and contrast but, above all, in what it confers on the subject. The effect is somewhat akin to the distinctive quality of a bromoil print but is created much more easily and cheaply. The speed with which the resin-coated papers can be processed makes the technique viable for portrait studios, where superior quality and technical excellence is of prime importance.

Paper negatives provide a quick method of making enlarged prints from colour transparencies. Project the transparency, reversed, through the enlarger to the required size and make a print in the usual way. This will be in the form of a nega-

15.11 Straight print on RC paper.

15.12 Paper negative made on RC paper.

15.13 Final print from paper negative. This is made on fibre-based paper.

tive from which a positive is made by contact. (Note, however that standard bromide and chlorobromide papers for black-and-white work do not respond to the full range of colours present in a transparency.)

Controls in print development

Let us now see if there are any ways in which we can control print production, as it passes through the processing stage.

Bromide paper. There is little that we can do during the development time for bromide paper, apart from assisting underexposed highlights to develop a little further by touching them with warm water or more concentrated developer. As we have already seen, bromide paper requires full and sufficient development to produce its best quality. No amount of control at the development stage will produce a print superior in quality to one that has been exposed correctly in every tone to allow development of each one to finality. We come back again to the realization that a good bromide print requires minimum *sufficient* exposure and maximum *sufficient* development.

There are times, however, when the result we are aiming for does not require any black tones, in fact the picture is to represent a mood, depicted in shades of white and grey. In this case we have a means of control that we can use for prints, although at one time it was more generally used for negative development. This control is known as water bath development.

For this control, a dish of plain water at the same temperature as the developer, is placed alongside the developing dish. The print is immersed in the developer for 30 sec, and then transferred to the water bath where it should remain, motionless, face down for a further 60 sec. This is repeated until the required depth of tone has been reached. The process allows for the highlight areas to continue developing after the shadows have exhausted the supply of developer, thereby producing a print with greatly reduced contrast.

A soft working developer can produce an extra soft result; alternatively a contrast developer will give a hard quality to the print. Apart from that, any controls when using bromide paper must be made during the exposure.

Warm tone paper. In warm tone paper the image colour can be varied during the development process from black to warm-black, brown-black, or even brown but, in most cases, extra exposure will be needed.

Three ways of doing this are as follows:

1 By diluting the developer with water. The

amount of dilution must be found by experiment, but if it is more than 2:1, a few drops of potassium bromide (10 per cent solution) should be added, together with a drop of anti-foggant. Extra exposure for the print will be needed and the development can be continued until the required tone is reached. This developer will soften the contrast in a print.

2 Extra potassium bromide can be added to the normal strength developer. Again, the amount must be found by experiment. The exposure of the print should be increased but the development time should not be prolonged.

3 A special low energy developer can be used. The image tone can be varied by straight development using D.163 for black tones, D.156 for warm-black and D.166 for brown-black.

Formulae for bromide and warm tone printing papers

Print developers may be purchased ready mixed, in powder or solution, for use with bromide or warm tone papers. Mixing your own chemicals, however, adds another dimension to the effects you can obtain.

The following formulae have been tested and found to be very useful.

D.165 Soft working developer for bromide papers

Reduces contrast by one grade of paper.	
Metol	6 g
Soda sulphite (anhyd)	25 g
Soda carbonate (anhyd)	37 g
Potassium bromide	1 g
Water to make	1000 ml

Dilute 1 + 3. Develop 1½-3 min at 20°C (68°F).

D.156 Soft working developer for warm tone papers

Metol	1.7 g
Soda sulphite (anhyd)	22 g
Hydroquinone	6.8 g
Soda carbonate (anhyd)	16 g
Potassium bromide	6.3 g
Water to make	1000 ml

Dilute 1 + 1. Develop 1½-2 min at 20°C (68°F).

Alternative formula without hydroquinone:

Metol	3 g
Soda sulphite (anhyd)	25 g
Soda carbonate (anhyd)	15 g
Potassium bromide	1 g
Water to make	1000 ml

D.72 Contrast developer for bromide papers

Metol	3.1 g
Soda sulphite (anhyd)	45 g
Hydroquinone	12 g
Soda carbonate (anhyd)	67.5 g
Potassium bromide	1.9 g
Water to make	1000 ml

Dilute 1 + 2. Develop 4 min at 20°C (68°F).

For increased contrast, dilute 1 + 1 and develop for not more than 4 min at 20°C (68°F).

D.163 Normal developer for bromide and warm tone papers

Metol	2.2 g
Hydroquinone	17 g
Soda sulphite (anhyd)	75 g
Soda carbonate (anhyd)	65 g
Potassium bromide	2.8 g
Water to make	1000 ml

Dilute 1 + 3. Develop 1½-2 min at 20°C (68°F).

Warmer tones on warm tone papers may be obtained with shorter development.

D.166 Warm tone developer for warm tone papers

Metol	1.15 g
Soda sulphite (anhyd)	25 g
Hydroquinone	8.5 g
Soda carbonate (anhyd)	25 g
Potassium bromide	12.5 g
Water to make	1000 ml

Dilute 1 + 3. Develop 2-3 min at 20°C (68°F).
First appearance of image 50 sec. Warmth of tone varied by increase or decrease of exposure and development.

For high or low key subjects, the exposure can be increased by two or three times and several drops of 10% potassium bromide added. A few drops of anti-foggant also will prevent tones becoming too brown. This is a very versatile developer for warm tone papers and is most exciting to use. Warm brown-black image tones with a wealth of inherent detail, can be obtained by increasing the exposure and diluting the developer – even as much as 1 + 6, and adding the extra bromide and 142. It is worth experimenting with this technique to produce rich quality. Increasing exposure and developer dilution will mean increasing developing time.

Aftertreatment of prints

Points to remember when developing prints are:

1 *Warm* tone prints appear lighter under the

normal safelight than they really are.

2 Allowance must be made for any print to darken slightly during the drying process. This is especially important for a matt-surfaced print, which reflects more light when wet than it does when dry.

A slightly over-dark print might benefit from a quick run through a reducing solution. For this purpose a 10 per cent solution of potassium ferricyanide and (in a separate large bottle) a 10 per cent solution of plain hypo should always be kept in the darkroom ready for use.

For overall lightening of a print, immerse the whole print in a dish containing some of the 10 per cent hypo solution, with one or two drops of the 10 per cent ferricyanide (the mixed solution should be a pale lemon colour). Rock the print for a few minutes and then transfer it to the washing tank for half an hour. A print that has been through a stop bath before fixing will take longer to respond to the ferricyanide treatment.

This process can be repeated if the print is still a little dark when dry but fresh solution must be used as the mixture lasts only a very short time.

A stronger solution of ferricyanide can be used to lighten small areas of light tone but care must be taken that the image is not completely removed, which can happen all too quickly. It is rarely satisfactory to try to lighten areas of dark tone by the same method. Unevenness of tone becomes visible in the dried print and the black is devoid of quality.

For small prints the quick run through a weak solution of ferricyanide is usually sufficient. As this works on the highlights first, the print should look brighter after treatment but the blacks should retain their quality.

Reducing a large print

Large prints often benefit from localized reduction – even very minute spots can be lightened with care and patience.

Let us 'reduce' a 40.6 x 50.8cm (16 x 20in) print in which there are some highlights lacking sufficient tone separation, some stray hairs over the forehead, a few blemishes on the skin, and the grey dress shows insufficient variety in tone.

We must first soak the print for 10-15 min to soften the emulsion, then blot off all the surplus water with a clean towel. The print is laid on a flat surface such as the underneath of a 40.6 x 50.8cm (16 x 20in) dish or a large enamelled tray (a butcher's tray, or any white enamelled metal sheet is admirable) and placed on the table at which we intend to work.

We have a large dish of water beside us (or a sink with running water), a little pot with a fairly strong solution of the ferricyanide mixture, some cotton wool and a spotting brush. We will cover the print with a smooth towel (except for the portion on which we are going to work). In one hand we hold a piece of cotton wool which has been wrung out in plain water and in the other hand the spotting brush or a small piece of cotton wool rolled round a matchstick (or a cotton bud). The spotting brush must, of course, be used for the major part of the work, the hairs and blemishes are too fine for the cotton wool.

Having dipped the brush in the 'ferri', we just touch the blemish, with the same movement used for ordinary retouching, and immediately wipe with the wet cotton wool in the other hand. This process is continued in quick succession, touch – wipe – until the required amount of work has been completed. At intervals we can immerse the whole print in water and then blot with the towel and continue. Keeping the print blotted prevents any solution from running down it, which could be disastrous. When the necessary reduction has been completed, the print must be washed in running water for half an hour. This process does take some time but is often well worthwhile.

Another print reducer which can be used is made, very simply, by adding some tincture of iodine to a tray of ordinary water. The dry print is placed in this solution and removed when the highlights take on a slightly blue tinge. A short soak in *plain* hypo removes the blue tone. The print should then be washed and dried as usual. Localized spots can be removed with the iodine in the same way as has been described with the 'ferri', with one difference – a piece of cotton wool wrung out in plain hypo must be used in place of the piece dampened with water.

Intensifying prints

A print that is a little too light when dry can be improved by intensification, provided that it has received sufficient exposure. In other words, if the print is underexposed, nothing can be done with it but if it is fully exposed and underdeveloped it can be improved.

72 Vietnamese boat refugee with child, Singapore; stark contrast, but with the shadow areas regulated to retain sufficient detail.

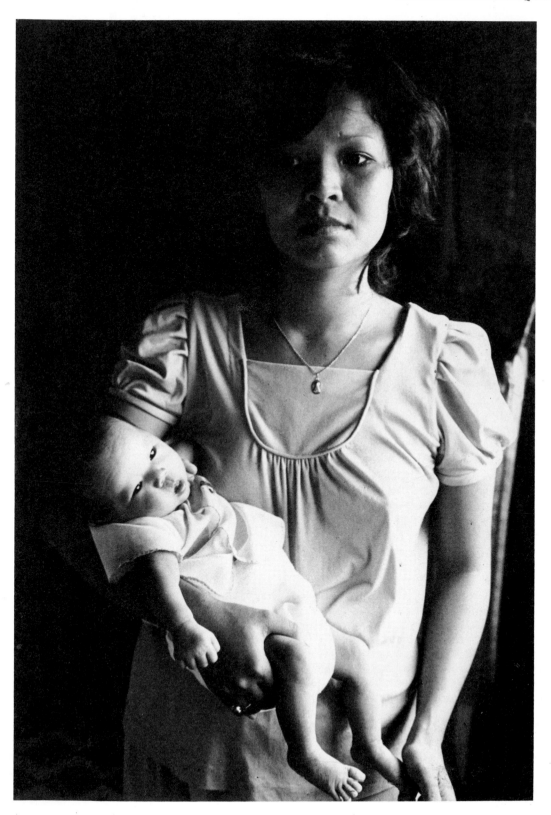

One method which gives slight intensification is to bleach the print in the bleaching formula used for sulphide toning and follow with a wash in running water for at least half an hour, and then to re-develop in an ordinary MQ print developer (not a warm tone developer).

For greater intensification, the chromium intensifier can be used very effectively, provided that sufficient washing time is given between bleaching and re-developing. The formula is made up in two parts:

Chromium intensifier: stock solutions

Solution A	Potassium bichromate	50 g
	Water to make	1000 ml
Solution B	Hydrochloric acid	50 g
	Water to make	1000 ml

The working solution is made up at the time of use as it does not keep. (Stock solutions keep indefinitely.)

Chromium intensifier: working solution

For Use	Solution A	100 g
	Solution B	200 g
	Water to make	1000 ml

If used for negatives this proportion gives only slight intensification but it is the most suitable for prints. It can, however, only be a guide, because the more acid that is added the less intensification results. For greater intensification use less acid.

Method. Bleach the print until the image is yellow-buff – there being no longer any black visible. The next stage is most important if the print is to be permanent and suffer no subsequent staining. Wash *well* in several changes of water and then immerse in one or two successive baths of a one per cent solution of potassium metabisulphite. Follow this with a brief wash and then expose the print, in the dish, to diffused daylight or strong artificial light for a few minutes. (I have found daylight out of doors and in the shade to be the most effective.) Finally re-develop in an MQ print developer – not a warm tone developer. Wash briefly and dry. The resulting print should have rich, warm-black tones.

The process may seem a trifle tedious, but is well worth trying on a large print, which would otherwise be useless. A print slightly grey in tone may have the colour much improved by using plenty of hydrochloric acid in the bleach. Printing paper is so expensive that few prints should be wasted when aftertreatment can save them.

Toning

Some photographs appear more characteristic if the prints are toned with sulphide or selenium especially if the model is auburn or brunette and wearing brown. It is possible to get three different colour tones from the use of sulphide – brown-black, warm-brown, or cold-brown. The brown-black is particularly useful if the model has very dark brown hair and is wearing pastel shades. The selenium tones to a beautiful purple-reddish-brown.

Sulphide toning

This is most suitable for bromide prints which must have been fully developed and washed completely free of hypo.

Stock bleaching solution

Potassium bromide	50 g
Potassium ferricyanide	100 g
Water to make	1000 ml

For use take 1 part of the stock solution to 9 parts of water. This solution will keep indefinitely if put in a dark bottle away from the light and can be used repeatedly until exhausted.

1 Soak the well-washed and dried bromide print for a few minutes to soften the gelatin and then bleach in the above solution until the image is pale yellow.
2 Rinse the bleached print in water for 1 min (longer washing will impair the tone).
3 Put the print in the sulphide solution where it will immediately darken to a sepia tone. When all action is complete transfer it to a washing tank.
4 Wash for half an hour.

Stock sulphide solution

Sodium sulphide (pure)	200 g
Water to make	1000 ml

For use take 3 parts of stock solution to 20 parts of water.

Discard the used solution immediately.

If a colder brown tone is preferred, the prepared print should be placed in the sulphide bath first for a few minutes. After a brief wash it is then bleached and toned in the manner already described.

Occasionally a print in which the deeper

shadows are more black than brown will give greater distinction. For this it is only necessary to remove the print from the bleaching bath before the dark tones have bleached out.

Sodium sulphide is not so easily obtained nowadays and, in any case, it is difficult to keep for any length of time. When its freshness wears off, it becomes watery and is unsuitable for use.

Barfen

Other chemicals for toning purposes are now being introduced. One that I have found to give good dark brown tones consistently is Barfen (distributed in the UK by Photocem Ltd). This has the added attraction of being satisfactory to use on both bromide and warm tone papers – the latter giving warmer tones. As with all toning processes, the image colour depends on the make and grade of paper used as well as the quality of the black print. There is no smell with this chemical, as there is with sodium sulphide and it can be kept and used in the darkroom without any fear of contaminating nearby sensitive materials. The method of use is similar to that described for sulphide toning. The print is first bleached until no black tones are visible. Then it is washed thoroughly and immersed in the toning solution until no further development takes place. It is finally washed and dried as usual.

Berg toners

The Berg range of toners, which also do not have an unpleasant smell, are suitable for use with any photographic paper material, resin coated or fibre based, and also with film. These are dyes rather than toners and are safe and easy to use.

The warm brown, or sepia tone, more generally used for portraiture, is obtained with a single bath solution. If the print is left for too long in the toning bath, it can be returned to its original black colour simply by re-developing it in an ordinary print developer. This suggests endless possibilities of obtaining prints of any colour you wish between black and brown, merely by returning the fully toned print to a diluted developing bath (diluted to prevent too fast a colour change) transferring the print to an acid stop bath as soon as the required colour is obtained. Do not use a fixing bath – simply wash and dry. A type of solarized image can be obtained by using the toning solution neat to get a copper tone but re-developing it in print developer before the copper tone becomes too dark. An endless variety of tones

can be produced by experimenting with different dilutions and lengths of time in each bath. The Berg Colour Tone single bath, produced by mixing two packages of solution, is obtainable in two different colours – brown-copper or brilliant blue. As with sulphide toning, the black-and-white print must be fully developed in fresh developer and fixed for the necessary time in a fresh fixing solution which does not contain any hardener. The 'no hardener' rule applies to any print which requires aftertreatment by chemical means. If the print has been subjected to hardener any image change will be produced with difficulty, if at all. Prints should be well washed after fixing and/or a hypo eliminator used. Resin coated (RC) papers are the quickest to use if time is short and will be more predictable in obtaining even tones and untinted highlights.

Before toning a large print, it is as well to tone a black-and-white exposure test strip first. Expose a large test strip, develop it fully, fix and wash correctly and then cut it into eight strips – each strip to include all the exposure segments. Leave one strip untoned and tone the rest for progressively longer times – the intervals being equal (as for the original exposure test strip). Wash and dry the pieces and carefully examine them to decide on the black and white exposure and the period needed in the toning solution. This may seem like a waste of time but, in the long run, it will not only save time, but money and nervous energy as well. The time during which the print is in the toning bath makes a great difference to the resulting image colour. Tones vary from a slight warming at 5-30 sec; through brown in ½ to 2 min; sepia in 2-6 min and copper in 6-15 min. For the intermediate brown-to-sepia tones it is advisable to dilute the stock solution 1:2 with water. As mentioned before, results can only be predicted if *no hardening fixer* has been used. After toning, the print should be thoroughly washed – resin coated papers for 5 min – all other papers and films for the normal wash time and, finally, dried at room temperature. Too much heat may impair the tone. This applies to the dry-mounting of the print as well – heat should not exceed 65°–82°C (150°–180°F). Films should be dried at room temperature.

Blue toner

There are times when a cold, rather than a warm tone suits the subject best. The choice will then be the one solution blue toner. Prints can be immersed in this bath for 1–10 min, during which

time the colour tone changes from a cold steel blue through to a rich royal. For a portrait, a slight blue tone to cool a high-key picture of a skier would be very effective, or a slightly darker blue tone could be added to a low key portrait of say, a miner or a steel worker. The use of all toners should be to enhance the character of the person portrayed not merely to exhibit a different technique. However, all techniques must be experimented with in order to make the necessary selection.

It can be quite exciting to try using both the copper and the blue toners on the same print.

All kinds of intriguing colours will result which, with a little imagination, could be useful. For example, if a copper toned print is partially redeveloped in a black and white developer, washed and, finally, blue-toned, the result is a mixture of copper and blue-green.

If you want to experiment further with colour toning of prints and transparencies, you could consider investing in the Berg Colour Toning System, which is supplied in kit form for a number of single-colour toners. These can be blended for an even greater variety of hues. The process is not quite as simple to use as the above brown/copper or blue single solution toners, as three baths of solution are necessary. These are:

1 An activator.
2 A toner, which, being similar to a dye, colours the whites and print borders as well, and
3 A clearing bath – which, unless the above effect is required, is essential.

Selenium toner

Another well-tried, simple to use and very effective toner is selenium; giving warm-black to purplish-brown tones on warm tone paper. It has no effect on bromide papers. Selenium powder is insoluble in water, but dissolves slowly in a solution of hot sodium *sulphite*.

Selenium toner	
Sodium sulphite (anhyd)	200 g
Selenium powder	30 g
Water to make	1000 ml

Dissolve the sulphite in a little hot water and add the selenium. When that is dissolved, make up to 1000 ml with water. Keep in full bottles, tightly corked. For use, add one part of selenium solution to 20 parts of 30 per cent plain hypo solution. Toning will take up to 20 min at 18°C (65°F).

Both stock and working solutions keep well – the working solution being used time and again until exhausted.

16 PRESENTATION

It is the presentation of a portrait which has the first impact on the viewer. The care that has been lavished on achieving a living portrait of a particular personality, through the techniques of lighting, camera angle and processing etc, needs to be continued throughout to the retouching, mounting and finishing stages if the effect of the picture is to be communicated properly.

Negative retouching
Partly owing to the smaller film sizes in popular use, partly due to the almost universal change over from black-and-white to colour but, perhaps mainly because the retouched portrait is no longer fashionable, the art of retouching has certainly lost favour.

Pencils
Special retouching pencils can be supplied by some photographic dealers or graphic suppliers and the long leads provided with them range from Nos. 1 to 6. The two most generally used are Nos. 3 and 4, No. 3 being the softer. Before the lead is used it must be sharpened to a fine point.

Glasspaper block
This is obtainable from a dealer in artists' materials and is used for sharpening the pencil leads. Insert a lead in the holder leaving about 38mm (1½in) free and screw firmly into position. Hold the block between the thumb and forefinger of the left hand and the pencil loosely in the right in such a way that the whole of the exposed portion of the lead is in contact with the block. Move the lead in a circular motion over the block, at the same time twisting the pencil round and round between your fingers and thumb. Now you will see why it must be held *loosely!* In this way you will get a fine point graduated from the holder to the tip.

Always put the lead back into the holder when not in use, as a fine point is easily broken.

Knife
A knife, suitable for retouching either negatives or prints, is obtainable from suppliers of surgical goods. The quality of the work done depends a great deal on the shape of the knife, the way in which it is used and its condition. The one illustrated is a useful type of surgical knife.

The knife must be kept sharp always, and for

16.2 Retouching knife. It is essential to maintain a keen edge by constantly re-sharpening.

sharpening it a piece of fine carborundum stone is required. Again, the touch must be very light as the delicate edge is very quickly blunted.

Brushes
Fine sable hair brushes should be used. These are obtainable in various sizes from any art dealer. Nos. 00 and 0 are needed for fine work and a No. 2 for a broader wash. It is essential to protect the brushes when they are not in use in order to prevent any damage to the fine points.

Finishing black-and-white prints
The term 'finishing' covers any work which is done on the surface of the print.

It consists of removing any spots and blemishes, either black or white, increasing the brightness of highlights and generally smoothing the skin texture where necessary. The requisite tools for a practical exercise comprise the following:

1 A large piece of hardboard on which to work.
2 Retouching knife and stone for sharpening.
3 Sable hair spotting brushes Nos. 00, 0 and 2.
4 Tubes of artists' watercolours – or airbrush colours, in lamp black and ivory black, and a palette.
5 Indian ink.
6 Gum arabic or retouching medium.
7 Retouching pencil and glasspaper block.
8 Wax polish or lacquer.

Seat yourself at a table with the piece of hardboard resting against the table edge and sloping towards you. An adjustable table lamp, positioned at the top of the board, will give good, even light.

Place the print, which must be perfectly dry, on the board and cover the lower half with a piece of clean, white paper. This serves two purposes: first, to keep the print clean, and second, to use for testing the colour of the paint to match the required print tone.

Knifing

The knife is sharpened at the point for the removal of black spots and a little further down the blade for the larger blemishes. It is again held lightly between the thumb and forefinger, in a sloping position for general knifing, but slightly more upright when the point is being used.

To begin work on the black spots, use the tip of the blade, and just 'pick' the surface of the spot until it disappears. Care must always be taken to ensure that only the emulsion itself is touched with the knife and never the paper base. Passing to the general dark blemishes, the wider part of the blade is used and the surface is 'pared' away layer by layer until the tone matches its surroundings.

Knife work on a print has one great disadvantage – it is difficult to cover up traces of the operation on the paper surface.

Spotting

Put a little watercolour on the palette, using the lamp black for a black tone, or the ivory-black for a brown-black, and spread it with a few drops of wetting agent or water. Leave to dry.

Moisten the brush on the tip of your tongue, gently twirling it at the same time to keep the fine point. Now twirl the brush on the palette on the edge of the dried paint. Very little paint is needed. Test the colour on the plain paper and select a spot within the matching tone. The action of spotting is to touch and draw back, not to push forward. If the brush is held in the upright position and the point pressed straight down onto the spot, the paint will circle the outside of the spot and the brush hairs will fan outwards. The brush must be held lightly in a sloping position and the paint left on the spot as the brush is drawn backwards.

The habit of moistening the brush on the tongue is derived from necessity. There is no other medium which enables the paint to adhere to the print as easily as does the slight moisture of the tongue. If you prefer to try something else use a pad of cotton wool soaked in wetting agent, or water. If the paint is made too wet it will not stick to the emulsion.

Should the spot not be removed at the first attempt, leave it to dry before trying again. On the light tones very, very little paint is needed; in fact the re-moistening of the brush is usually sufficient without re-charging with paint.

Glossy prints which are intended for glazing are spotted with indian ink instead of paint. This is waterproof, and enables the print to be wetted before glazing without affecting the finishing.

Glossy prints which are to be left unglazed can be finished with paint mixed with either a drop of gum arabic or of retouching medium.

Matt prints can be finished with a brush and paint as usual or with the retouching pencil and a soft lead. If pencil is used the print should be held in the steam from a boiling kettle for a few minutes to 'set' the graphite.

Wax polish or lacquer

After mounting, the prints, apart from matt or glazed glossy, may be either lightly polished with a pure white wax or sprayed with a clear lacquer. This will protect the print surface and conceal any finishing work.

Finishing colour prints

A colour print, straight from the laboratory, is almost sure to require some finishing. There will probably be facial blemishes to remove, stray hairs to tidy, highlights to be strengthened and overdark shadows modified. The depth of tone in parts of the background or clothes may need intensifying. Corrections can be made quite extensively, with patience and care, by means of an airbrush, brush or colour pencils.

It is first necessary to prepare the print surface by spraying with a retouching lacquer to give a very matt surface with a 'tooth'. The spray can must be well agitated before use, in order that the matting agent, which settles to the bottom of the can, may be distributed evenly throughout. Incomplete agitation results in white, gritty flecks over the print surface, which take a long time to remove. The spray can should be held 20 to 25cm (8 to 10in) away from the print and at an angle of 30°. Starting close by and working away from yourself, lay a wet coat over the area of print to be retouched. Allow it to dry completely – fifteen to twenty minutes or until hard dry.

Pencils can be obtained in a great variety of colours – Eagle Prismacolor or Prismalo – each being numbered to facilitate making a collection without duplicating. There are several subtle shades in skin tones and each one is important in matching the work to the original. The pencils should be sharpened to a fine point before commencing work. Skin blemishes may be removed with white or light flesh colour and afterwards blended in with the surrounding skin tone. Highlights on the face may be strengthened and skin texture smoothed where necessary. Always work in the direction of the facial bone structure as described for black-and-white negative retouching. Blend the work by rubbing with the finger tip or a piece of india rubber cut to a suitable point. Mistakes can be rectified by wiping with a piece of cotton wool moistened with lighter fuel, which removes the work but does not affect the underlying lacquer.

Using a magnifier, check to see the real colours within the grain of the paper. A woman's skin will be a mixture of light and dark flesh colour, a little pink and darker red with some grey, while a man's skin will contain some of the darker tones of brown and red as well as the lighter flesh. While thinking about flesh tones, take a little time to study your own skin under a magnifying glass and learn at first hand what colours are included. You will find the subtle shades of bluey-grey which comprise the larger veins and, sometimes, especially in a man's face, the bright red, cotton-like veins forming a network under the skin. There is an overall creamy-pink surface with underlying tones of red and grey.

Nowhere is there one solid colour, but only an impression which is gained from an infinite number of shades.

By studying the colours inherent in a variety of skin types you will find it of inestimable value when finishing a colour print, especially where there are large areas of skin tone.

Finishing with airbrush

Backgrounds may be lightened or strengthened by spraying with an airbrush primed with watercolour. It does take some practice but, once the techniques are mastered, the effects to be obtained are limitless. Airbrushing blends in well with pencil work making the use of both mediums suitable for finishing large prints. Final spraying with a clear lacquer, or heat sealing the print, will ensure protection.

Finishing in oils

Oil paint is a comparatively easy medium to use as a substitute for the airbrush. Materials required include Winsor and Newton's Opaque Artists' Oil Colours and a small quantity of linseed oil.

The print to be worked on should be sprayed, as before, with retouch lacquer and allowed to dry for twenty minutes to half an hour. When quite dry, rub the surface over lightly with a pad of cotton wool moistened with linseed oil, wiping off the surplus. This allows the colours to be blended easily. Using a small cotton wool pad, squeeze a small quantity of paint onto the area and rub it around in circular movements, blending it in with the surrounding colour. Colours can be mixed or overlaid as required. Any fine work can be done with a brush, blending it in with dry brush or stump.

When you have completed the work, give a light spray of lacquer and leave to dry. Re-spray with a medium coat. This should conceal the work as well as protecting the surface.

Presentation

The techniques practised throughout this book have a primary consideration in common: to produce a 'living' portrait, whether the truth is revealed through a mood, an idea, or something more personal. So far, we have been involved only with ourselves and our subject but now we have reached the stage when we must introduce a third person – the viewer.

We aim at his acceptance of our portrait, whether or not his response is favourable. If a picture is unsuitably mounted, the viewer immediately becomes aware that he is on the outside – that he is only looking at a photograph on a mount. To involve the viewer completely we must use presentation techniques imaginatively. Today we are free to do this, as restrictions to standard sized mounts for use in exhibitions have very largely been removed. Mounts may be of any colour, size or shape, according to the photographer's creative vision.

Colour of mount

Mounts of a definite colour are sometimes most effectively used for colour photographs when their role is to enhance the theme of the picture. But for monochrome a coloured mount will, all too often, attract attention to itself and so defeat its object. However, a black mount for a subject predominantly dark in tone, a grey for a half tone, and

a white for high key, will all give greater impact to the picture content than to the mount.

Size of mount

The size of the mount depends on the mood of the picture. An idea, or emotion, which needs space to convey its meaning needs a large mount with the picture suitably – not necessarily conventionally – placed.

Some subjects achieve the greatest impact when the picture is flush mounted to its particular shape.

Shape

The shape of the picture is all-important. We thought about this before making the enlarged print, when with the help of two L-shaped pieces of card we selected the picture content. The overall shape may be upright, horizontal or square. The essential factor is whether or not the shape suits the subject. If we have used a particular shape with the sole object of presenting something different, the result may or may not be successful. But in either case we shall have failed to use the technique creatively.

Mounting

The best and cleanest method is dry mounting. The requirements are:

1 Ruler.
2 Adhesive dry-mounting tissue.
3 Fixing iron.
4 Trimmer, or knife and steel rule.
5 Dry mounting press, or household iron.

Method

The first essential is to ensure that the print and the mount are absolutely dry, then proceed as follows:

1 Straighten the print. Place the print face down on a soft but firm surface. Hold one corner between the thumb and forefinger of the left hand. Hold a ruler in the right hand and place it (lightly but firmly) diagonally across the back of the print. Holding the ruler still, draw the print out from under the ruler. This will turn one corner outwards from the centre. Repeat the process for all four corners. The print will then curve slightly backwards. *Note:* Do not straighten a print immediately after heat drying or the surface will crack.

2 Apply the tissue. Take a piece of adhesive dry mounting tissue the same size or a little larger than the print and lay it over the back of the print. With a heated fixing iron, tack the tissue to the print from the centre outwards to form a diagonal cross, leaving the corners free. This prevents wrinkles occurring in the tissue when it swells with heat. Substitutes for a fixing iron are a soldering iron, or any piece of *smooth* metal which can be heated. The handle of an old spoon will suffice. The correct temperature must be found by trial and error. No harm can result from a tool which is insufficiently hot – the tissue will just not stick. Too great a heat will not only burn the tissue, but make a shiny mark on the print surface. If you can just touch your hand with the heated tool it is about the right temperature. Experiment with an old print first and you will quickly discover the right heat.

3 Trim the print and tissue together. If you do not have a trimmer or a guillotine, you can use a steel ruler and a *sharp* knife.

4 Position the print on the mount, carefully measuring the distances. Hold the centre of the print down firmly with the fingers of the left hand, leaving your thumb free to raise one of the corners. With the heated fixing iron in your right hand tack the tissue to the mount. Repeat the process with the other three corners.

16.3 Tacking iron. This is an essential tool for the dry mounting process. Electrically heated to a low warmth, it is used for fixing the tissue to the print and the mount.

The final stage should be accomplished by using a dry-mounting press, which gives firm, even, pressure and uniform heat over the entire surface.

There is no really good substitute for this machine, but a makeshift tool, which is used by

16.4 Dry mounting press – available in a number of sizes, it is open on three sides to accommodate large mounts. The heat is thermostatically controlled.

many amateur photographers, is the household iron. This is very good for small prints, but is not so satisfactory with large scale enlargements.

However, to obtain the best results with a household iron, proceed as follows:

1 Heat the iron to its lowest control – below 'silk' – to start with. The temperature can always be raised slightly if necessary, but more trouble is caused by over-heating the iron than by having it too cool.
2 Place a large piece of hardboard on a table and have nearby a piece of plain white paper, greaseproof paper or fluffless blotting paper, which is larger than the photograph and mount.
3 Rub the heated iron over the hardboard and the paper to dry out the damp which may have been absorbed from the atmosphere.
4 Place the photograph to be mounted, onto the hardboard and cover it with a piece of paper.
5 Press the iron squarely onto the centre of the print.
6 Raise the iron, remove the paper to ensure that it is not sticking to the print surface. It will only do this if there is any dampness present or if the iron is too hot. Replace the paper.
7 Press the iron again onto the centre of the print. Hold it there with firm pressure for a minute or two and then slowly and firmly work outwards towards the corners and edges. Finally, press the edges all round. This means that half the iron will be over the mount.

8 Pick up the mounted photograph and bend the mount slightly inwards. Look along the surface of the print and if a bubble is visible, re-apply the heat.
9 Test again as before and, if no bubbles are seen, bend the mount slightly backwards at each of the four corners. If the print leaves the mount in any place, re-apply the heat.
Note: If the iron is not hot enough, the tissue will stick to the print but not the mount. If the iron is too hot the tissue will stick to the mount and not to the print. Too much heat usually results in the destruction of the adhesive power in the tissue, and the whole operation has to be repeated with a fresh piece. It pays to have patience and use a cooler iron, even if it means keeping the pressure on the print for a longer time.
10 Put the photograph under an even weight for a time. If the print is to be flush-mounted and the tissue is more or less the same size as the print, there is no need to trim until after the mounting has been completed.

If the print to be mounted is a glazed glossy, at stage **4** you should cover the print with the chromium sheet from your glazing machine. Without the protection of this sheet the heat will destroy the glaze.

RC papers
All RC papers can be dry mounted, using special double strength tissue. At every stage ensure that the face of the print and the mount are perfectly dry. Use only a very light pressure with the tacking iron. Before inserting in the dry mounting press, cover the print with a sheet of clean, perfectly dry, cartridge paper, photographic blotting paper, or, if the print has a glossy surface, with the glazing sheet. The print should be left in the press for three to five minutes, or longer if necessary, but the temperature of the press must not exceed 85°C (185°F).

Dry mounting Cibachrome prints
The dry mounting of Cibachrome prints need not cause any concern, provided that a few simple precautions are taken.

1 Use dry-mounting *film,* not the usual adhesive tissue. You will find the film sandwiched between two protective papers.
2 To prepare the piece of film for use, strip the protective paper off one side and lay the film, face

up, on a flat piece of card. Pierce the film thoroughly all over with a special multiwheel piercing tool, or something similar.

3 Place the print to be mounted face down on a piece of card (covered with clean white paper for protection) and lay the prepared film over the back of the print. Squeeze all the air from between the two with a rubber roller squeegee. *Never* use a tacking iron.

4 Trim the print and film together to required size and then peel off the remaining protective paper.

5 Position the print on the mounting board and press down.

6 Insert in the dry-mounting press for one minute, making sure that the temperature does not exceed 85°C (185°F). All resin coated papers can be mounted as above, using the adhesive film. Most colour prints, excluding Cibachrome, can be mounted with dry-mounting adhesive tissue in the ordinary way, using *minimum heat.*

Heatsealing

Heatsealing is a safe way of protecting colour prints – including Cibachrome – when the pictures are to be used for display purposes. It also protects all print finishing, such as the work done by airbrush, pencil or paint, preventing it from being seen or accidentally wiped off. Heatsealing protects from dust and damp and removes the need for glass when framing.

Heatseal film is obtainable in matt or textured finish. The film must first be pierced all over, as described for the adhesive film in mounting Cibachrome prints. It is then smoothed over the print surface with the rubber roller squeegee and inserted in the mounting press for about two minutes at 85°C (185°F). The process may be

mount
dry mounting tissue
print
heat seal

16.5 Dry mounting and heatsealing the surface of the print can be carried out in one operation. The diagram shows the careful positioning of a 'sandwich' before placing in the press.

carried out at the same time as the mounting, thus requiring only one insertion in the press.

Heatsealing lends itself to plenty of experimenting for unusual results. Place a piece of sandpaper in contact with the film and insert it in the press and the photograph will appear to have been printed on a rough surfaced paper – according to the coarseness of the sandpaper used.

Canvas mounting

A few colour portraits, enlarged for display purposes, can be enhanced by canvas mounting. This employs 'Special tex' heatseal film and a special grade canvas. It is comparatively easy to handle. When the prepared photograph is stretched and framed in the normal way, it gives an impression of the canvas on which it has been mounted.

Materials for canvas mounting, together with full instructions, can be obtained from suppliers.

BIBLIOGRAPHY

The publications listed below are suggested for further study.

A Manual of Advanced Photography / Andreas Feininger / Thames and Hudson
Diane Arbus / An Aperture Monograph / Aperture, New York
Karsh Portfolio / Yousuf Karsh / Nelson
The Sculpture of David Wynne / Photography by Clive Barda / Phaidon

The Artist's Airbrush Manual / Clement Marten / David & Charles
How to Judge Character from the Face / Jacques Penry / Hutchinson
Lighting for Portraiture / Walter Nurnberg / Focal Press
The Life of Rembrandt / Charles Fowkes / Hamlyn

ACKNOWLEDGEMENTS

The exceptional difficulties experienced in the preparation of this book could not have been surmounted without the valuable help of:
 John Allen ARPS
 Maureen Murphy
 Derek Gardiner FBIPP
 and the staff of Element
to all of whom I extend my grateful thanks.

All photographs by the author except the following:

 Ed Buziak 53
 Roger Clark 1, 2, 4, 6, 7, 10, 14, 15, 21, 28, 36, 37, 38, 39, 42, 44
 Bob Irons 3, 9, 29, 46, 47, 50
 Anna Lempicki 49
 K G Maheshwari 70
 Susan Mayer 35
 Michael Mittelstädt 11, 18, 27, 30, 31
 Paul Petzold 51, 63
 Picturepoint 60, 65, 68
 Rod Shone 19, 20, 22, 23, 24, 25, 26, 33, 34, 41, 45, 48
 Jack Taylor 52
 Tessa Traeger 69
 Charlie Waite 12, 40
 Joan Wakelin 5, 8, 32, 72

INDEX